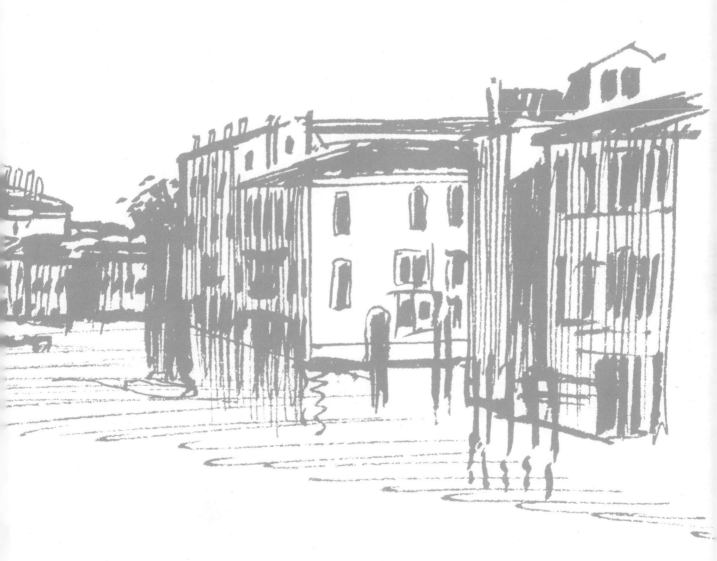

PAINTING
TOWNS & CITIES

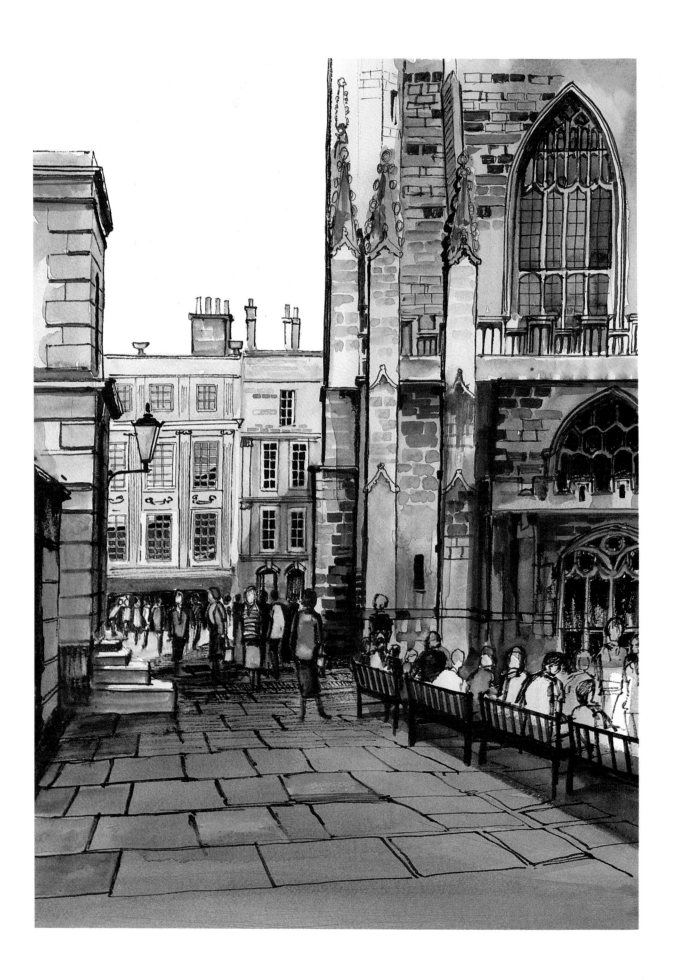

PAINTING TOWNS & CITIES

MICHAEL B. EDWARDS

Cincinnati, Ohio

For Sybil

ACKNOWLEDGEMENTS

I am greatly indebted to the artists whose work appears in this book — Patrick Collins, Brian Lancaster, Neil Murison and John Frederick Palmer. I would also like to thank Alison Elks as editor for all her support and helpful encouragement, Jane Illingworth for typing the manuscript, Brian Middlehurst Photography for the photographic support, and BGP Group Architects, Bristol, for the use of their drawing.

Lee and Joan Topps' kind hospitality made the North American visit possible.

The following owners of paintings in the book are thanked for their permission to reproduce the work — Robert Illingworth, Gordon Copley, Douglas Green, Keith Court, Fred Pamenter, and Larry Tapp.

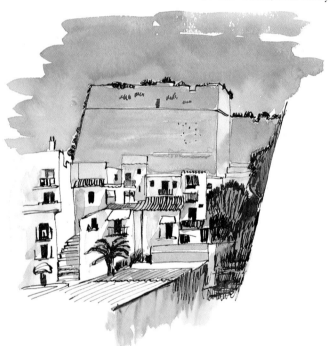

British Library Cataloguing in Publication Data

Edwards, Michael B.
 Painting towns and cities.
 I. Title
 741.2

 ISBN 0–89134–455–1

Copyright © Michael B. Edwards 1992

The right of Michael B. Edwards
to be identified as author of this work
has been asserted by him
in accordance with the Copyright,
Designs and Patents Act 1988.

Book design by Cooper · Wilson, London
Typeset by ICON, Exeter
and printed in Hong Kong
by Wing King Tong Co., Ltd
for David & Charles plc
Brunel House, Newton Abbot, Devon

Frontispiece: **Bath Abbey.** Watercolour, 16×12in (41×30.5cm)

CONTENTS

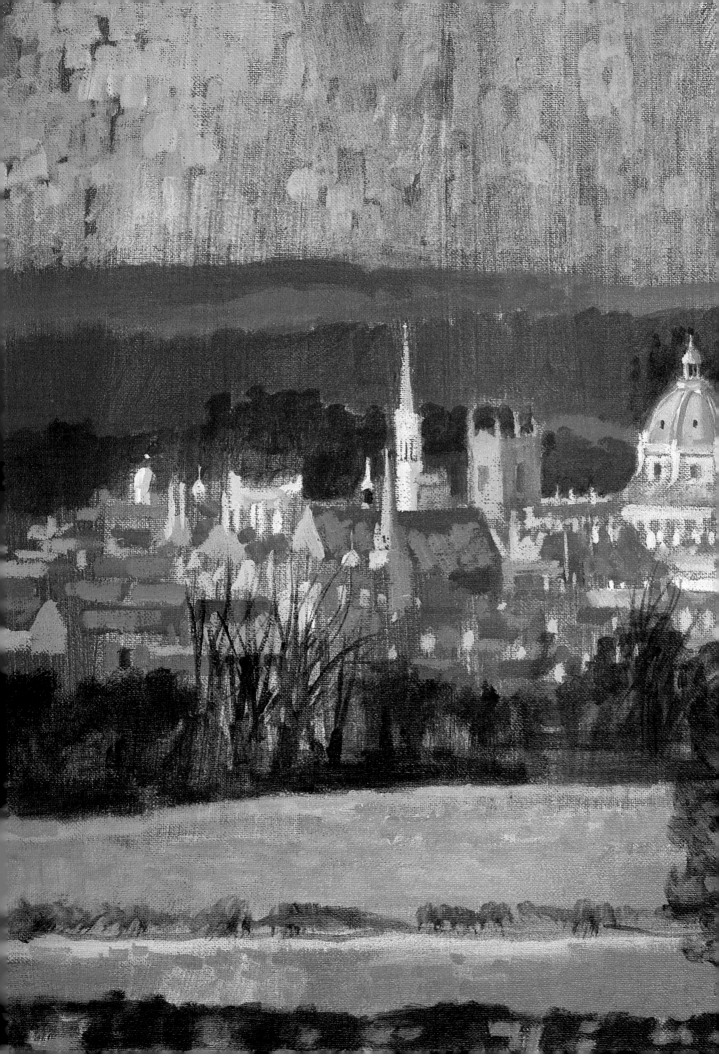

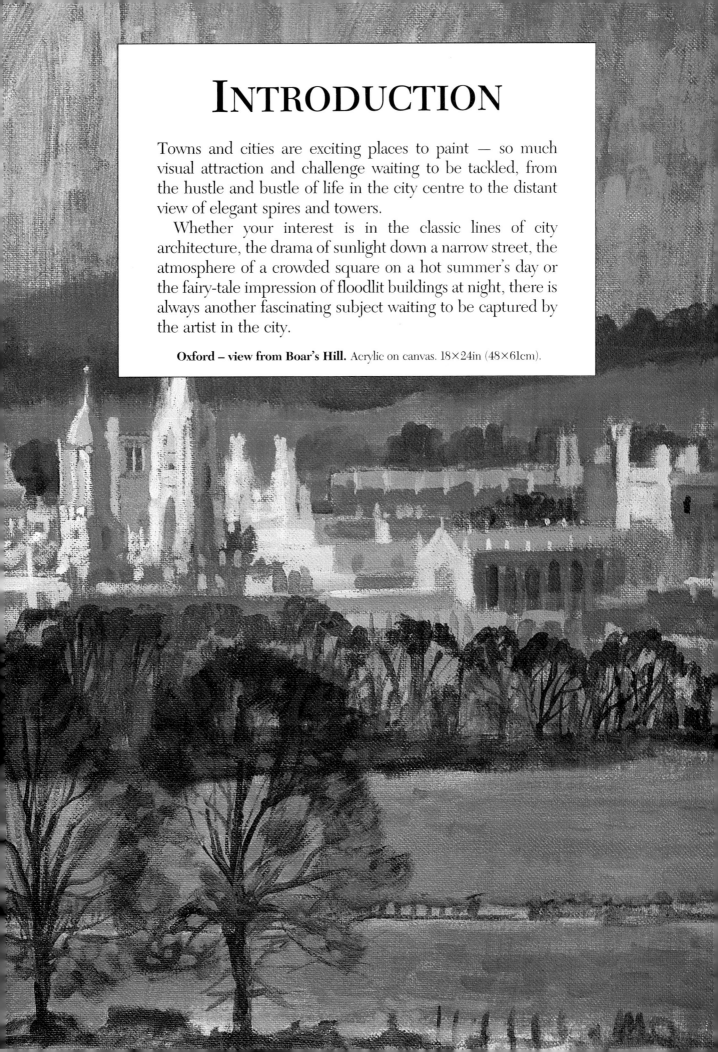

INTRODUCTION

Towns and cities are exciting places to paint — so much visual attraction and challenge waiting to be tackled, from the hustle and bustle of life in the city centre to the distant view of elegant spires and towers.

Whether your interest is in the classic lines of city architecture, the drama of sunlight down a narrow street, the atmosphere of a crowded square on a hot summer's day or the fairy-tale impression of floodlit buildings at night, there is always another fascinating subject waiting to be captured by the artist in the city.

Oxford – view from Boar's Hill. Acrylic on canvas. 18×24in (48×61cm).

In the centre of a major city you are often close to the heartbeat of the nation. Features of cities become symbols of the nation. The Statue of Liberty and the Manhattan skyline are symbols of the USA, as Big Ben and the Houses of Parliament are of the UK and the Eiffel Tower and the Champs-Elysées of France. Moments of history are in the very fabric of our great cities, such as the beginnings of the American War of Independence in Boston or the turbulent past of the British monarchy in the Tower of London.

In spite of these attractions, the city remains for many painters a daunting project. Busy interfering crowds, noisy cars and trucks and the complexities of architecture and perspective all appear to make life too difficult for many painters to contemplate, and they make tracks yet again for the peace and quiet of the country. In my early days as a painter I would often drive for hours around the countryside looking for the 'ideal' landscape, only to return tired and frustrated with an unexciting result. Yet on my doorstep in the city were opportunities in abundance for inspiration.

Cities have inspired some of the world's most famous painters. Venice is the prime example, with Turner's cityscapes or Canaletto's depiction of classical architecture influencing for evermore the way we look at the city. No artist, however committed to landscapes and fearful of painting in the city, could fail to be moved to paint in Venice. The breathtaking beauty of a narrow canal from a back-street bridge with the light softly filtering through the maze of houses is enough to make everyone wish they could put brush to paper!

The purpose of this book is to help the reader unravel the opportunities which the city provides and overcome the apparent problems in tackling them, and above all to provide ideas and encouragement to enjoy the activity of painting in towns and cities. Although it is not a book for the absolute beginner the subject of painting towns and cities is introduced from the simple pencil drawing of single buildings to the complexities of perspective, composition, light and colour.

Three different mediums are featured: watercolour, acrylics and oils; which not only provides interest for a wider readership but hopefully will encourage each reader to try an alternative. Some years ago, having painted mainly in watercolour, I tried acrylics and at once found that the change of medium gave me a great boost in ideas, interest and enthusiasm. The benefit to my work was considerable, not only in acrylics but also in watercolour when returning to the original medium.

▷ **Venice.**
Pencil and wash. 20×16in (51×40.5cm).
A magical city for the painter, Venice provides an abundance of subjects. This pencil and wash painting was completed in situ in approximately two hours, using an HB pencil, with watercolour washed onto the drawing.

Trafalgar Square

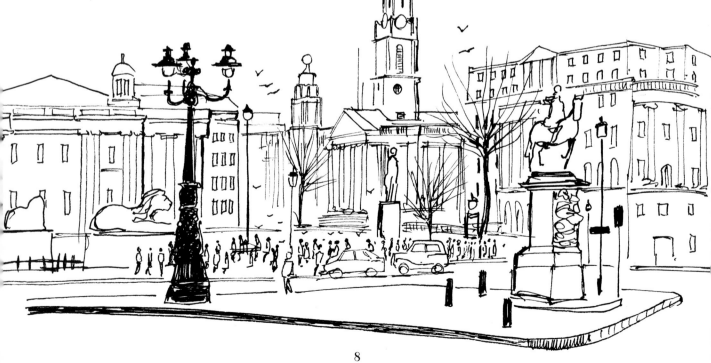

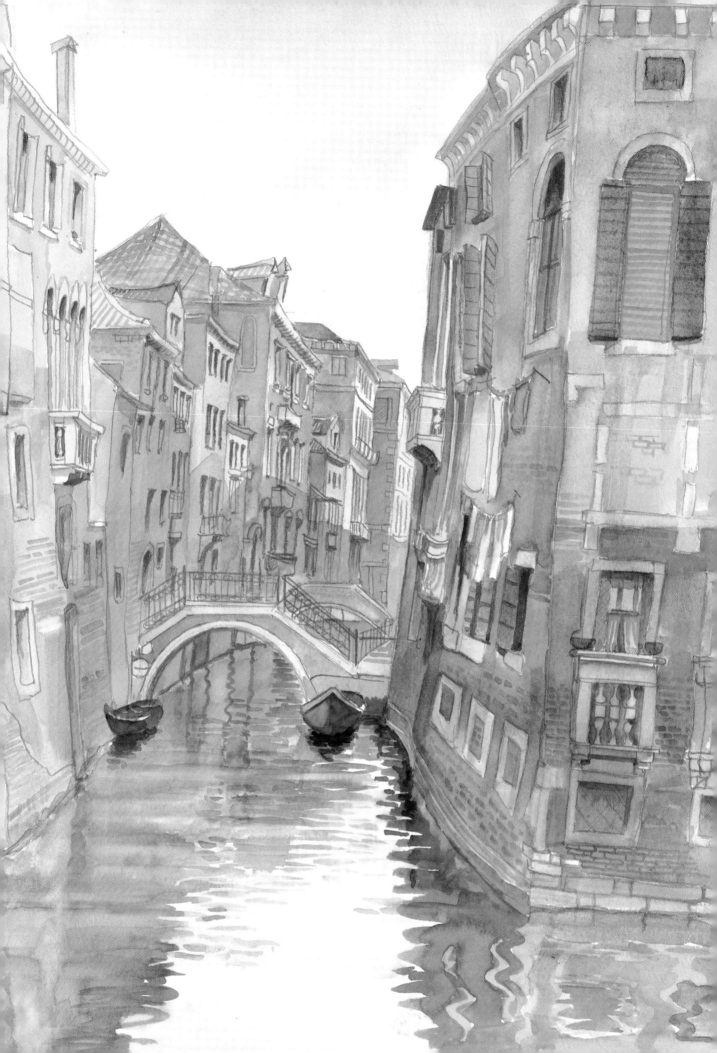

The emphasis throughout the book is on the visual elements rather than text. As many as possible examples of buildings, cities and towns have been included, to provide, hopefully, ideas of subject, method, composition and technique which can be interpreted and utilised by the reader.

My own approach when reading books on painting subjects is to go rapidly from illustration to illustration reading the captions, and enjoying the artist's interpretation of the subject. Only later do I read the text. I suspect many other painters have the same approach and I hope that the emphasis on the visual aspects of the book will be welcomed.

My own underlying interest in cities has been primarily architectural, as will be evident in many of the illustrations. Nevertheless, however much the architecture becomes my focus, cities without people or vehicles are dead and characterless. Consequently a section of the book deals specifically with people and vehicles. Ultimately a cityscape needs to reflect the total environment, blending and integrating all elements into a cohesive whole evoking atmosphere, culture, environment and ambience.

What of the problems of the crowds, the noise and complexity of subject? Even the most experienced painter sometimes avoids at all costs the possibility of spectators watching the work in progress. People find a fascination in watching other people work. Construction sites are a magnet for spectators and companies wishing to foster good public relations provide viewing areas. Similarly tours of factories, offices or craft workshops have a great appeal. The artist seems to be particularly prone to attracting spectators. While the experienced professional may be able to shrug off the distractions, there are many who shudder at the thought. While I personally have suffered in the past and have now become hardened to painting with spectators, I can still beat a hasty retreat when for instance a busload of Cub Scouts heads for my easel, complete with ice-cream, backpacks and chewing-gum!

With practice it is possible to avoid many of the problems by carefully selecting sites to paint, finding a corner to sit in, or a wall to sit against. Most spectators

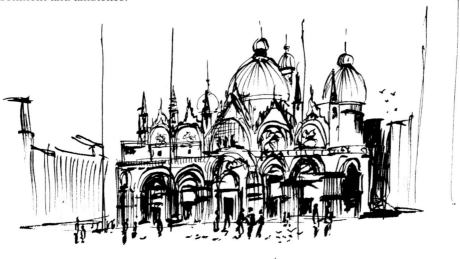

Pen sketches such as these of St Mark's, Venice and Moreton in Marsh, Gloucestershire are an invaluable aid to painting cityscapes.

It is always a good idea to carry a small sketchbook with pen or pencil when travelling for instant recording of attractive buildings or other subjects.

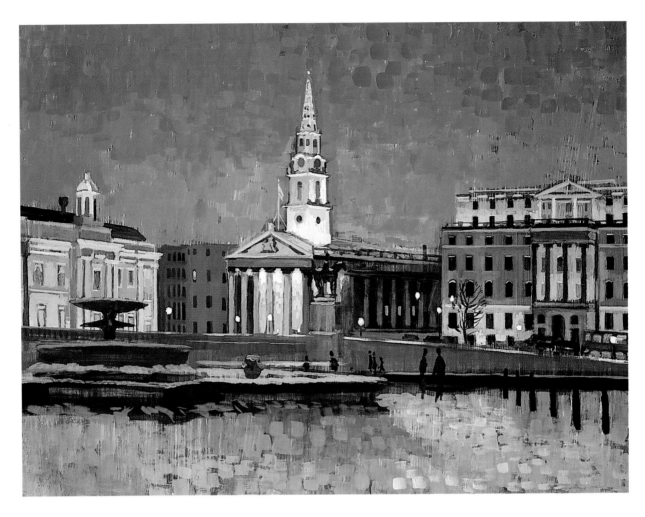

like to creep up from behind and peer over your shoulder so having a wall behind can deter many. Parks and squares can offer quiet spots, as too can a weekend in the city centre. The quietest spot in country or town will often be the business quarter of a city at the weekend. However, if you are determined to paint Piccadilly Circus in London, or Fifth Avenue in New York, spectators are inevitable.

For many the most effective compromise is to take sketch-books and camera and generate sufficient reference material to be able to paint the final picture in the quiet and convenience of the studio. Sitting in the most crowded areas with a small sketch-book tends not to be noticed by the passer-by and with a small watercolour box in one hand, sketch-book on knee and paintbrush in the other hand, much can be accomplished with little harassment. Collecting reference material and the use of the camera is dealt with separately later in the book.

On a more positive note spectators can be fun. You can meet more interesting people painting in the city than in a corner of a distant field in the countryside with only the cows for company. From a Lebanese ice-cream seller on Fifth Avenue to a country vicar in the

△ **Trafalgar Square by Night.**
Acrylic on board. 18×24in (48×61cm).
Floodlights provide an almost fairy-tale scene in many city centres. Difficult to paint on the spot, unless from a local window, so reference has to be made to photographs and sketches. In this example the treatment of sky and snow suggests reflection of the lights; the brush-strokes are separate, providing variety and texture to the sky and snow.

English Cotswolds I have met a wide range of fascinating people in my travels with a sketch-book and in many cases amusing anecdotes result. The ice-cream seller was most interested in my sketching in New York. My daughter suggested that a small sketch of him and his ice-cream cart might result in the gift of an ice-cream for her.

He was certainly amused and pleased with the sketch but the ice-cream was not forthcoming!

Above all painting in the city should be enjoyable. Apart from meeting people, I find great enjoyment in discovering more about a city's history, its architecture, town planning and atmosphere. There is no way better to retain a feeling for a place than trying to paint it.

11

▷ **Steam Engine Joy Rides.**
Oil on board. 20×24in (51×16cm).
An industrial museum can provide interesting alternative subject matter in the city. In this case backlighting has provided a dramatic view of this historical subject, of an ancient steam engine providing joy rides for visitors to the museum.

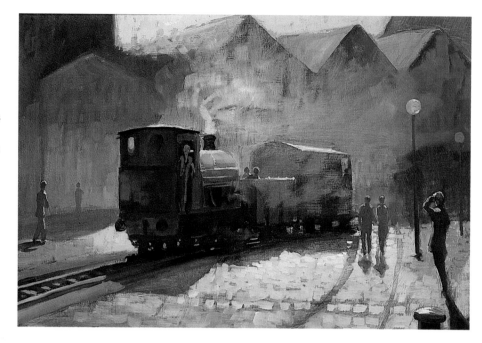

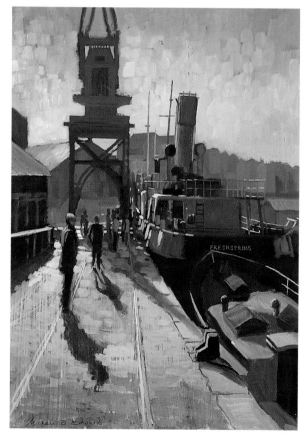

◁ **The Old Tugboat.**
Oil on board. 18×24in (51×61cm).
Another example of subjects to be found in the city, the docks are full of interest, with dockside cranes, boats and spectators. In this scene the tugboat is a museum piece together with the crane, creating an attraction in the city centre. The painting has a strongly textured underpainting which is evident in the finished picture.

▷ **Church Interior.**
Acrylic on board. 14×10in (35.5×25.4cm).
Interior scenes provide useful material in towns and cities, including cathedral or church interiors, cafés, galleries and museums. Very useful on a wet day, as it is possible to find a quiet situation to paint uninterrupted.

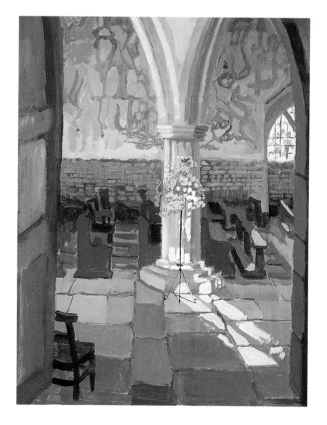

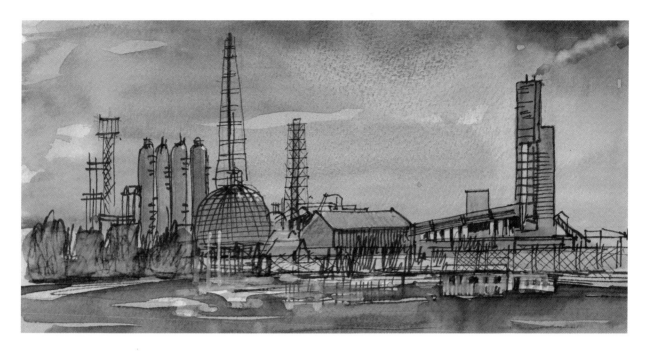

In my travels to cities in various countries I have tried to find places which may be more typical of the country or region than the tourist spots.

The comparison of the ways in which cities have attempted to combine or separate modern development and historical remains is fascinating. In the UK, for example, many provincial cities abandoned their often worthy past history in a rush for development in the 1950s and 60s, which has created a uniform, often ugly banality, and will be increasingly seen as an architectural and historical disaster. In all major cities the different attempts to handle the overpowering influence of the modern office tower block, and retain some human and historical perspectives, are quite often very varied in success. A painting or sketching visit to a city often results in a permanent interest, appreciation and fondness for the place, its inhabitants and problems as well as producing, hopefully, some exciting paintings.

I have included in this book my own visits to three beautiful cities: Cambridge, England; Vancouver, Canada; and Boston, USA; I have a great fondness for each. They are in my view three of the most beautiful cities and in the case of Boston and Vancouver combine modern business centres with historical and geographical attractions.

While the vision of a cityscape painting is of soaring spires and elegant avenues, of skyscrapers and tree-lined squares, there is a host of subjects for the painter looking for new challenges: museums, galleries, the interiors of churches, docks, railway stations, and many more. On a wet weekend it would appear that a city is an unwelcoming place for the intrepid painter, but many an interior offers attractive subjects. Most city-

△ **Chemical Complex at Avonmouth.**
Pen and wash. 20×16in (51×40.5cm).
Even industrial complexes in city areas can provide interesting material. This pen and wash sketch attempts to convey the dark depressing aspects which often prevail in such areas.

centre churches and cathedrals offer quiet interiors where painters are welcome (it is courteous to ask permission before starting). In some of the most famous cathedrals there can be throngs of tourists and the spectator spectre raises its head again. If a small church or chapel can have attractive subjects, so too can the interiors of galleries or museums. There are some cafés made famous by the attentions of artists in the past, such as Florian's in Venice (which has remained popular with contemporary artists), and a small sketch-book on a table is often unnoticed.

With the strong industrial heritage of many cities, there are outdoor museums of old ships, steam engines and other memorials of the past making strong subjects for the painter, and even the modern industrial site can have value in providing material. Indeed some painters have found an enormous challenge in interpreting the industrial landscape with its chimneys, cranes, blast furnaces and chemical process plants. You could argue that painting in the city should be an exploration of all the aspects of city life from the showpiece centre or restored antiquity to the back-street slum or industrial wasteland. The value of the city to the painter is that it offers a wide range of possibilities — much wider than can be covered in this book, which concentrates on the core aspects of buildings, streets, and the urban environment.

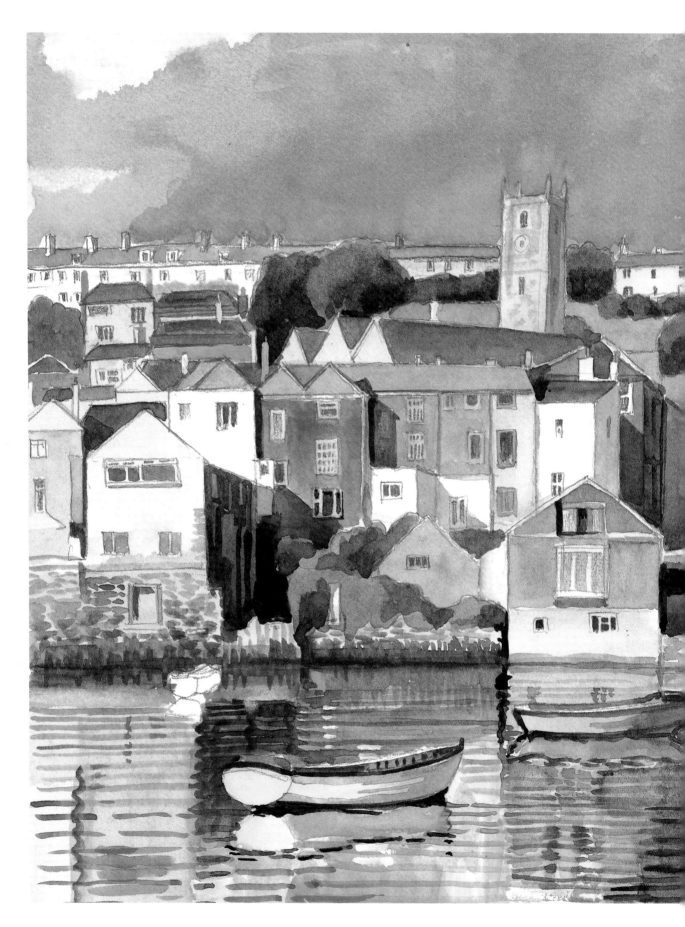

◁ **Falmouth, Cornwall.**
Watercolour. 12×16in
(30.5×40.5cm).
*Cityscapes by the sea often
have a special attraction,
with the reflections in the
water adding light and
interest. This watercolour,
painted on Bockingford
140lb paper, emphasises the
patterns created by the
houses on the hillside with a
strong focal point being
provided by the church.*

CHAPTER 1
DRAWING AND DESIGN

Drawing is an integral part of creating a cityscape. From the simplest line-sketch to complex panoramas of the city a strong element of drawing and design is fundamental to success.

There are artists who through the use of colour, light and tone alone achieve exciting and interesting interpretations of city scenes, but the focus of this book is directed to the more widely used approach where drawing is the foundation of cityscape painting.

Downtown Vancouver. Pencil. 16×20in (40.5×51cm).

LINE-DRAWINGS

The line has an elegance and beauty in the artist's hand which can be difficult to analyse but is unmistakable. Look at the Old Master drawings of Dürer or Leonardo or more recent drawings by artists such as Augustus John or David Hockney and you will immediately recognise the superb mastery of the line-drawing, with economy, simplicity and elegance.

In the artist's hand the pencil drawing has a quality and style unique to the individual, set by a combination of mind, eye, arm and hand, whereas in engineering drawing or architecture the line is controlled by pencil and calculator and depicts the contours of machines or buildings in a precise manner which does not vary greatly according to who draws it.

Nevertheless there is a beauty in architectural drawings or engineering designs and they can be an art form in themselves. When architecture is featured at an art exhibition it is worth spending time looking at plans and elevations and the overall cohesion of the complete work.

Line-drawings of classic cars or early sailing boats are collected avidly, framed and hung. Their functional lines have an elegance of design which is instantly appealing. The architectural elevation depicted below shows a line of terraced houses. The proportions of the buildings have a measured exactness and the lines are precise and of controlled thickness, nowadays often made by computer. Yet it is an attractive piece of work.

It is an apparently small step from such an architectural drawing to the drawing of a Suffolk building below it. But the building in Suffolk was drawn sitting in my car on a cold spring morning in a beautiful village square with the sketch-book on my knee — not in an architect's office with drawing-board and ruler. It has lines which wobble, vary in thickness, and are dark or light in tone. There is clearly a texture created by the softness of the pencil (3B) and the surface of the paper (140lb Bockingford).

The Suffolk drawing reflects my interpretation of the building; the width of each window or doorway is probably technically incorrect in comparison with other parts of the building, some uprights are not

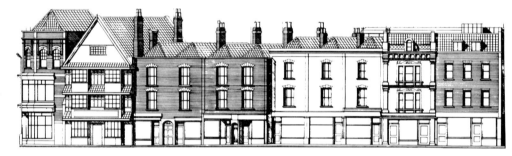

▷ *The ruled lines of an architect's drawing differ strongly from the freehand drawings of the artist; the mechanical nature of the drawing differs considerably from an artist's freehand sketch.*

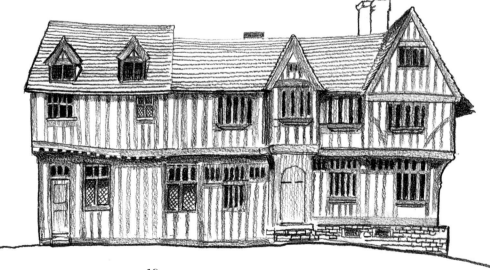

▷ **A timber-framed building in Suffolk.**
This sketch of the elevation provides an interesting pattern of lines and shapes and contrasts with the precision of the architect's drawing.

vertical and some components are missing. Nevertheless it is as I saw it on that spring morning.

Drawing buildings needs practice. You have to get used to estimating proportions. How high is the building compared to its length? Use a pencil in your outstretched hand to measure the height visually and see how many times the height goes into the length. How deep are the windows — or how many windows fit into the height of the building? Usually each second-storey window is vertically above the window below it on the first floor. The proportions of the building give it its character.

Another tip is to start by drawing faint lines which are absolutely vertical in areas of your picture where buildings are likely to be. It is very easy otherwise to finish your drawing and find one or more buildings with a distinct tilt, and unless you are in Pisa, tilted buildings are unusual . . . In the excitement of starting a picture I often forget to check the verticals only to curse later on when I have to try to correct several hours' work.

Elevations of buildings such as the Suffolk timber-frame are a useful start. A simple stone cottage, say, would be an even better subject to start. Look carefully at other artists' drawings in pen or pencil, see how they have used thick and thin lines to great effect. Try this yourself, using several pencils of differing hardness. Use different textures, watercolour rough paper, cartridge or writing-paper, even brown wrapping-paper — which gives an interesting ribbed effect. Practise, practise, practise whenever and wherever you can, using ball-point, felt-tip, pencil, charcoal or pastel. Every line you draw will add to your experience. The sketch-books of contemporary artists are often master-pieces in themselves, with pencil drawings of very high quality. Sometimes such sketch-books are on display at one-man exhibitions. Study them well to see the quality of line used even when the artist was taking simple notes.

The elevation of a single building can develop into an elevation of a group of buildings such as those below. These particular buildings are from Portsmouth, New Hampshire. In typical New England style there are clapboard houses next to Georgian brick, with all types of shapes and textures in one small group.

TEXTURES AND DETAILS

Some ideas to help you draw textures and details of buildings are shown on page 20. Hatched lines create tones for shadows and can be widely spaced for light tones or closely spaced for dark. Cross-hatching creates darker tones and is often rather better for keeping a drawing fresh and clean in appearance than the grey which results from rubbing a pencil over the surface of the paper.

Other effects illustrated include brick walls, where you will often see a better result by drawing individual bricks than a grid of vertical and horizontal lines. Similarly a pavement can be more effective when slabs are drawn rather than a grid.

Windows can be sketched using a grid for the window-frame or drawing individual panes. Often leaving certain panes unshaded adds to the realism of a window.

▽ **Streetside buildings in New England.**
A line of buildings in Portsmouth, New Hampshire, USA, provides a contrast of clapboard and brick. The drawing, using a

3B pencil on cartridge paper, makes no attempt at three dimensions, yet has an attraction of its own and could be developed into a pleasing picture.

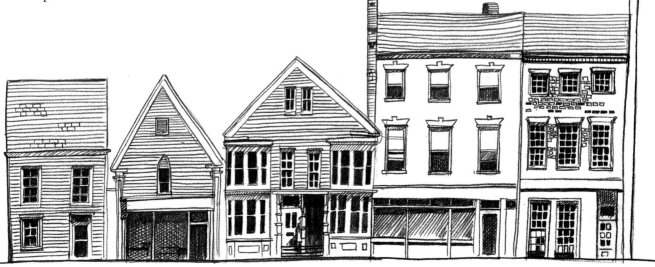

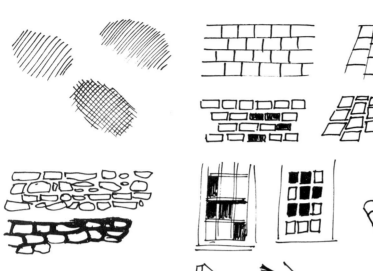

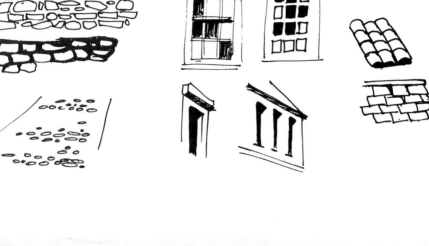

◁ **Sketching Aids.**
Various techniques aid pencil sketches — using hatching for shading, for instance, or drawing each brick or tile separately rather than a grid of lines. Windows are a frequent feature in drawing buildings and various approaches should be tried in drawing window-panes.

▽ **Dartmouth, Devon**
Pen and wash. 14×20in (35.5×51cm).
The attraction of an elevation of buildings in two dimensions is used here to create this pen and wash watercolour. The interest in the picture is the contrasting colours and styles of the buildings set in a harbourside view.

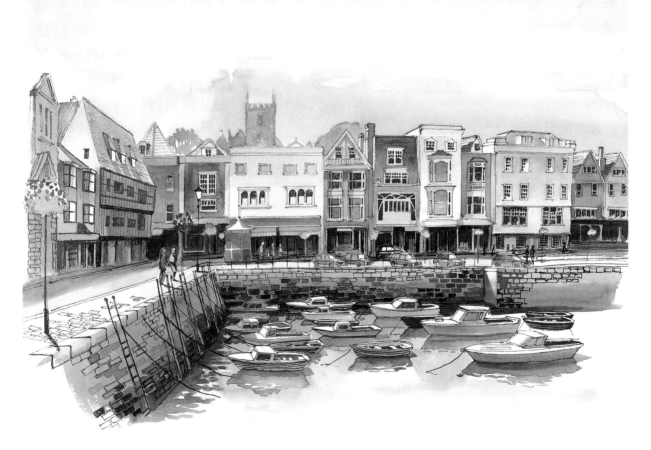

GROUPS OF BUILDINGS

From a line of buildings, as in the New Hampshire sketch, it is a relatively small step for you to create a painting with an interesting group of buildings such as those to be found on the beautiful south-west coast of England at Dartmouth in Devon. The pen and wash illustration opposite is primarily an elevation drawing in two dimensions with the harbour and boats added to create variety and interest.

You will find that two-dimensional drawings and paintings of individual buildings or rows of buildings can make attractive pictures, portraying the character and history of the subjects and being a reminder of a visit or a record of a building of particular interest.

DRAWING STYLE

Everyone has a handwriting style which is unique: it is well known that graphologists use handwriting to assess personality characteristics in great detail. Drawing equally expresses individual style and often reflects the state of mind of the artist at the time. As an engineer by original training I have difficulty in making my drawings flow as freely as I would like. My original training is telling my subconscious perhaps that a straight line must be straight, and a right angle should have 90° between the two elements. When you are relaxed is often a better time to create loose and flowing drawings than when you are anxious or pressed for time. Quite often at a drawing class a student will struggle hard with a drawing, getting more and more intense with little success, but after a coffee break and relaxation the drawing will be corrected and finished with style in a short time. Tightness and too much detail often result from trying to get the drawing 'right'. As soon as an eraser is used drawings deteriorate in quality. It is often better to leave the original line and the corrected line on the drawing and thus maintain a fresh clean line on the paper than scrub the surface with an eraser.

Look at drawings by Picasso, Degas or an Old Master: the corrected lines are often in evidence. Alternatively, once a pencil drawing is complete and 'right', redraw over it with pen, leaving out details and only using the essential lines to describe the subject, with a freedom which comes from not having to concentrate on getting the drawing right. Then rub out the original pencil and you may find a much freer drawing with more style than ever achieved by pencil alone. Or with an eraser — preferably a putty-type soft eraser — remove from your completed drawing lines which might not be fundamental to describing the subject and explore the looseness and freedom which the drawing gains.

△ **The 'Tailor of Gloucester' Shop.**
Pencil on cartridge paper. 20×16in (51×41cm).
The Beatrix Potter stories refer to the 'Tailor of Gloucester' shop which is today a museum and shop of Beatrix Potter memorabilia. The drawing, in 3B pencil on cartridge paper, uses the textural effects for brick, tiles, paving-slabs and windows. Hatching and cross-hatching are used to create shadows. Many subjects suitable for detailed pencil-work can be found in any city. It is a medium which is very effective in recording buildings and architectural details.

Try different pencils, pens, crayons from those that you normally use. A recent innovation is the calligraphic felt-tip pen which has a flat, spade-shaped tip, enabling thick and thin lines to be easily drawn.

Enjoy the pleasure of sitting with sketch-book and pencil in the park, the square or the café. Make a habit of keeping a sketch-book with you in the car or in the office; not only will your drawing steadily improve but you will find subjects for paintings which perhaps would never have been noticed had you not sketched in the city first.

PERSPECTIVE

To the landscape painter, one of the horrors of cityscape painting is perspective. Buildings of all shapes and sizes, frequently in streets which bend or go up or down hills, create complexities of perspective which send shudders down their spine.

Certain cityscapes or buildings contain complex perspective, but by analysing the underlying principles most perspective problems can be simplified. With practice it is possible to think in perspective so that when drawing a building each line you add is broadly correct and in perspective.

There are two types of perspective to consider initially: linear and aerial. The first is concerned with drawing an object to create an impression of three dimensions — the second is the use of lighter tones for objects which are more distant. In towns and cities both are used but the most problematical is the linear perspective of buildings. Linear perspective can be calculated through geometric diagrams to cover all different angles in a complex street scene. To do so in practice would not only be a soul-destroying exercise, but would also kill off most of your creative or artistic flair, resulting in rigid and mechanical drawings. Indeed there are computer programs which will turn an architect's front, side and plan drawings into a three-dimensional diagram perfectly in perspective.

There are many famous painters who deliberately ignore perspective, or distort it in order to create the image they need. However, a good understanding of the fundamentals of perspective is essential to be able to distort in a meaningful way.

How can perspective best be tackled in drawing buildings, streets, cathedrals and all the other elements of cityscapes? Most buildings can be considered to be derivatives of cubes. If a large cube is placed between a spectator and the horizon, lines on the cube visible to the spectator which are horizontal would if extended appear to converge to meet at the horizon, The point at which parallel horizontal lines on the cube would appear to meet on the horizon is called the vanishing-point. Lines on the cube below the eye level of the spectator rise to the horizon, while those above, fall. Vertical lines on the visible faces of the cube which are equidistant from each other would appear to the spectator to get closer to each other the further they are away.

The application of these principles to a house is shown in the diagram opposite. The windows which in reality are of equal width appear to be getting progressively narrower on the drawing as they recede into the distance, as too does the space between the windows. This narrowing is termed 'foreshortening'. The position of the peak of the roof is determined by drawing diagonals across the end wall of the cube. A vertical line through the intersection of the diagonals will provide the location of the peak of the roof. The line drawn along the top of the roof is parallel to the line of the roof edges and therefore will appear to converge to meet at the vanishing-point.

In most cases you will find that linear perspective can be handled by the application of vanishing-points and foreshortening. Errors most frequently occur when the parallel horizontal lines you have drawn on a building do not appear to meet at eye level and the same vanishing-point. Often the groundline is obscured in town or city by vehicles, road signs or people, so that it is difficult to obtain a strong line at the base to 'fix' perspective. Consequently the lines of the roof and windows must be carefully drawn.

When a row of houses or buildings is on a curving street each building has a different vanishing-point. In the diagram opposite, cubes A and B are parallel and have similar vanishing-points but C and D are not parallel and each has its own vanishing-point.

◁ **A Suffolk Village (sketch).**

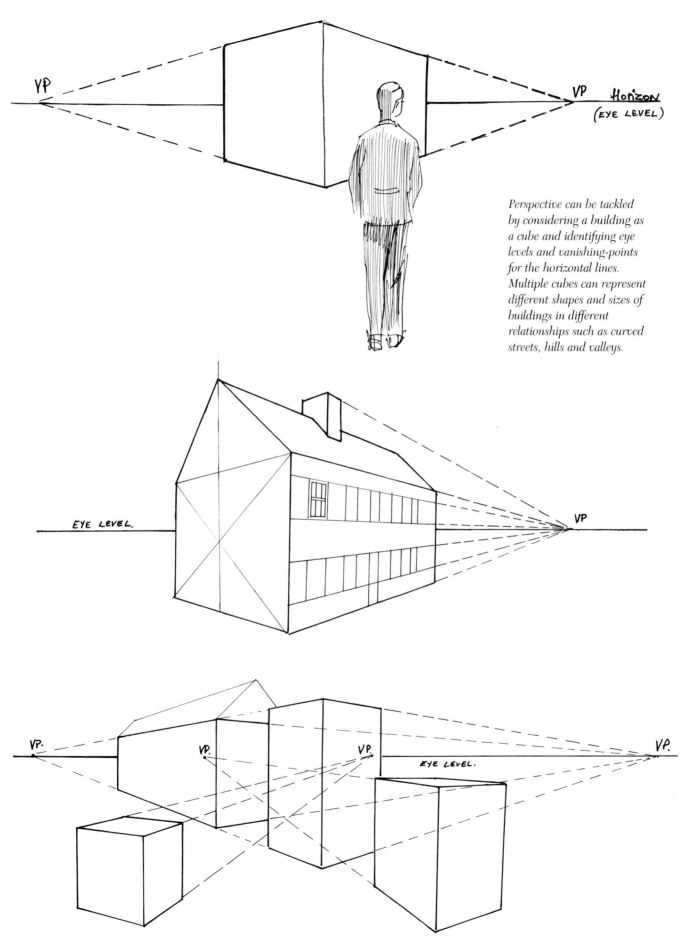

VP

VP Horizon
(EYE LEVEL)

Perspective can be tackled by considering a building as a cube and identifying eye levels and vanishing-points for the horizontal lines. Multiple cubes can represent different shapes and sizes of buildings in different relationships such as curved streets, hills and valleys.

EYE LEVEL.

VP

VP. VP. VP. EYE LEVEL. VP.

OVERCOMING PROBLEMS

In practice there are seldom city scenes which provide perfect examples of perspective, whether houses are in straight lines or smooth curves. Old houses have roofs which often sag in the middle and have eaves which droop. Windows are not equidistant from each other, vehicles completely block out groundlines, making it difficult for the artist to get a 'fix' on the base of the buildings, and hence it is impossible to set a line to vanishing-point. In these cases you have to interpret what you see for the best possible result on the paper. Sometimes if there is a feature which destroys orderly perspective and undermines the whole picture you either have to choose another subject, modify the feature or leave it out. Often it is possible to emphasise one or two lines of a building, which establishes the true perspective and thus 'carry' the anomalies of drooped eaves, sagging roofs or vehicles obstructing the view.

In the picture right, painted in a back-street on a hot summer's day in the French fishing-town of Camaret-sur-Mer, there is a cottage in the centre with sunlight on the roof which has a gutter drooping to the right side of the house. This problem is counteracted visually by the strong lines of the roofs of other houses on both sides of the street. Consequently the drooping gutter does not undermine the perspective and makes a positive contribution to the sense of antiquity of the street. The curve of the street is clearly identified by both perspective and foreshortening and is emphasised by the strong shadow-line which curves into the picture. The size of the van in comparison with the height of doorways and windows on the cottage on the left emphasises distance in the painting.

AERIAL PERSPECTIVE

A sense of depth derives not only from the linear perspective in a painting but also from the recession effect of steadily lightening tones or 'aerial perspective'. In landscape paintings the use of aerial perspective is often a dominant feature of the painting, with distant pale-blue mountains contrasting with strong tones and colours of trees and buildings in the foreground.

The landscape painter often has little linear perspective to emphasise recession, and thus concentrates on aerial perspective to give depth to the painting. In the city the strong linear element provides the overriding sense of perspective but this can be virtually destroyed if the tonal balance between distant and near objects is not correct.

The strength and colour of shadows is often a key to aerial perspective. In the watercolour of Camaret-sur-

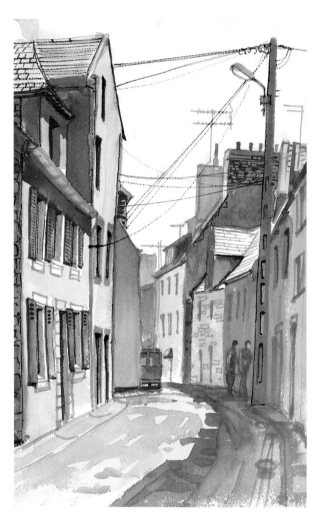

△ **Camaret-sur-Mer.**
Watercolour. 16×12in
(41×30.5cm).
This small fishing-town on the coast of northern Brittany has much appeal for the painter. The back-street in this painting demonstrates the handling

of perspective in a curved street scene. Note how the drooping gutter of the cottage in the middle has little impact on the perspective in the picture, due to the strong linear perspective of the other buildings.

Mer, compare the tone of the darkest element of doorways and windows on the left-hand side to that of the windows in the most distant house. The tone of window-panes is quite often the most noticeable aspect of aerial perspective, houses in the foreground having almost black window-panes compared to the pale grey ones of houses in the distance. One way to control tones in a watercolour of a street scene with many windows is to paint the window-panes first in the correct tonal relationship to achieve the required aerial perspective and then complete the picture using the windows as a guide for tonal control.

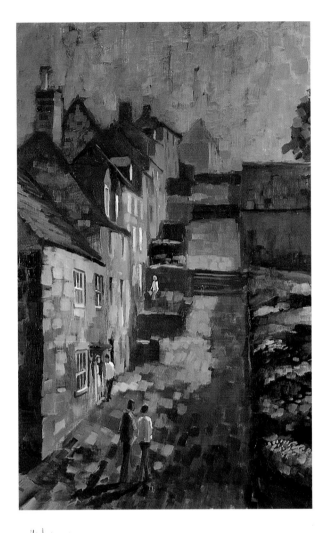

COMPLEX BUILDINGS

So far we have considered buildings as cubes or derivatives of cubes. But life is not that easy. Buildings can be circular, or in a crescent shape. There are domes, minarets, steeples, columns, arches; in fact, all types of geometry.

The crescent of terraced houses, beloved by architects in Georgian England and evident in classical styles elsewhere, is a particularly difficult problem. While in theory you could divide the crescent into individual houses each with its own vanishing-point, in practice the houses form a smooth curve and it is far too laborious to calculate hundreds of vanishing-points. Consequently my only solution is to keep trying until you hit the appropriate perspective (or better perhaps to avoid the crescent altogether!).

Buildings in cities often climb hillsides, making dramatic shapes and skylines but giving another apparent headache for drawing. In this case you should ignore the road and treat each house as a cube, with the roof-line and the lines of rows of windows converging on the same vanishing-point at eye level. Having achieved the correct perspective for the houses, the hill can be added later to complete the drawing. In the oil painting left, the houses are all parallel from the bottom until the penultimate house, which is at a slight angle to the rest. All the parallel houses have the same vanishing-point and the most powerful indicators of perspective are the roof gutters. The line of the gutters is supported in most houses by the line of the windows. In fact the perspective problems of hillsides are less difficult to overcome than those of curves, crescents or domes, and a hillside picture often has considerable attractions of unusual shapes, skylines and composition.

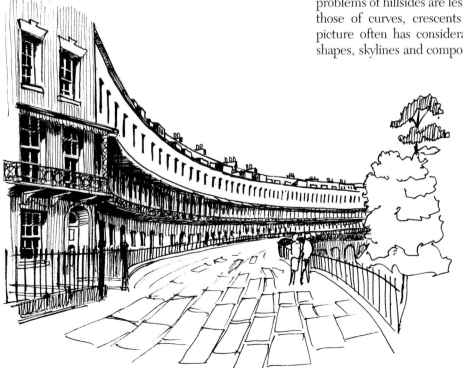

(Above left)
**Tetbury,
Gloucestershire.**
Oil on board. 22×15in
(56×38cm).
The perspective of a row of houses climbing a hillside is best captured by concentrating on the line of the roofs, gutters and windows, adding the path later.

◁ **The Royal York
Crescent, Bristol
(sketch).**

The base of a dome on a building is a circle. For example, in St Paul's Cathedral, if you look upwards from the inside the dome appears as a great open circle with the Whispering Gallery around it. Outside, the base of the dome you can see is one half of an oval disc. The further you walk away the more shallow does the disc become.

To construct a drawing of the cathedral, the building itself can be considered a cube (or set of cubes) with the base of the dome on top (as an oval disc) touching the four sides of the cube (as in the diagram below). In thinking of domes in this way it is possible to clarify perspective and produce a drawing where the dome sits on the cathedral rather than floating on top or at an angle. Similarly, when looking at a church spire, the cross-section of the spire as seen from the ground will vary from an oval disc at the bottom to nearly a circle at the top. Often spires have bands round the outside of the spire at intervals from bottom to top and the correct perspective of these bands will be obtained by following the oval-to-circle analysis.

VERTICAL VIEWS

In a modern city with tower blocks, the problems of perspective become more complicated due to the vertical perspective created when looking upwards at a tower building. In Manhattan the effect is dramatic with the skyscrapers looking as though the sides converge to meet at the top. There is a vanishing-point in the sky where the vertical lines converge.

In reality all tall buildings will exhibit elements of vertical perspective, depending on the closeness of the spectator. But beware! Introducing vertical perspective into a drawing or painting is hazardous. The difficulties in my experience are enormous, particularly as the drawing approaches the edge of the picture when it meets the vertical side of the canvas or paper. If you are determined to paint a picture of the Empire State Building from the street below then use the dramatic elements of vertical perspective as a fundamental aspect of the picture design. When skyscrapers are in the middle distance it is often better to ignore vertical perspective altogether.

Many small automatic cameras have a 35mm wide-angle lens fitted which when photographing in the city exaggerates vertical perspective. This problem of cameral lens focal lengths is considered in more depth on page 105.

APPLICATIONS TO OTHER SHAPES

Complex shapes such as boats and cars can be more easily drawn if they are placed within a theoretical cube which is drawn within the correct perspective of the rest of the painting. The centre lines of the sides of

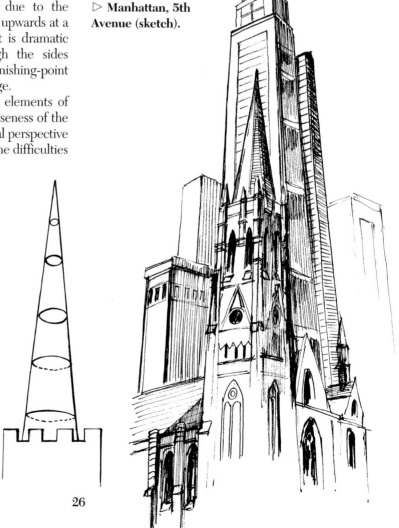

▷ **Manhattan, 5th Avenue (sketch).**

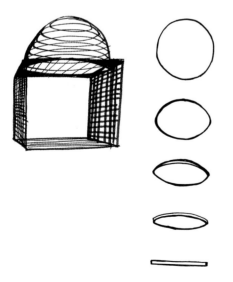

Drawing a church spire.

the cube can be found by using the diagonals as illustrated earlier; this will give the centre line of the vehicle or boat, and other key aspects of windscreen, roof, wheels and so on can be placed in the correct position inside the cube, by reference to grid-lines placed on each side of the cube.

This laborious and mechanistic approach can be

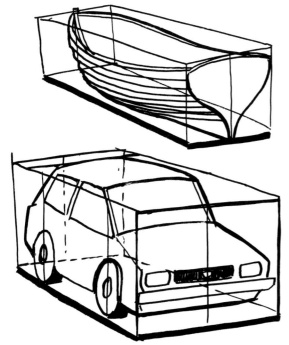

valuable for a subject such as a car or boat in close-up, when it is essential to position all the elements of the object precisely and in correct perspective, but for normal everyday painting it should be unnecessary after sufficient practice. When drawing freehand it is useful to keep the cube idea in your head to position key shapes and features properly but not draw it in each time.

Technical drawings of cars or boats in an engineering environment are an entirely different matter, and precise calculated perspectives using cubes and other devices will ensure a correct engineering drawing in three dimensions. There are books available which explain in detail how this technical illustration requirement for precise perspective can be met.

When I am drawing in the city and feel that there is something wrong somewhere with my drawing, on ninety per cent of occasions the problem lies in incorrect perspective. Often a line of windows has a different vanishing-point from the roofline, or one building appears to be at an angle with another when in fact they are parallel. Window-frames have to line up in perspective with the rest of the building. Sometimes the apparent eye level for one part of the picture is different from that of another.

So when you have an uneasy feeling that the drawing you have just completed is not quite right, check the perspective and you will probably find the problem.

△ When drawing complex shapes such as cars or boats, it is a help to draw a rectangular box which is in correct perspective within the painting. The centre line can be constructed using diagonals, as in the example of a house shown previously. The vertical and horizontal lines of the vehicle or boat can then be drawn inside the box to achieve the correct overall shape, after which details can be added and the box removed.

▷ **St Paul's, London (sketch).**

27

△ **Chipping Campden, Gloucestershire.**
Acrylic on board. 20×36in (51×91.5cm).

In the heart of the English Cotswolds, Chipping Campden is a preserved piece of architectural history. This painting demonstrates the linear perspective of a curving row of buildings, with figures creating additional effects of recession.

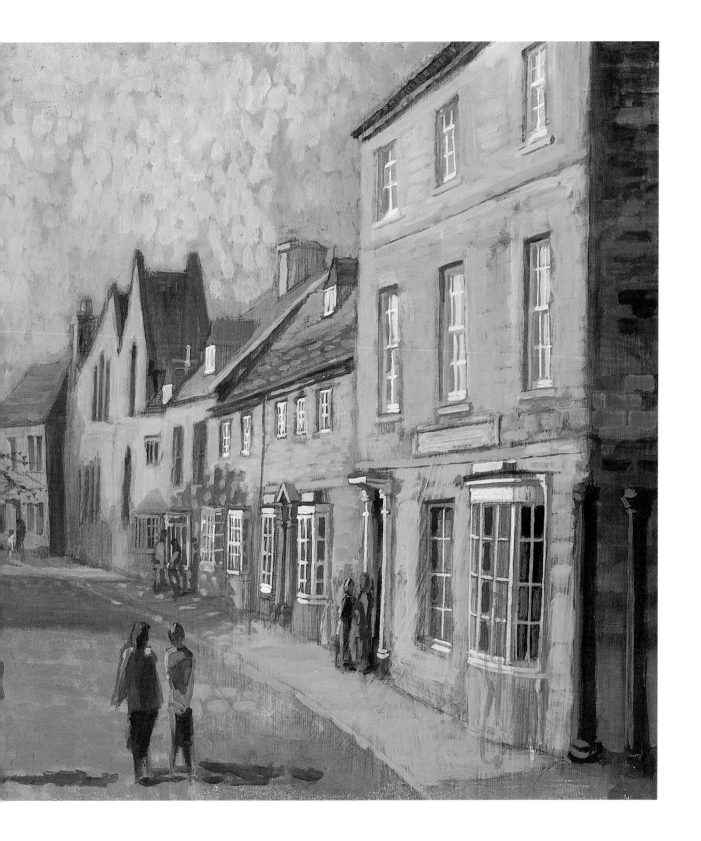

COMPOSITION

Unlike the landscape painter, who can move a tree, omit a barn or change the skyline, the cityscape painter has to limit his artistic licence. Manhattan without the World Trade Centre is not Manhattan. That is not to say that every interpretation of the city has to be strictly representational and recognisable as a specific city. Many painters have used the subject as an inspiration to create works of art with no intention of producing a recognisable portrait of the city in question.

A painter wishing to sell his or her work as a view of the city, or who has been commissioned to paint a specific scene has to establish a reasonable representation. It depends entirely on your objective. The first step in composition is to decide what you are trying to paint. Is it a view of St Paul's which will display the

architectural design, the size, grandeur and elegance or is it a view of St Paul's in its environment of the river, embankment and city tower blocks? Perhaps it is the light and shade of a setting sun creating an impression similar to Monet's *Rouen Cathedral*, or a view of the city in which St Paul's happens to be a part. Once you have set the objective, the composition of your painting will help you to achieve it by focusing the eye on the principal subject and relating it to its context.

Unless you have a clear understanding of your objective your ability to compose a painting is extremely limited, so the first question is: what am I painting and why?

If you are in the fortunate situation of painting whatever appeals rather than a specific commission then make your objective something that really excites you — a new angle of a famous view perhaps — a

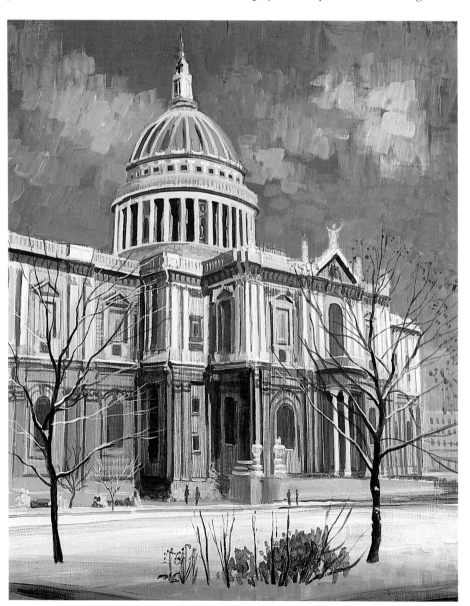

▷ **St Paul's and the City of London from Waterloo Bridge.**
Acrylic on board. 18×24in (46×61cm).
The composition of this painting includes placing the cathedral on the Golden Section, using the strong curve of the Embankment to lead the eye into the cathedral and City and placing the key buildings in a triangular structure.

◁ **St Paul's Cathedral, London,**
Acrylic on board. 24×18in (61×41cm).
The objective of a painting needs to be clear from the outset in order to decide on composition and layout. Here the intention was to illustrate the architectural grandeur of Wren's masterpiece. When close to large buildings such as this the problem of vertical perspective, lines converging towards the top of the picture, has to be addressed.

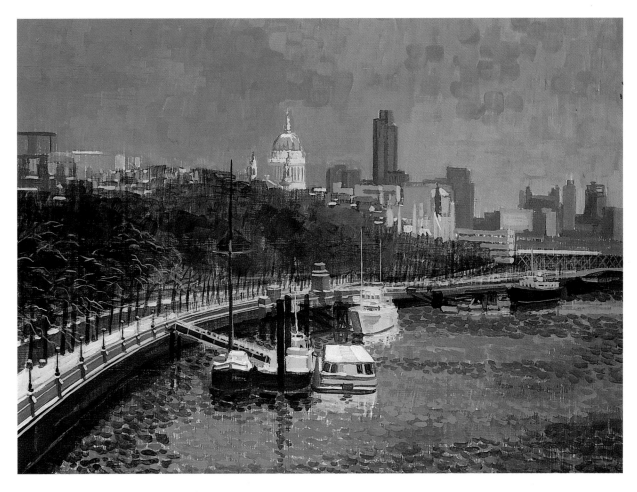

back-street unknown but with fascinating light and shade — a market-place where you can capture the spirit and character of the people.

With the excitement of a new discovery the sobering thought follows. What should be included? Should my painting be square or rectangular? How should I compose the picture? Many teachers recommend using a card with a hole cut into it the shape of the picture you might paint and selecting your composition by looking through the hole. It can certainly be valuable to do so. But what should be in the picture and what left out?

The view from Waterloo Bridge of St Paul's (above) is well known, but in winter I was attracted by the snow on the embankment which emphasised the curve of the riverside leading into the painting. The brown mass of winter trees provided a contrast to the white stone of St Paul's Cathedral and the contrast of the city tower blocks also provided an interesting background to the elegant classical architecture of St Paul's.

THE GOLDEN SECTION

Having decided on the content, how should I compose the picture? Should the cathedral be in the middle, the horizon high or low, more river or less? The embankment — should it be from one corner across the painting or in the middle of the left-hand side? What principles of composition should I consider? Old Masters' paintings were often produced to a precise formula for composition. It is fascinating to read an analysis of the elements of composition in a well known Old Master painting. While today painters do not slavishly follow such formulae, it is useful to know about them and their application. One underlying principle is known as the golden section. Believed by some in history to be the divine proportions bringing art and nature into harmony, it is basically a division of the canvas, the vertical side and the horizontal side being divided into a similar ratio. In the painting of St Paul's a strong vertical line exists through St Paul's dome and down the post in the river against which the boats are moored in the foreground. This line happens to be on the golden section whereby the ratio of the length of the painting to the left of St Paul's (A) divided into the length of the painting to the right (B) is the same as the ratio of (B) to the width of the painting (C), ie A/B is equal to B/C. The Old Masters would then further subdivide each area of the painting into further golden sections.

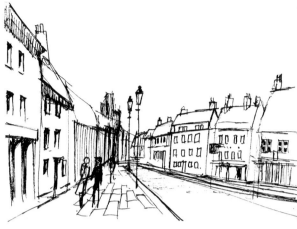

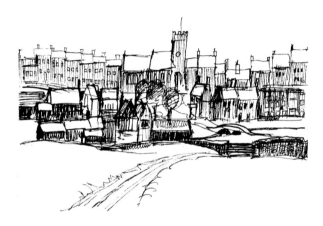

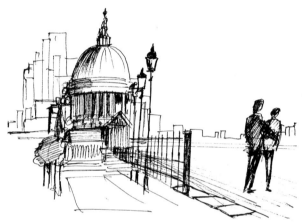

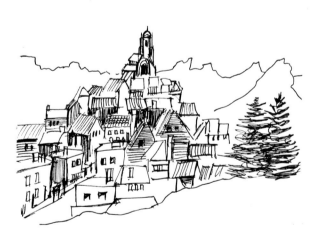

These sketches illustrate elements of composition with the top left-hand sketch showing an over-centralised symmetrical layout. A move of the focus to one side, as in the top right, improves the layout considerably.

The middle left sketch illustrates the benefits of dividing a picture in thirds from top to bottom rather than having the horizon halfway up the picture. The middle right sketch has smaller objects, such as the people, at a greater distance from the centre, balancing the cathedral. Finally, the lower sketch features the triangle shape beloved by Old Masters, which gives a very stable feeling to any composition.

OTHER PRINCIPLES OF COMPOSITION

Another favourite device is to adopt the shape of the triangle, whereby elements of the picture form natural triangles. Often a group of figures would be drawn in the overall shape of a pyramid. The isosceles triangle — one with two equal sides — would also appear, with two corners of the triangle being placed in two corners of the painting. Other devices included diagonals from corner to corner. In some cases multiple geometric devices would be used, creating a complex grid on which a painting was created.

In practice, sitting on site in the city you have limited opportunity to use such devices and even less motivation! What practical composition rules should be applied? Avoid symmetry. For example do not have a straight road disappearing into the middle distance with rows of similar houses on either side. Make the disappearing-point of the road to left or right. Or have a greater area of subject to one side or other.

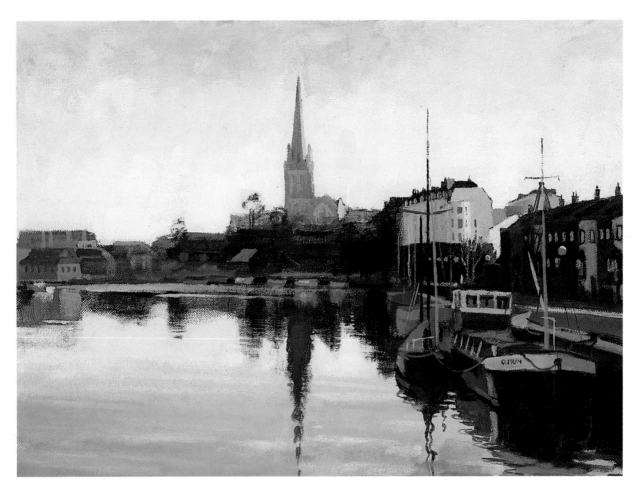

In the painting of St Mary Redcliffe, Bristol (above), the church spire is virtually central. This should normally be avoided, but in this case the composition is far from symmetrical, having far more weight to the right of the centre. Consider the painting as a balance with the pivot being placed on the principal vertical axis of the painting. A massive component close to the pivot on one side will be balanced by a much smaller component at a distance on the other side. In the painting above, the small red building on the very edge of the painting to the left helps to balance the heavy weight of houses and boats to the right.

Another practical aspect of composition is to avoid dividing the picture in half by the horizon. Quite often the composition benefits if it can be divided horizontally into three, the top third usually being the sky. When you look at paintings in the rest of this book and elsewhere, try to detect the elements of composition which help to make the picture balanced.

Using as a background the knowledge of the basics of composition, you have to choose how to apply them to your subject, or how to ignore them and still create a satisfactory result. Too balanced a picture can be boring. I often admire paintings in exhibitions where

△ **St Mary Redcliffe, Bristol**
Acrylic on canvas. 16×20in (41×51cm).
Although the spire of this most beautiful church is virtually in the centre the picture has very heavy content on the right, thus avoiding over-symmetrical composition. The balance in the composition is kept, to a degree, by the red building on the far left.

the composition breaks all 'rules' yet produces a wonderful creative result. Many of my landscapes and cityscapes from the past seem, when I look at them later, to be boringly obvious in composition, so I am trying hard to ignore the rules and experiment with new ideas in the future. Excitement in a painting can be generated by breaking one rule and compensating with another. In an Impressionist painting by Pissarro where a tree is placed in the middle foreground, completely bisecting the painting, the rest of the picture totally compensates by providing a dramatic interest on one side and thus offsetting the symmetry.

An experienced artist walking round an exhibition will appreciate instantly the orchestration of the composition of each painting where, as in a well-conducted symphony, excitement has been generated by emphasis, differentiation, rhythm and balance.

33

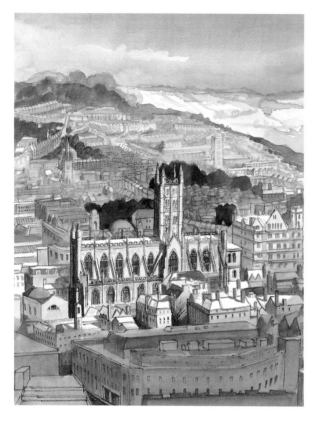

The composition principles discussed so far have involved two-dimensional aspects of the painting. In some cityscapes two dimensions predominate, with interesting patterns as we have seen in previous illustrations.

THREE-DIMENSIONAL ASPECTS

Most cityscapes have a strong three-dimensional aspect, however, and the composition of the painting in three dimensions is equally important as that of two.

For instance the balance between foreground and background, the location of the focal point or principal subject in the depth of the painting, and the path into the picture which the composition suggests to the eye of the beholder, are all elements of the three-dimensional composition and as important as those previously discussed for two dimensions. If your picture has an empty foreground with all the content of the picture at the middle or rear it will feel uncomfortable, as your eye finds it difficult to leap across the empty foreground. Equally, when the focus should be on the foreground, distractions in the background can disrupt the harmony of the painting.

The choice of low horizon or high horizon has both two- and three-dimensional composition implications. High horizons with large foregrounds often require paths for the eye to be led across the expanse of the foreground to the focus of the painting. You can use posts, trees, the masts of yachts to lead the eye from one part of the painting into another. Likewise, shadows across a street can join one side to the other and avoid half the picture being isolated as in the painting opposite.

△ **Bath Abbey and City.**
Watercolour. 16×12in (41×30.5cm).
A view taken from the top of a nearby hill shows Bath in winter with the sun lighting patches of the city. The composition here uses a high horizon which provides a large area to be handled from the base to horizon, requiring variation of tone and detail to retain interest.

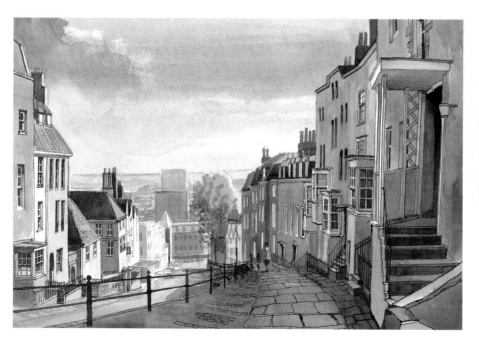

◁ **St Michael's Hill, Bristol.**
Watercolour. 16×20in (41×51cm).
The composition is dominated by the curved path and houses on the right leading the eye down the path and into the picture. Strong linear and aerial perspective are featured in this view.

COLOUR IN COMPOSITION

Colour can be used to aid composition as well as for its inherent contribution to the painting (see Chapter 6). When you have an apparently unbalanced picture it can often be brought quickly back into balance by the use of colour to place emphasis on one component. For instance a small building on one side of a painting which is insufficient to balance a large building on the other could be strengthened by adding colour, thus giving it more emphasis and bringing the composition into balance. Colour can also link elements of the composition together: touches of the same colour in different places across the painting bring a sense of cohesion to the whole work.

Finally, paintings must have rhythm. Straight lines can be boring. If the eye of the beholder is led straight to the focus, without distraction, there is little to hold the attention. If, however, the path the eye takes is a waltz through an interesting voyage of discovery, with a delight here, and a titbit there, disclosing as a surprise the real objective of the painting, then the viewer will get great satisfaction from his or her efforts to appreciate the painting.

In practice in the city you have to manoeuvre your composition around the fixed elements which cannot be adjusted physically. There will always be compromises and 'fixes' which when fully explored may result in a satisfactory solution or total failure. The sort of questions constantly arising are: how can I cross the large expanse of foreground to capture my objective? — the city across a wide river for example. Can I put moored boats with tall masts — or move near to the bridge and use it to lead into the painting? How about strong clouds giving vertical reflections across the river? With a wide street there is a danger of dividing the picture into two separate paintings: can I make it narrower or does that lose the identity and character of the location? If I come back this afternoon will shadows be across the road linking the two sides together? How can I balance the large church on the left when there are only small houses on the right? Should I change my viewpoint — but if so the tree will obscure the church?

Composition is inevitably a compromise and one of the key elements of painting in the city.

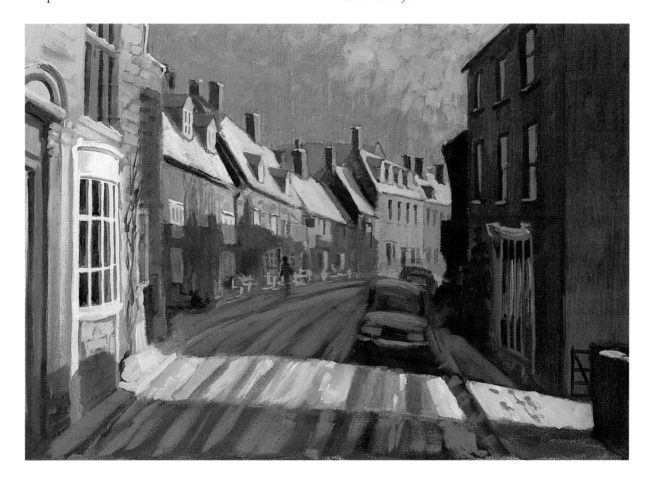

▽ **Blockley in Winter.**
Acrylic on canvas. 16×20in (41×51cm).
The composition of this winter scene features the strong sunlight beam across the foreground, linking the two sides of the painting firmly together.

CHAPTER 2

MATERIALS

The purpose of this chapter is not to evaluate the extensive ranges of materials available in watercolour, oils and acrylics or other media such as gouache and alkyd, but simply to describe what I use for painting on site — with some comments on studio materials.

WATERCOLOURS

In watercolour I use Winsor & Newton artist's colours in tubes and in a small sketching-box. There are considerable benefits from getting to know one manufacturer's products as you will gain experience in precisely how they mix, their intensity and other practical properties. I have not used other products to any extent but have become very familiar and very satisfied with my current products.

For work out of doors mobility is the key. I have used both tubes and the small box for sketches; the latter excels in performance. I have a shoulder-bag into which I fit a sketch-book, water-bottles, set square, rags, paintbox, masking fluid, fixative, pens and pencils, penknife, eraser, a sweater, can of drink and camera. Over the top of the bag I hang my sketching stool and thus have a complete kit, with excellent mobility. Without an easel I have to place the sketch-pad on my knee but find no problems with this. There are combined stools and pad supports which look excellent but the one I have measured is too long to fit into my largest suitcase for travelling overseas.

The paper I use is 140lb weight Cotman or Bockingford. These do not require stretching and have a medium roughness which helps to create texture when you need it. Rough watercolour paper is not as easy to draw onto as cartridge paper and I often use the latter for pen-and-ink drawings.

I use a fixative to give pencil or charcoal drawings permanence, and masking fluid for the occasional sparkle of light on water or other such application. I have tried using masking fluid more extensively but on a rough paper the fluid leaves a very ragged edge. Nevertheless certain watercolour painters use masking fluid to greater effect.

In the studio I use tubes of artist's watercolour paint and a large plastic palette which enables me to create larger pools of wet paint for washing on big sheets of paper. The brushes I use are mainly Sceptre, in a range of sizes from 2 to 20.

I try to use the biggest brush possible for the picture I am painting in order to keep my handling of the paint loose and fresh. The No 20 is my most used brush and sometimes is the only brush used for a complete watercolour painting. I do not use tinted paper often but have used the Daler Ingres Pastel Paper which I find has an excellent range of tints. This is not a heavy-duty paper.

The felt-tip calligraphy pens I use include Berol Italic, Kuretake Calligraphy (double-ended). For waterproof pen-and-ink work I use Pilot drawing pens 0.8, 0.5 and 0.2mm, and the old-fashioned nib and Indian ink.

In all my watercolour work I try to keep the equipment simple and uncomplicated. I tend to use the most practical range of colours. Other essential items of equipment are a large set square to check the verticals, and plenty of clean rags.

ACRYLICS AND OILS

For acrylics and oils I have a combined box and easel which is excellent for painting outdoors. Before I acquired it I struggled with boxes, cases, easel, canvas and then had to weigh down my easel to prevent it blowing over and continually had to stoop to pick out colour tubes. Now all that is over as everything packs into one combined unit. This is relatively expensive but for anyone painting in oils or acrylics outdoors it is worth the extra expense. I do not stretch my own canvas but use a ready-stretched fine-tooth canvas. A version which I find excellent for low-cost everyday use is the Winsor & Newton Colourman Canvas. This has an acrylic priming which provides the right degree of finish for my work. Again it is a good idea to become familiar with a small range of supports so that you can use the tooth or surface finish to its optimum as you paint. Other types of support I use regularly are hardboard, where I prime the smooth side with acrylic primer, and another board I have used quite often is a synthetic board primed on both sides, providing either a white or brown surface.

When painting outside I use a parchment palette which saves the messy problem of cleaning the palette. In the studio I use a normal wooden palette for oils

and an old dinner plate (!) for acrylics — the latter is easy to clean as the acrylic paint peels off the plate when dry. There are various additives to make oil paint dry quickly (Wingel) or acrylic dry slowly (retarder) but I seldom use either. Similarly there are now fast-drying oil-type paints such as alkyds.

The brushes I use for oils and acrylics are similar. I rarely use a bristle brush; I prefer the synthetic equivalent to sable or, as in the Sceptre range, a mixed synthetic and sable. I use the wedge-shaped brush, often using a square brush technique in both oil and acrylics. I feel it is pointless to use expensive sable brushes with acrylic paints because they dry so quickly that they clog the brush, which is then impossible to clear. Although there are many views on how to rescue acrylic brushes, few are proven. My overall philosophy on materials is to keep them simple, practical and reliable. I want to be able to paint easily on location with as few problems as possible and achieve a quick satisfactory result.

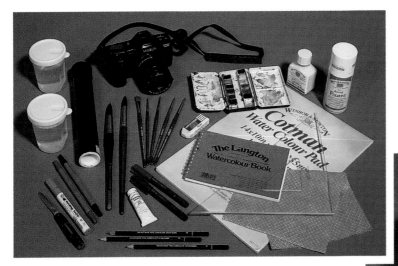

△ Watercolours

For sketching I take the minimum necessary, including a Winsor & Newton artist's watercolour box, brushes, pads, set square, water-bottles, fixative, masking fluid, penknife, eraser, rags, pens, pencils and markers and a camera. Packed into a shoulder bag with sweater and lunch, a folding stool hung over the top, I have a very portable kit.

In the studio I use tubes of Winsor & Newton artist's, watercolours including Venetian Red, Winsor Red, Vandyke Brown, Raw Umber, Yellow Ochre, Cadmium Yellow, Chrome Lemon, Sap Green, Hooker's Green, Cobalt Blue, Ultramarine, Davy's Gray, Payne's Gray and Black.

Acrylics and Oils

I use a combined box and easel for both oils and acrylics, with a parchment palette and canvas or boards (see above and below right). Brushes are synthetic or sable (not bristle) and I carry water or linseed oil and turpentine. Colours are as follows:-

Acrylics
Red Iron Oxide, Cadmium Red, Dioxazine Purple, Naphthol Crimson, Raw Umber, Yellow Ochre, Raw Sienna, Azo Yellow Light, Hooker's Green, Olive Green, Cobalt Blue, Cerulean Blue, Neutral Gray, Payne's Gray, Black, Titanium White.

Oils
Venetian Red, Alizaron Crimson, Winsor Violet, Raw Umber, Yellow Ochre, Raw Sienna, Cadmium Yellow, Terre Verte, Olive Green, Cobalt Blue, Ultramarine, Payne's Gray, Titanium White, Black.

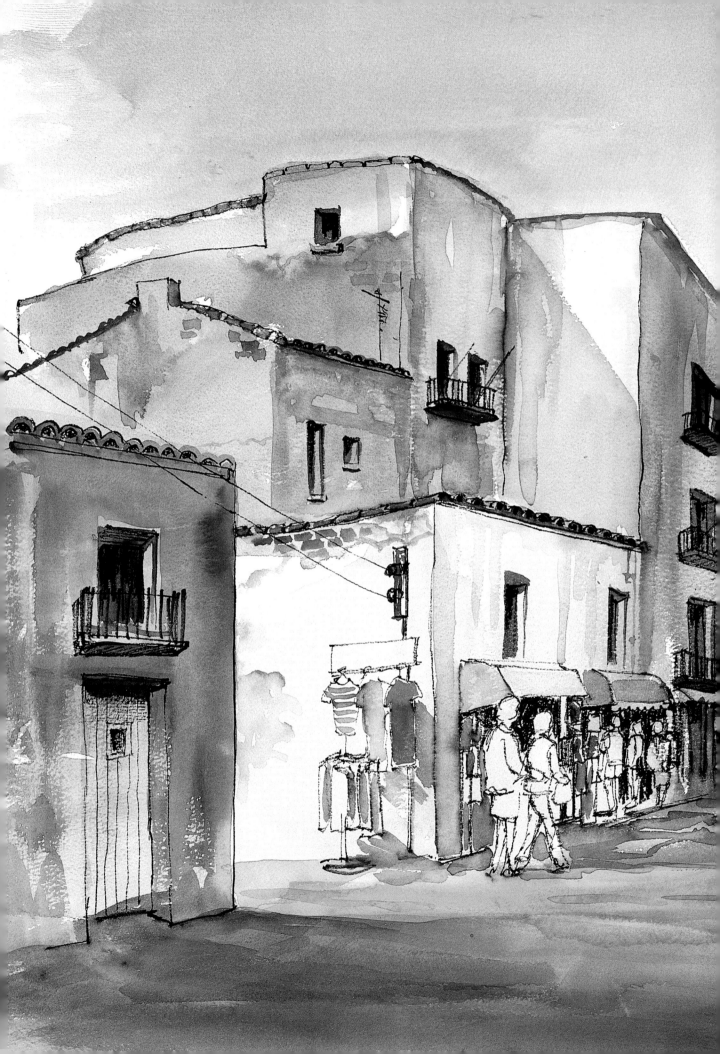

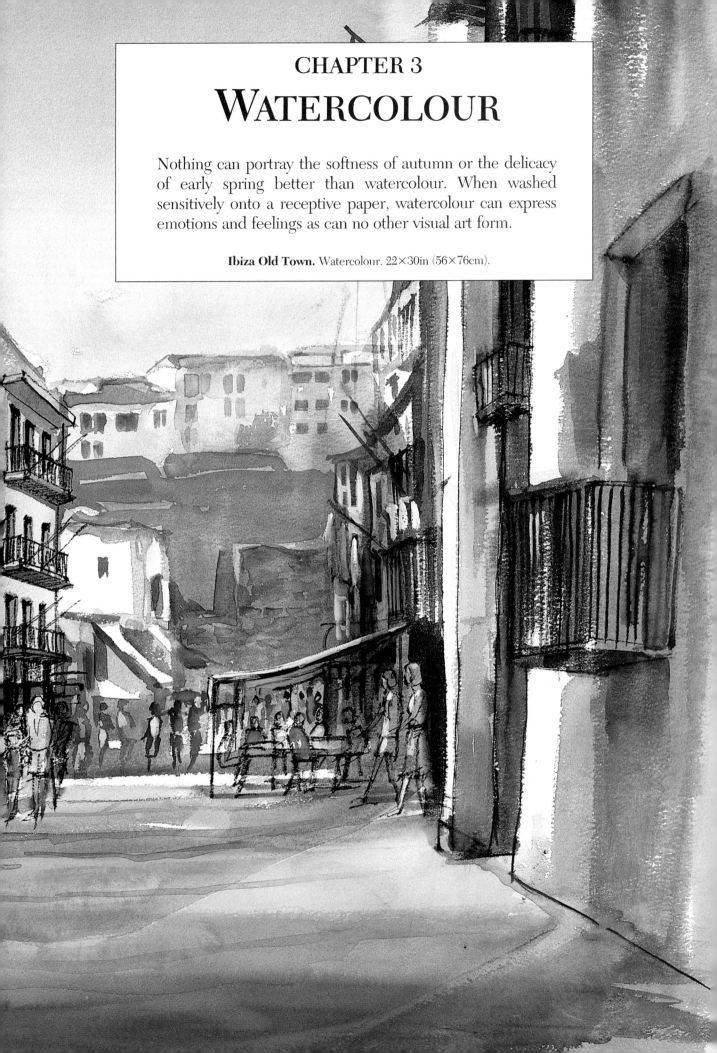

CHAPTER 3
WATERCOLOUR

Nothing can portray the softness of autumn or the delicacy of early spring better than watercolour. When washed sensitively onto a receptive paper, watercolour can express emotions and feelings as can no other visual art form.

Ibiza Old Town. Watercolour. 22×30in (56×76cm).

△ **Bath.**
Pencil and wash. 16×20in (41×51cm).
The softness of the Bath stone and winter light is suggested using a pencil drawing and a colour range of greys and umbers. The pencil drawing included tones created by hatching, requiring little additional tonal values in the paint.

Watercolour captures the softness of colour or texture in stone, the atmosphere of winter, spring or summer haze; in fact watercolour is equally at home in city or in the countryside. Turner, one of the greatest exponents of atmosphere in paint, used watercolour to its ultimate power of delicate and sensitive portrayal.

It is well known that watercolour, for all its virtues, can be very difficult to handle well. Washing broad bands of colour, changing in intensity and tone under total control is not easy and only comes from much practice and persistence. Many people choose watercolour when first starting to paint for its apparent simplicity, ease of use and low cost. They then rapidly realise that what looked simple can be very difficult. In fact, beginners would often be better served by starting in gouache, acrylic or oils.

My approach to painting watercolours in this book takes the logical progression from the most direct and straightforward to the more complex and sophisticated.

PEN AND WASH

The best way to start painting buildings or total cities in watercolour is to add colour to a completed drawing. This method is demonstrated above in the painting of Bath. A pencil drawing was completed as described earlier, using the pencil to portray tones by hatching, the bricks, tiles and cobbles being drawn in detail. In fact the picture could have taken the form of a pencil drawing. The pencil used was HB — which I often use if I intend to paint on top of the drawing, as it leaves a firmer line which will show through the paint and is less prone to smudge. The paper was 140lb Bockingford. When this was completed and given a light spray of fixative, watercolour was added with little use of complicated washing techniques. White paper was left in the foreground and elsewhere to provide a loose appearance and to give it light. With this technique it is often better to use a loose colour application or the picture will become very rigid, having such a strong drawing as its base. The softness of the pencil line used with soft colours and without using strong tonal contrasts all helped to create an atmosphere of a winter's day amongst the soft Bath-stone houses and shops in this attractive and busy small square near the city centre.

Contrast the Bath painting with that on this page: a hot summer's day in Ibiza. Again it was drawn first, this time in waterproof brown ink using a technical drawing pen with a 0.8mm tip. I drew it straight on to the paper, although I could have drawn in pencil first and redrawn it in ink. Colour was then added. The ink drawing and strong colour and tones are in keeping with the hot Mediterranean atmosphere in Ibiza's old town. The drawing was kept loose to provide a fresh approach, and colour added with a loose style of brushwork to produce an informal and lively sketch.

The technique of adding colour to a drawing (pen and wash or pencil and wash) is well suited to painting in towns and cities, both for the sketch-book and the finished painting. Many of the early English exponents of watercolour used them for typographical paintings on the 'Grand Tour' of Europe and elsewhere. Very delicate paintings using superb drawings as their base were produced in the eighteenth and nineteenth centuries.

Adding watercolour to a drawing can be a sophisticated technique, with all the skills of a line-drawing combined with the complexities of water-colour. Thick and thin pen-lines displaying the personal 'signature' of the individual artist can be supported by wet in wet washes and the whole gamut of watercolour manipulation, creating pictures which range from semi-abstract to the most realistic portrayals. Pens now vary enormously, with felt-tip, roller, technical drawing and marker pens. The most straightforward approach is to use a waterproof pen and to paint on top. The type of pen you use will need to be determined by trial and error. The technical drawing pens produce a line of constant thickness. Calligraphy pens have broad nibs which will provide thin and thick — but often they are not available with waterproof ink. The old-fashioned pen with nib which you dip in a bottle of Indian ink is still used by many for its simplicity and controllability. Waterproof ink has a tendency to clog any type of fountain pen or reservoir.

You can add other media to pen and wash, such as gouache or pastel, and provide a multi-media painting. It is always useful to have a go with alternative media and you will learn something new to benefit your skills in the original medium. White gouache is often used to add highlights to a watercolour and may be described as body colour.

▽ **Ibiza Old Town.**
Pen and wash. 12×16in (30.5×41cm).
This strong pen drawing with bold washes of colour emphasises the

Mediterranean atmosphere. Drawn loosely with a technical drawing pen using waterproof ink, the intention was to create a fresh, direct impression of the scene.

CHOOSING A SUBJECT

The selection of the subject to paint can be affected by a vast range of criteria. It is only too easy to look for the ideal subject and spend hours tramping the streets with a heavy load, searching and never finding.

I usually keep a look-out when driving through cities for a new idea for subjects. When visiting a new city with the intention to paint, I make a first call at the tourist information centre or equivalent visitors' guide office. Browsing through the guides often indicates the history of the city and where you can find various aspects such as the market, cathedral, shopping areas, zoo, museums etc. Depending on your particular interest, or if you are working on a specific project, you can save a great deal of searching on foot by prior research.

Holidays are often one of the best times for the painter to relax and find interesting subjects in different climates and cultures. Pen and wash techniques are very suitable for quick sketches before the rest of the family rebel at your absence.

New inspirations often arise when visiting new countries, even for the professional artist taking a 'working' holiday. The painting of Ibiza on this page was selected as a subject because in the first instance there was the great contrast of dark streets in deep shadow with the bright sunshine above. To anyone with my abiding interest in architecture and buildings, the tower in the background with the red pointed roof immediately identifies it as being in a Mediterranean country. I liked the windows with the green blinds and

△ **Ibiza Street Market.**
Pen and wash. 16×12in (41×30.5cm).
Contrasts of the dark shadows at street level with *the white sunlit buildings made this scene attractive. The figure leads the viewer into the picture and the architecture beyond.*

▷ **Ville Close, Concarneau.**
Pen and wash. 12×16in (30.5×41cm).
A small bistro in the back street of this ancient part of the city created an interesting sketch, the stonework being set against the white and yellow buildings on either side. The watercolour painting was augmented with a calligraphic felt-tip pen using brown ink.

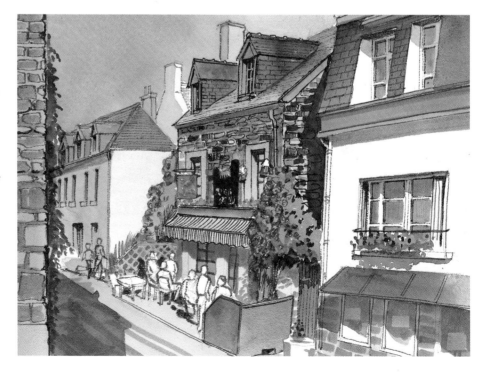

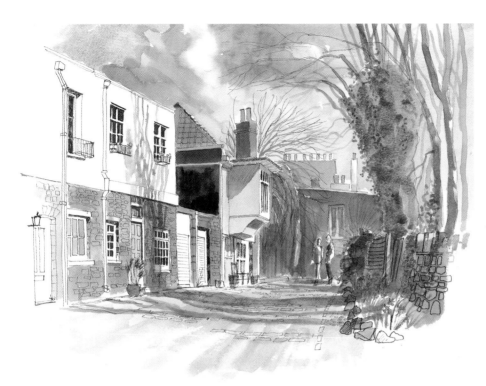

◁ **Caledonia Mews, Bristol.**
Pen and wash. 12×16in (30.5×41cm).
A mews location often provides a quiet spot to paint unaffected by traffic and crowds. This traditional pen and wash uses colours and tones which reflect an English spring day. Note how the shadows across the foreground help to fill the space and link the two sides of the painting.

balconies and the washing hanging out above the street. The clothes in the shop on the left added variety of colour and indicated clearly it to be a market/shopping street. The composition had as its focus the central tower with the line of the street leading into the centre of the picture. The figure at the front not only added interest but by walking into the painting served to lead the eye again into the subject. I started with a light pencil drawing, added watercolour and then applied a brown technical pen on top as I wanted a strong line to emphasise the powerful shapes and contrasts. The limitation of the pen however was the constant thickness of the line, without variation. I was able to sit comfortably against a wall and in the morning temperature did not suffer too much from the heat — always a consideration in a hot climate. Sitting in full sun is not only uncomfortable but means watercolour dries so fast that it is difficult to paint freely.

In the bistro painting in Concarneau the attraction of the subject was the stone building between two light-coloured houses, and the typical outdoors seating in the streets (as in most French towns and cities). This bistro was in a small back-street and I had a perfect sitting place in a car park which was six feet above street level. I could sit quietly in a corner looking down the street, uninterrupted. On reflection the attractive sitting position had as much appeal as the subject. The sun being directly behind provided interesting contrasts of light and shade, and the deep blue sky of a French summer made the sunshine effects more

evident. Note how the tone of the blue sky is darker than the shadow on the chimneys.

The painting was started with a simple pencil sketch followed by blocks of watercolour, most of the detail being drawn in using a calligraphic felt-tip pen on top of the watercolour. I used brown to add warmth but also because brown ink is particularly in sympathy with stone walls. I was not too happy with the wall on the left of the painting but decided it was essential to include it to stop your eye disappearing off the left side of the painting as you followed the line of the street from right to left.

The mews painting in Bristol shows a totally different atmosphere and climate: a spring day in England with cool temperatures and long shadows from the leafless trees. The attraction of the subject was the shapes and colours of the buildings on the left, the black wall contrasting with the white front of the houses. The scene also had brick and stone textures. I particularly liked the shadows on the white frontage of the house. The architectural feature of the window jutting out on the yellow house provided a point of interest, and I added the figures there to accentuate the focus on the yellow house. The cool green of the ivy on the trees to the right offset the warm reds of the chimneys and roofs. It was a delightful place to sit, with no traffic and a supply of cups of tea and cake from interested residents! The long shadows across the foreground helped to hold the two sides of the composition together and filled the large foreground expanse of the road.

Stage 1.

Stage 2.

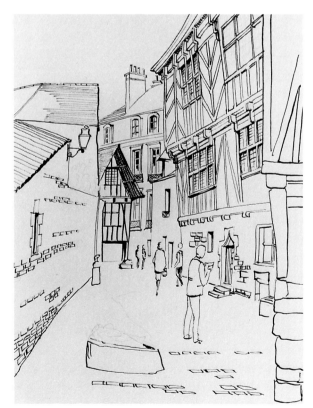

Stage 3.

The stages of a typical pen and wash watercolour are shown here. Stage 1 is the preliminary sketch. This initial drawing is to identify the core elements of composition and to lay out the page. At this stage you have a go/no-go potential situation where you decide whether the scene you have chosen has the merits for a painting which you first imagined. Stage 2 is to complete the drawing in pencil, filling out and correcting the initial sketch and providing details of architecture, people, etc. Note how the figures have been included at an early stage and not added as an afterthought. Stage 3 is to ink in the drawing. This stage can copy the drawing closely or be much looser, using the pencil only as an indicator of the contents. When completed the pencil lines are usually erased, although some painters leave pencil and pen to the final picture. Stage 4 is the addition of watercolour. The brushing of colour can be very loose, relying on the drawing to convey the detail, or the colour can be applied more precisely. When completed it is still possible to apply more pen to key areas or to emphasise certain features.

Finished work: **Quimperlé.** *16×20in (41×51cm).*

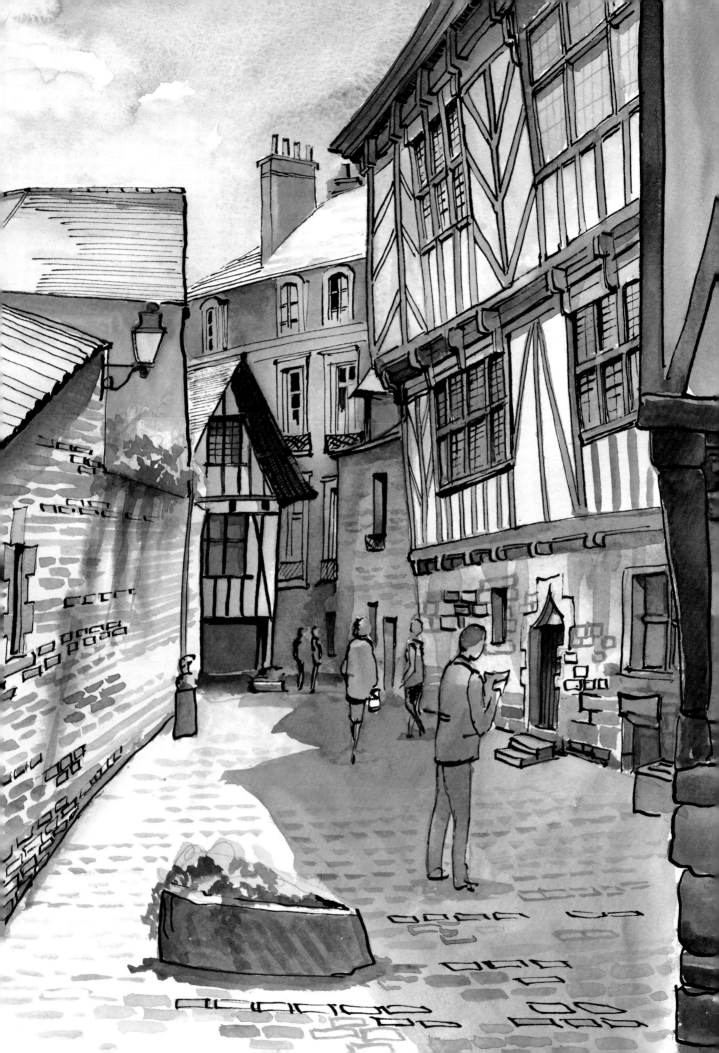

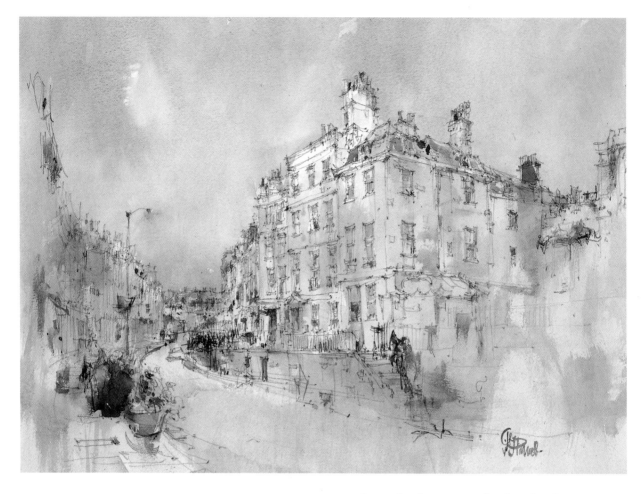

STYLE

For many painters who are developing their skills progressively, the achievement of a standard of watercolour which depicts the subject well, is praised by colleagues and sells at local exhibitions is the major objective. One of the most notable differentiations with the experienced professional will be style. Having mastered the techniques of drawing and applying washes, of composition and atmosphere, the painter has to ask: how do I interpret the subject? What do I want to say? What feature of my work do I emphasise? How do I create a unique work which is distinctly mine?

Often the style of a well known painter will appeal, and by a close study of his or her work or by attending a course he or she runs you will learn how to produce a similar style of work. I personally see nothing wrong with this provided that it is a stepping-stone to developing your own approach. If you can learn from many examples and from that melting-pot create paintings which you enjoy — excellent. If they are admired (and bought) that's a bonus. The galleries and dealers have a strong commercial influence in this area. Once a painter has developed a style which is popular and achieving good sales, the dealer is most anxious for the same style to persist *ad infinitum* as the customers will ask for a 'Bloggs' and if it isn't identical to the Bloggs that everyone knows and loves they will not be happy.

I have selected the picture on this page, by John Palmer, as an illustration of style in pencil and wash. John has a quite unique style which captures the essence of the building and atmosphere of the place, by touching on a few details and leaving the rest to your imagination. The marks he makes are sensitive and each is positioned precisely to add to the character and to produce an elegance and economy in his drawing which is exceptional. His paintings have some affinity with Turner's in their fantasy elements and the use of space and light. The materials which he uses are not unique: a 3B pencil on Cotman paper, and Winsor & Newton artist's colours.

In contrast, my painting of Chipping Campden opposite is solid, realistic and strongly architectural with its emphasis on the buildings. The statement it makes is quite explicit with little left to the imagination. It does however emphasise the character of the buildings and particularly the texture of the stone. While it is a traditional approach to the subject, the

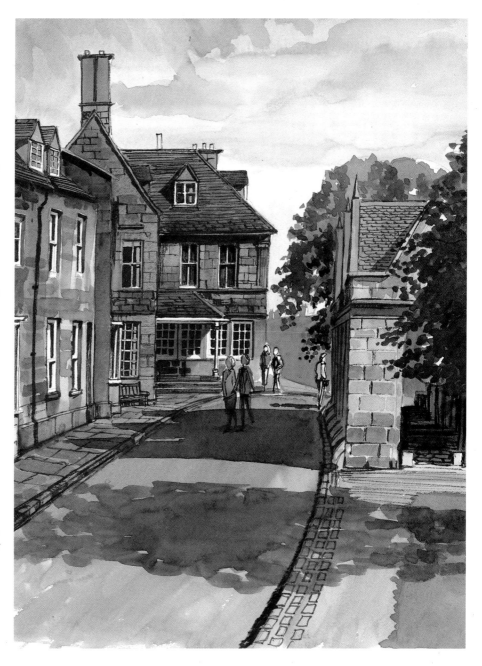

◁ **Bath, by John Frederick Palmer, RWA (Royal West of England Academy).**
Pen and wash 16×20in (41×51cm).
Delicate pencil work which suggests the tracery of Georgian architecture in Bath is depicted here in John Palmer's unique style. Combined with thin washes of pale colours the overall effect is a sensitive impression of buildings, space and light. John has developed from the basic pencil and wash technique a different approach which is recognised instantly as his own.

▷ **Chipping Campden, Gloucestershire.**
Pen and wash with marker pen. 20×16in (51×41cm).
Compare the strong colour, tones and line of this painting of a Cotswold market town with the delicate lines and washes of John Palmer's work opposite. Cityscapes provide opportunities for all styles of painting in watercolour.

use of marker pens on top of the watercolour is different and the effects produced are distinctive and recognisable.

Varying the texture of the paper can produce widely differing results and the use of unusually rough paper for instance could help to create a distinctive approach. Equally, maintaining the same palette of colours creates a cohesion about a painter's work that becomes a distinguishing feature.

You will notice when looking at pictures in an exhibition or in this book that there is a consistency of approach across the painting which adds to its quality. In other words, if you are drawing like John Palmer in one part of the picture you should draw in that way across the whole. Similarly with brushwork: if you have adopted a particular type of brushwork in one area, it should be consistent across the work. Small, controlled brush-strokes in detail should not be side by side with broad, loose brush-strokes in another. (There may be exceptions to this rule but it is generally sound.)

Finally, fashions in painting come and go, with particular styles often set by a well-known artist and by prints and articles featuring his or her work. Usually underlying the fashionable style is a quality of design, drawing and painting which is very sound. Follow the fashion by all means but try to detect the quality underlying it and build quality into your own painting with a style uniquely yours.

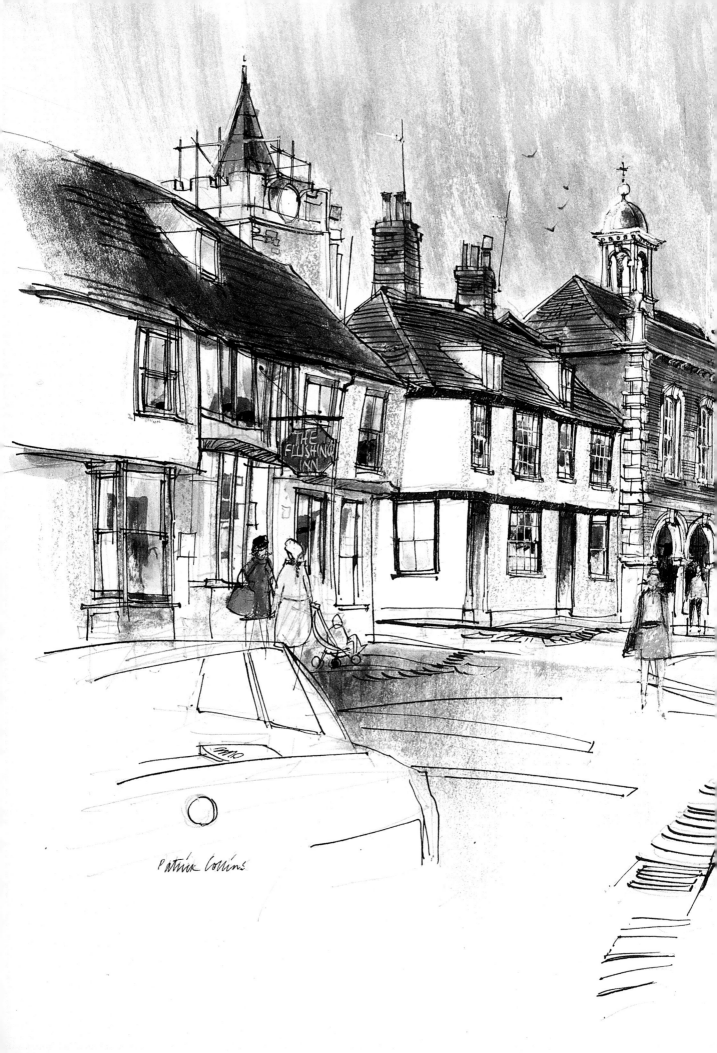

Patrick Collins

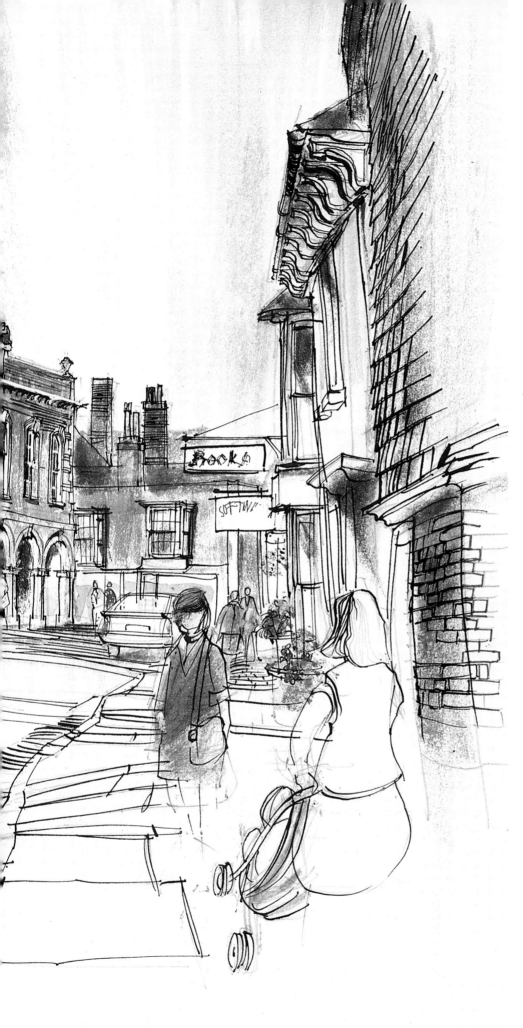

◁ **Rye, Sussex, by Patrick Collins.**
Pen and wash and pastel.
14×20in (35.5×51cm).
A free-flowing line-drawing is combined with both wash and oil pastel to produce this fine work by Patrick Collins. The quality of the line is particularly notable, with variations of thickness and character adding to a stylish interpretation. The figures complement the composition and Patrick's use of the white paper showing through adds to the freshness which permeates the whole work.

PURE WATERCOLOUR

A direct route from a pencil drawing to a pen and wash painting has been followed in previous chapters, providing the quickest way to achieve results in towns and cities for the painter new to the subject. Many watercolour painters, however, prefer the effects achieved by painting without the line appearing in the finished picture (for which I use the term 'pure watercolour'). A softer effect is certainly more usually achieved in this way and the artificial line, for instance on the corner of a building between light and shade, is removed. You will still need to draw the outline of the town or city scene, more lightly than in pencil and wash — the pencil lines being obscured by the completed painting. Totally freestyle watercolour, whereby washes are used without any form of drawing, is difficult to apply within a city context unless you are an expert or a genius! In landscape painting fields, woods and rivers can be beautifully expressed using a wet in wet technique, but the use of extensive wet in wet methods is difficult in cityscapes apart from the sky.

THE DIRECT METHOD

A practical method of watercolour in the city — the direct method — is to paint each element of the picture separately and work your way from one end to the other. In the case of Park Street, Bristol (below), I started with an outline drawing without details, then washed in the sky using a French Ultramarine, leaving white paper showing for the top of the clouds. While

the paint was wet I quickly applied some Raw Sienna and Davy's Gray to the clouds, making the horizon a yellow grey colour — when this was dry I added further darker clouds with Davy's and Payne's Grays. The buildings were started with the tower at the centre back with a mixture of Raw Sienna, Davy's Gray and Payne's Gray, the tone of the tower setting the tonal range for the picture. I then worked down the right-hand side of the hill, washing a light Davy's Gray at the top and Yellow Ochre and Raw Umber towards the bottom. The base colour of Yellow Ochre plus Raw Umber was added for the buildings on the right, (leaving the tree-trunk shape in white paper). Details were then painted on top of the buildings in Payne's Gray, Davy's Gray and Raw Umber, the red brick areas being Venetian Red and grey mixtures. Having detailed the tonal range with black window-panes and archways in the foreground, I painted in the buildings on the left using the same colour combinations. The road was washed in using Davy's Gray, and foreground grass washed loosely in to suggest uneven lawns — Sap Green was the principal colour of the grass. Figures and vehicles were added, using white gouache to add highlights to figures and to cars and shops' blinds on the hill. The trees were painted in towards the end of the exercise with the shadows across the grass being Sap Green and Charcoal Grey. The final painting has certainly more softness than if pen and wash had been used, and the slightly misty atmosphere of the hill and distant tower would be more difficult with pen and wash. The direct method can make your painting less loose and fresh but will produce a reliable result.

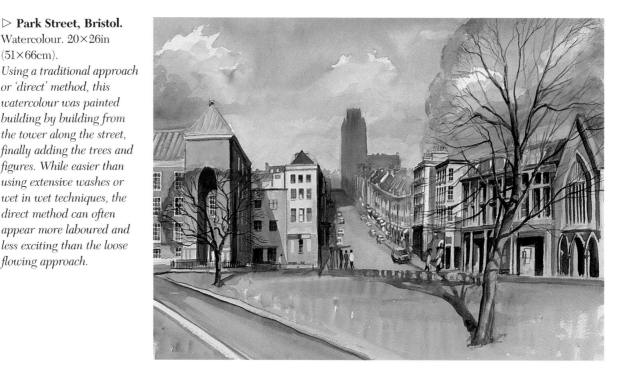

▷ **Park Street, Bristol.**
Watercolour. 20×26in (51×66cm).
Using a traditional approach or 'direct' method, this watercolour was painted building by building from the tower along the street, finally adding the trees and figures. While easier than using extensive washes or wet in wet techniques, the direct method can often appear more laboured and less exciting than the loose flowing approach.

▷ **View from the Studio Window.**
Watercolour. 12×14in (30.5×35.5cm).
I have the good fortune to have a studio overlooking a beautiful Georgian square in Bristol. This winter night-time scene was painted from the warmth of the studio. The principal attraction was the effect of the lights from shop windows and streetlamps on the fronts of the houses, which was tackled by merging wet in wet washes for the stone buildings, leaving white paper for the snow.

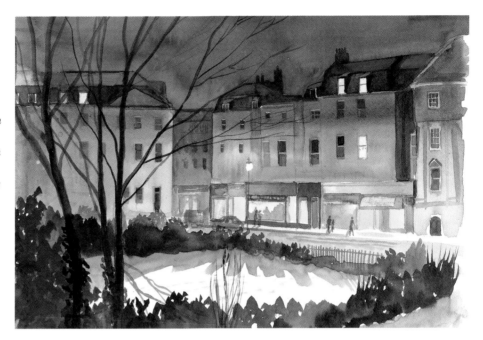

WASHES

In the view from my studio, a limited use of wash and wet in wet has achieved the gradated colour and tone on the terraced buildings. My studio is on the second floor in a square of Georgian houses and I have the opportunity in winter to paint snow scenes from the warmth of the studio. In this picture the tonal variations were the key to the success of the work. I started a brief outline sketch of the buildings and then washed in a very dark sky of Payne's Gray, Ultramarine and a touch of Winsor Red. The stone faces of the houses were painted using a wet wash of Yellow Ochre at the base with a mixture of Vandyke Brown and Davy's Gray added to the wet Yellow Ochre wash (leaving spaces for windows and shop fronts). When dry the roofs were added in Payne's Gray with Charcoal Grey. The bushes were touched in using the point of a No 20 brush to keep the loose nature of the brushwork. Vandyke Brown, Hooker's Green and Payne's Gray were employed, with wet paint merging with wet in places. Shadows on snow were in Cobalt Blue and the tree and other details added last, with a touch of white gouache on the streetlight.

Simple sketches make good practice in handling washes. The little sketch below of Nailsworth in Gloucestershire is an example whereby the darks were washed in first (after an outline drawing of roof lines and street). When dry the Yellow Ochre frontages and Raw Umber roofs were added. Subsequently details of windows, eaves, gutters, brickwork and pavements were added, together with trees and bushes to the right and shadows across the road and on the face of the cottages and wall on the left. This took me approximately thirty minutes; such a sketch provides good practice in washes and tone control.

▷ **Nailsworth, Gloucester.**
Watercolour. 7×13in (18×33cm).
A sketch such as this can provide good practice in handling colour and tone and also suggest subjects for larger paintings.

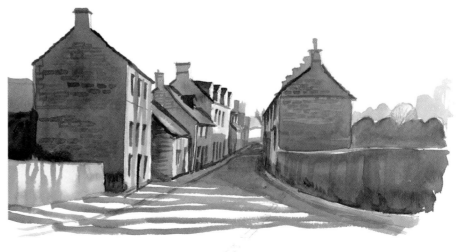

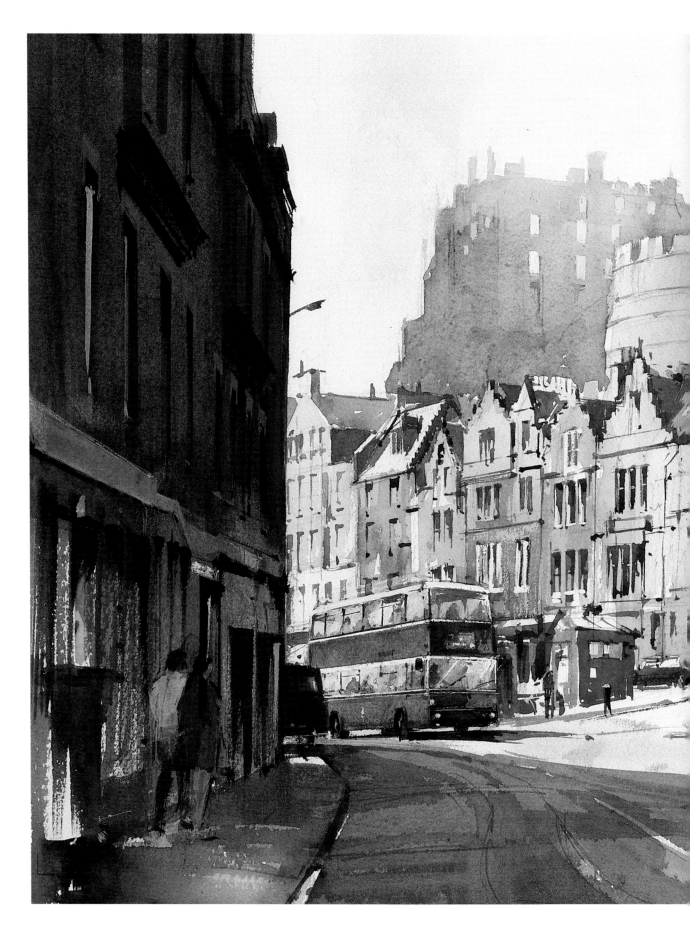

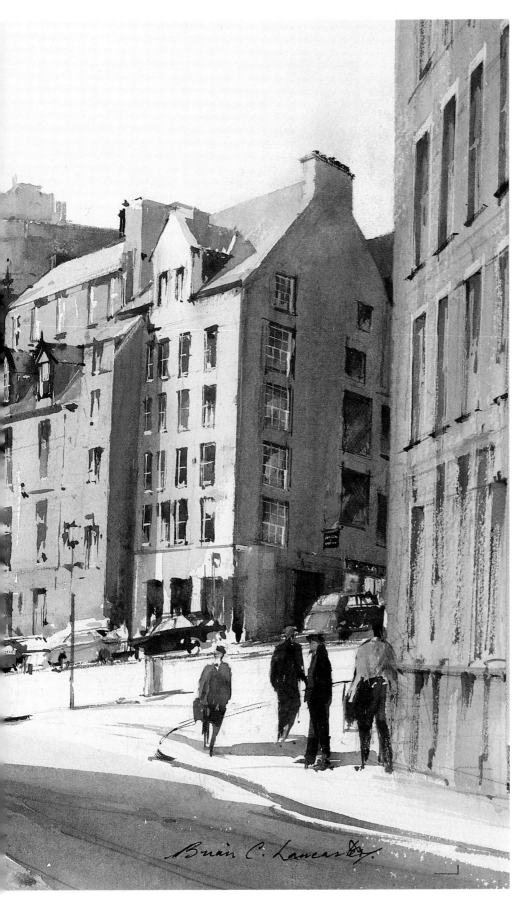

◁ **Edinburgh by Brian Lancaster.**
Watercolour. 16×18in (41×46cm).
The image of Edinburgh is well captured by Brian Lancaster, with the tall stone buildings overlooked by the silhouette of the castle. Brian Lancaster depicts the architecture accurately but keeps his painting fresh by clean washes and excellent tone control. Note how he handles the light across the foreground and figures to pull the composition together, and how he creates aerial perspective with the tones of the castle providing a strong recession into the picture.

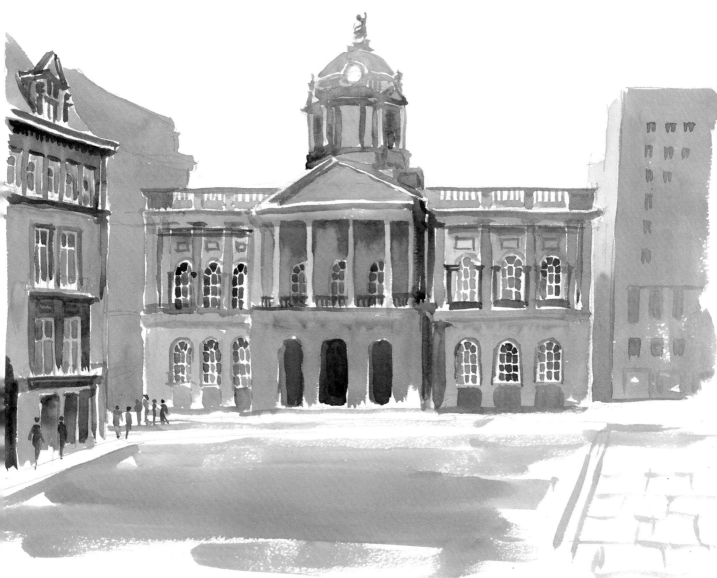

OTHER TECHNIQUES

By using masking fluid, tape, wax and other resists to prevent the watercolour paint from marking the paper in specific places, a wide variety of effects can be developed. Also washing off paint from the surface and repainting areas of the picture will produce different textures from traditional paintings. Exciting images can be developed using these techniques, pioneered in the UK by John Blockley whose books have been widely read by watercolour painters in many countries. There is not space to cover these approaches properly in this book, but you should find time to try some of these ideas as they can be incorporated into your own style, often with beneficial results.

WATERCOLOUR IMPRESSIONS

A very loose approach to watercolour painting can produce fresh and spontaneous results, dubbed by some an 'Impressionist' approach. The brush-strokes

△ **Liverpool Town Hall.**
Watercolour. 12×16in
(30.5×40.5cm).
A very loosely painted impression of this elegant building in the heart of Liverpool demonstrates the fresh and spontaneous approach which can be obtained. Very little preparatory drawing is evident and a large No 20 brush was used to ensure that details and tightness do not creep into the picture.

are very evident, with tone and colour being accurately depicted in a single stroke.

You will find that what looks easy and relaxed in watercolour is often most difficult. Using very little preparatory drawing, exponents of the 'fast and loose' methods create realistic portrayals of cities, buildings or landscapes.

Ron Ranson's book *Watercolour Impressionists* (David & Charles 1989) includes a number of examples of fluid, loose paintings by artists in the UK, the USA, and elsewhere and is well worth studying to ascertain the full scope of loose watercolour painting.

In the painting of Liverpool Town Hall opposite I have used a very loose approach to illustrate this type of painting. Starting with a drawing of the outline of the buildings, I painted the frame of the Town Hall in a mixture of Vandyke Brown and Yellow Ochre using a No 20 brush. A large brush helps to keep the painting loose and provides a better flow of paint. White paper was left for the windows and bays in the façade. The stone structure of the cupola was added, and the darker shaded areas under the portico, leaving the grey columns to be added later. The detail of the windows was blocked in using a No 6 brush and Payne's Gray colour. The windows were deliberately left loose with no attempt at precisely describing window-frames. Final details were added of the balustrade and key architectural features. The building on the left was completed in a similar fashion, walls, windows, details — then the background buildings washed in, and after the road and pavements were suggested (using Davy's Gray), figures were indicated very briefly to give scale to the buildings.

The small sketch of Derby below was painted in a similar loose Impressionistic way using a No 20 brush for most of the sketch from the barest outline of the buildings in pencil, the principal colours being Payne's Gray, Yellow Ochre, Brown, Ultramarine and Charcoal Grey. The areas in shadow were painted first with the Yellow Ochre cathedral and buildings next, and details last. Leaving white paper showing in many areas adds a freshness and spontaneity to this type of work.

It is well worth practising a looser style of watercolour, not only for the end result — which can be a most attractive picture — but more importantly for the experience you will gain, with no doubt some frustration as well!

The key to success, and the underlying skill of the expert in this field, is the control of tone and colour in a single wet brush-stroke, the total picture being a series of brush-strokes, many wet in wet where every stroke has been applied with exactly the right tone and colour.

▽ **Irongate, Derby.** Watercolour. 12×16in (30.5×40.5cm). *Another loose approach in this sketch using broad washes of colour and tone with little attempt to detail features of architecture. Extensive areas of white paper add to the loose and spontaneous nature.*

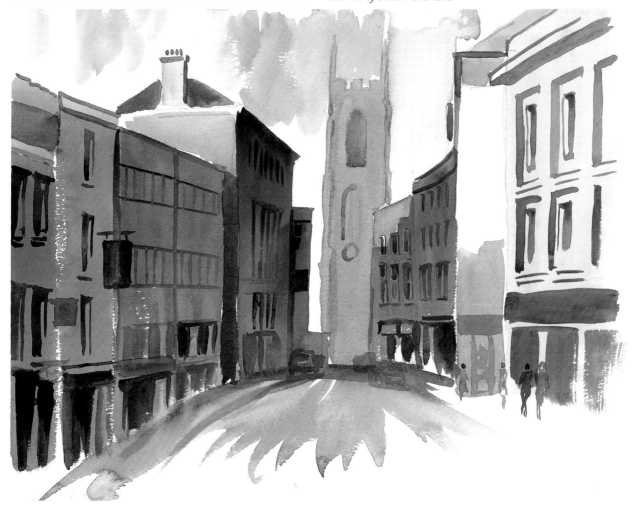

A loose approach can also be applied using pen and wash, as in the case of the above picture of Leadenhall Market, London.

In this approach washes were applied very loosely without a preliminary drawing of any sort, with much white paper being left. The colours used were Cadmium Yellow Pale, Payne's Gray, Ultramarine, Vandyke Brown, Scarlet Alizaron and Davy's Gray. The paper was 140lb Cotman. When thoroughly dry the lines were drawn on top of the washes using a black felt-tip pen, the whole sketch being completed in approximately one hour. I think it's a rather fun picture and I enjoyed doing it tremendously.

In contrast, the watercolour of Venice by Neil Murison uses loose washes which employ to the full the translucent effect of the white paper shining through the paint. Neil has conveyed the watery effect of the canal and reflections on the buildings by a few washes and wet in wet techniques. Details are few and suggested very simply but effectively; the variations in tone from the dark water to the white sunlit building are perfectly captured in a few washes. The colour is restricted to ochres and browns, creating the mood and atmosphere of the dark, damp canal with the sunlight high above and some stray reflections adding a few touches of light amongst the shadows.

△ **Leadenhall Market, London.**
Watercolour and felt-tip pen. 16×20in (40.5×51cm).
The market is normally a scene of great activity in the city of London during the week, but on Sunday is extremely quiet. In this sketch the colour was first washed in with no preparatory drawing and a bold line added in felt-tip pen.

▷ **Venice by Neil Murison, RWA**
Watercolour. 15×11in (38.1×28cm).
This loosely painted watercolour captures in a few liquid washes the character and atmosphere of Venice, with its contrasts of light and shade and watery reflections in the shadows. Painting on a lightweight Waterman paper, Neil Murison has suggested all the elements necessary to identify the place, time and character.

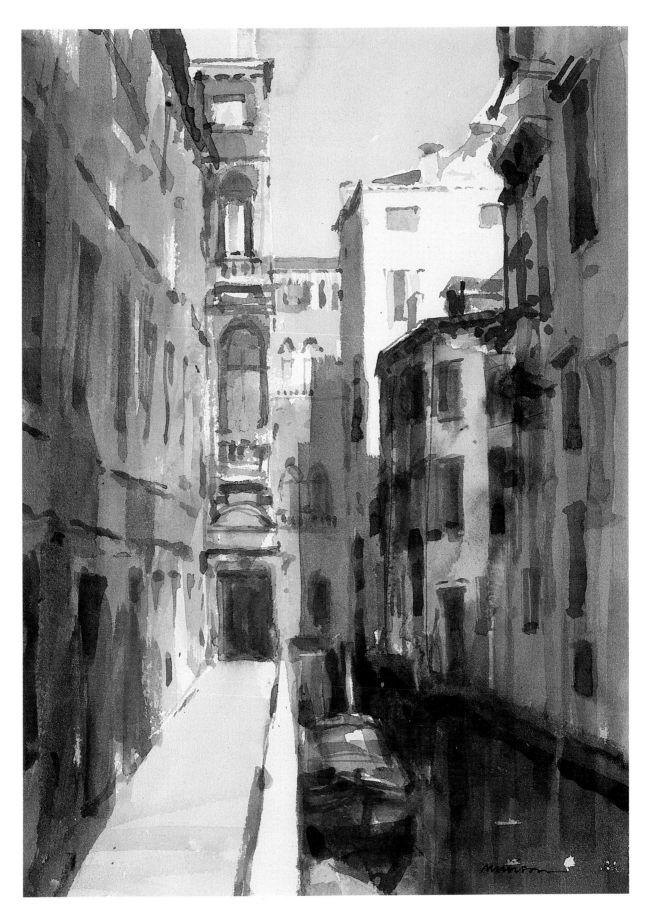

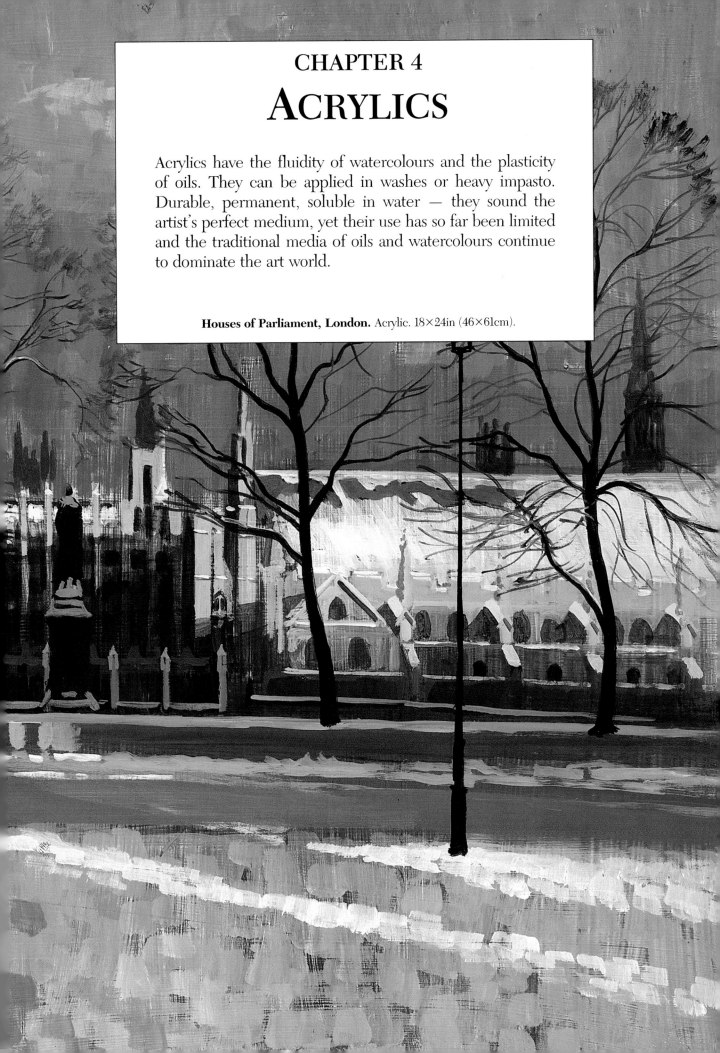

CHAPTER 4
ACRYLICS

Acrylics have the fluidity of watercolours and the plasticity of oils. They can be applied in washes or heavy impasto. Durable, permanent, soluble in water — they sound the artist's perfect medium, yet their use has so far been limited and the traditional media of oils and watercolours continue to dominate the art world.

Houses of Parliament, London. Acrylic. 18×24in (46×61cm).

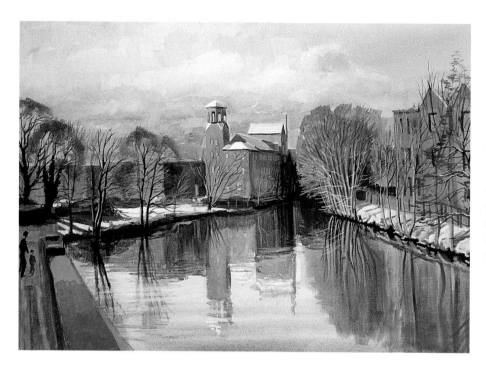

◁ **The Old Silk Mill Museum, Derby.**
Acrylic on canvas. 18×24in (46×61cm).
Acrylics can be painted using watercolour techniques, as shown in this painting of The Old Silk Mill, now used as an Industrial Museum. The thin washes of diluted acrylic paint allow the white underpainting to show through, providing a translucent effect.

△ **Chipping Campden, Gloucestershire.**
Acrylic on board. 12×14in (30.5×35.5cm).
*This painting uses a pen drawing over which washes of acrylic have been applied in a similar fashion to a traditional pen and wash watercolour.
The result is very durable and does not need to be framed behind glass.*

ACRYLIC WASHES

Acrylics can be painted in washes exactly as in watercolour painting, the benefit of acrylics being that each wash can be laid on top of another without the lower wash being disturbed. Consequently there is not the possibility of dirty colours resulting where washes intermingle. Acrylic washes have thus a greater translucency and are brighter than watercolours. Combined with the intensity of the acrylic colours, it is possible to create vivid washes of colours in acrylics. A Royal Academician in England, Leonard Rosoman, is a great exponent of the acrylic wash, his paintings being wonders of translucent colour as each wash or glaze adds to the colours of the painting. The painting *The Old Silk Mill* above is painted in a similar fashion to a watercolour, using a white canvas support. The light tones and colours of the water and the browns and siennas of the trees were washed onto the white canvas. The sky was washed in very thinly with Cobalt Blue and Naphthol Crimson with the clouds being lifted with a dryer brush while the wash was still wet, and final white highlights being added to clouds and the foreground with impasto white paint. The brushes used were the same as I normally use in watercolour but great care has to be taken not to let the brushes dry until totally free of all paint.

PEN AND WASH

Pen and wash can be used in acrylics in an exactly similar fashion to watercolours. You can produce a drawing in waterproof ink and then wash in colour and

tone using acrylics. In the painting of Chipping Campden shown opposite, the support was a piece of board which had a white emulsion paint priming onto which the drawing was applied with washes added later. (It is better to use acrylic primer on the support as the resulting surface is easier to work and there is no danger of a chemical reaction between the ground and the acrylic paint.)

Should you try acrylics? The answer is definitely yes. If you are a beginner acrylics can be easier to use than watercolour, in those early stages when handling watercolour seems an impossible task. As acrylic paint dries very rapidly, corrections can be made without picking up the underpainting.

If you are an experienced watercolour or oil painter, should you try acrylics? Yes again — the experience will be rewarding and extend your range with, I believe, benefits to your original medium.

Are acrylics the perfect medium? Not proven: there are problems — the quick-drying nature of the medium can be an advantage but also extremely irritating — paint on the palette dries rapidly forming a skin — paint drying in brushes ruins them and although there are many ideas for cleaning clogged

acrylic brushes, there is none which the manufacturers will recommend as the ideal solution to the problem. I always keep a spare jar of water to use to keep my brushes moist when painting acrylics. I try not to put more paint onto the palette when starting a picture than will be needed before the paint dries.

There are palettes which have a reservoir and continually moisten the paint, but I have not tried them as I have become accustomed to using the minimum quantity of paint.

Acrylics also have colours which can be very intense, leading to a garishness in some applications — this can be used to advantage, particularly in some abstract paintings — but once you are experienced in acrylic painting, handling colours will not be a problem.

Acrylics can be painted on virtually any support —

▽ **Horse Guards, London.**
Acrylic on board. 18×24in (46×61cm).
In this painting acrylics have been applied in a similar manner to oil paint,

with strong brush-strokes, opaque and impasto paint. Note how the original underpainting and drawing have been left to show through in several places.

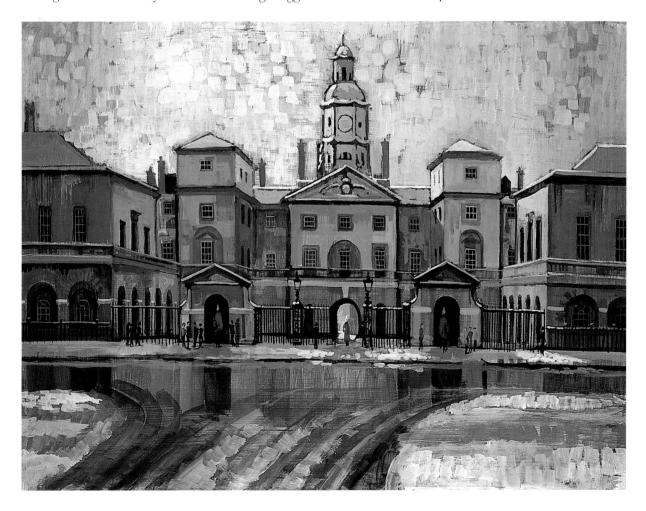

61

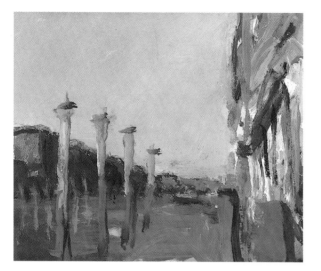
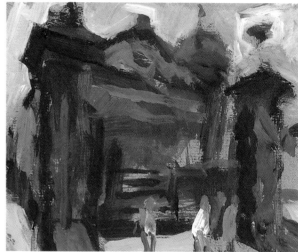
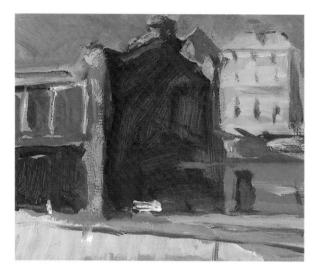
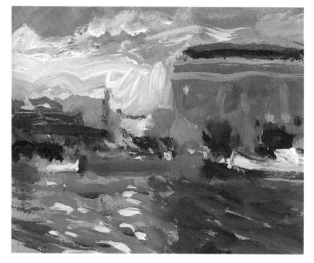

canvas, board, paper, cardboard – provided it is primed with an acrylic primer.

You cannot paint acrylic on top of an oil painting as the acrylic paint will not adhere to an oil under-painting. On the other hand, oil paints will adhere very well to an acrylic underpainting and acrylics form an excellent base.

Some of the disadvantages of acrylics can be overcome, for instance by using retarders to slow the rate of drying — but this can be a distraction reducing the spontaneity and speed which can often come from acrylics.

You can paint thin acrylic layers onto thick layers, which is not feasible in oil unless you are prepared to let the thick layer dry thoroughly, which could take months. The quick-drying nature of acrylics allows total flexibility. Also thin washes can be combined with thick impasto with some unique results.

Within the period of time that acrylics have been generally available, since the 1950s and 1960s, techniques have been developed by artists to use

△ **Acrylic sketches by Neil Murison, RWA.**
Acrylic on board.
Acrylic paint can be used as a sketching medium due to its rapid-drying properties. Neil Murison uses such sketches to evaluate the colour and composition of potential subjects for larger-scale acrylic or oil paintings. The sketches in themselves make attractive pictures and have become popular with galleries. Neil uses mounting-board with acrylic primer; the size of each sketch is normally 6×4in (15.3×10.3cm).

acrylic's unique properties. I have already mentioned the abstract painter who utilises many of the unique properties of intense colour and quick drying to gain special effects. Similarly with photo realism: where paintings resemble photographs the properties of acrylics are particularly suitable.

As with watercolours, acrylics can be used in sketches where the quick-drying properties are valuable. Unlike watercolours, it is possible to produce impasto sketches much closer in colour and texture to

a final oil or acrylic painting and therefore of more value in evaluating the potential of a subject for a larger painting.

Illustrated opposite are a number of sketches produced by Neil Murison. Neil uses the acrylic sketch extensively and his studio is full of such delightful sketches, sometimes in piles of fifty or more! Painting on mounting-board with an acrylic primer Neil identifies subjects for his full-scale paintings in this way. In those shown opposite, Neil has explored the colour and composition in particular city views to evaluate the potential for a full-scale painting.

IMPASTO TECHNIQUES

When used in a similar way to oils, opaque and impasto, acrylics have both advantages and disadvantages. You can be more flexible in applying acrylics to the support, as the short drying time prevents problems of cracking which can occur in oils.

Acrylics also have the great advantage that an underpainting or brush drawing will be dry very quickly, enabling the picture to be completed immediately on top. The illustration of the Horse Guards, London, demonstrates the oil-like handling of the paint in the sky with strong brush-strokes, while in the road the paint has been used as a transparent glaze. You will find difficulty painting gradated tones as the paint dries too quickly to allow mixing of different colours and tones on the canvas. In portrait painting, for example, acrylics can be quite difficult when using traditional techniques without the use of an acrylic retarder, the subtle changes of tone and colour in the face being easier with oils where you can work the paint for some time to achieve gradated changes. Be aware that acrylics tend to darken in tone as they dry, and have a more matt finish than oils.

Whether to work in oils or acrylics when painting cityscapes has to be a personal choice. I prefer acrylics when painting on site, because of their quick-drying property and the use of water as a solvent. I can also paint in details of architecture much more readily when previous layers of paint are dry. Sometimes I will paint a full-size sketch in acrylics, painting the final picture in oils on top of the sketch. The biggest benefit I find in acrylics is to paint an underpainting which dries immediately, on top of which I then paint subsequent coats in acrylic or oil using the underpainting as a base colour and texture.

In the painting (below) of Quimperlé you can see the base texture and colour which I have left exposed to the right and the way in which it appears under the completed picture to the left. This picture was painted on a smooth board using Raw Sienna for the underpainting and a Neutral Grey/Payne's Gray mix for the drawing. The sky and road were painted using individual brush-strokes, letting the underpaint appear — this can also be seen in the treatment of the walls of the bridge. Using the quick-drying properties of acrylics and applying the underpainting on site in this way enables a painting to be completed very quickly.

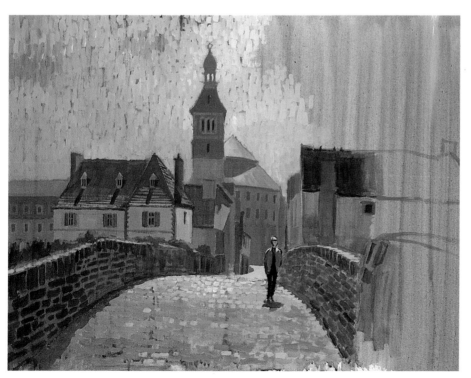

◁ **Quimperlé.**
Acrylic on board. 18×24in (46×61cm).
The benefit of quick drying enables an underpainting to be applied on site. In this case a Raw Sienna underpainting was applied using heavy brush-strokes to give a texture which shows through the painting in places. The drawing was completed in outline with a brush using a Neutral Grey-Payne's Gray mix. The finished painting on the left shows how the underpainting provides a warm base to the picture — appropriate to the warm summer's day in South Brittany.

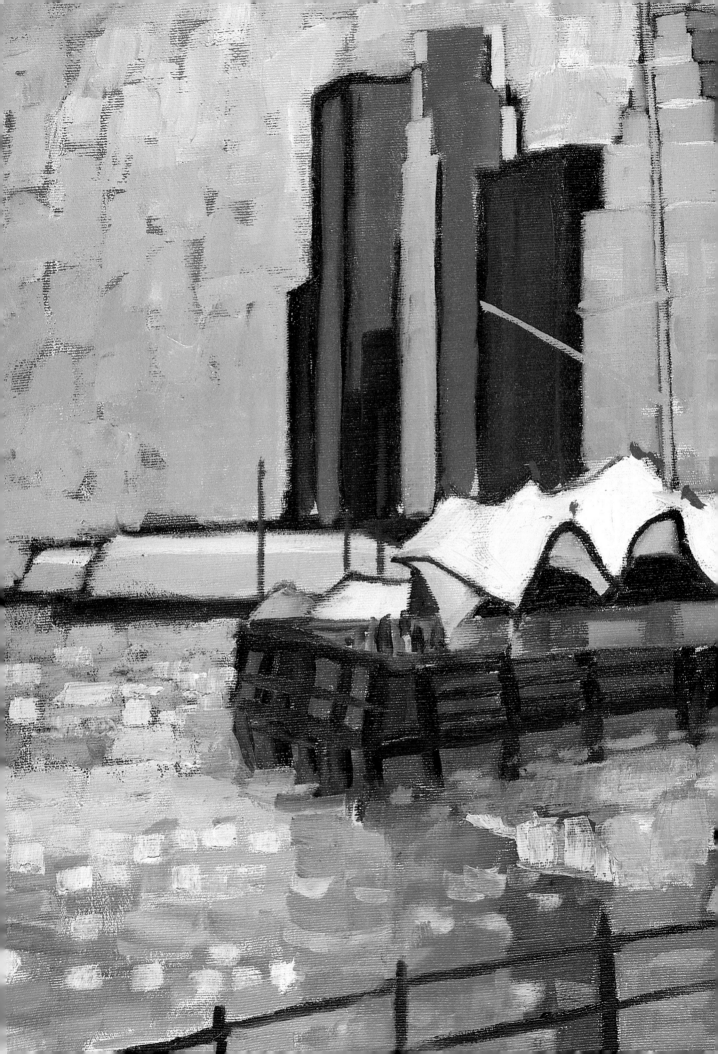

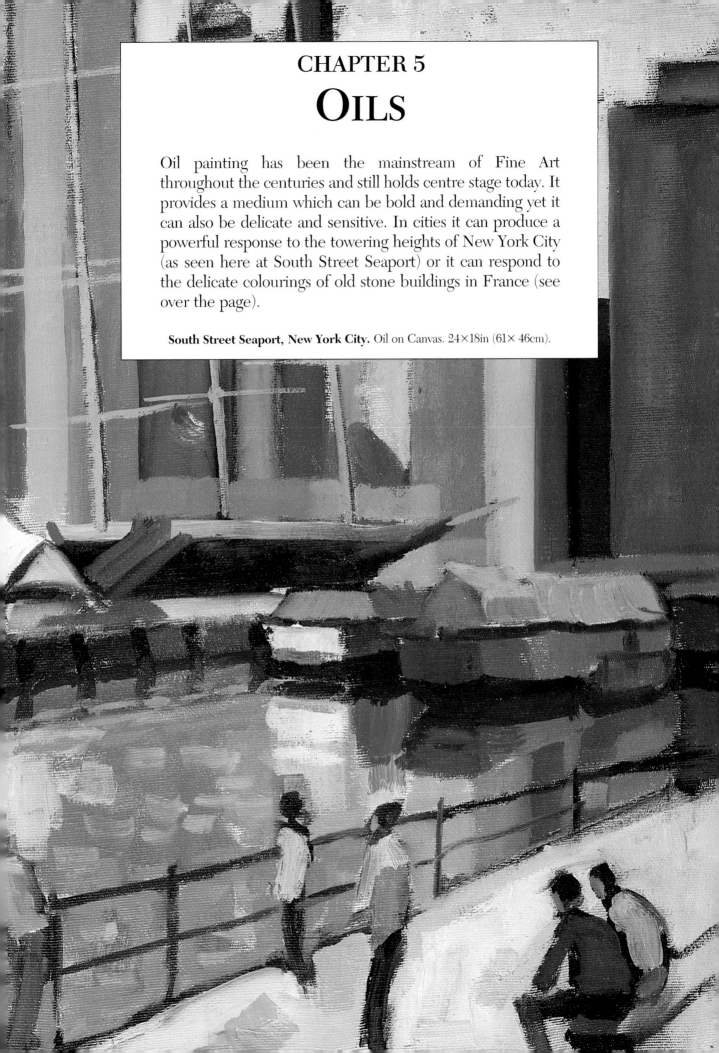

CHAPTER 5
OILS

Oil painting has been the mainstream of Fine Art throughout the centuries and still holds centre stage today. It provides a medium which can be bold and demanding yet it can also be delicate and sensitive. In cities it can produce a powerful response to the towering heights of New York City (as seen here at South Street Seaport) or it can respond to the delicate colourings of old stone buildings in France (see over the page).

South Street Seaport, New York City. Oil on Canvas. 24×18in (61× 46cm).

△ **Camaret-sur-Mer — evening.**
Oil on board. 12×12in (30.5×30.5cm).
This small oil painting *demonstrates the use of thick oil paint applied with no underpainting. The resulting texture is an integral part of the final picture.*

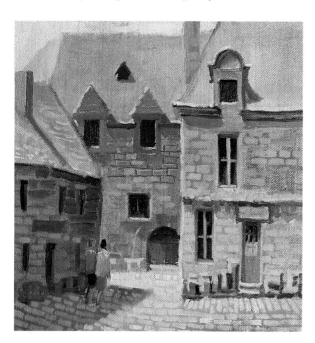

△ **Locronan — Corner of the Square.**
Oil on canvas board. 12×10in (30.5×25.5cm).
Painted onto a yellow ochre underpainting, this picture demonstrates the effects of the canvas texture in the *final painting. When the brush is drawn across the canvas, paint sticks to the weave of the canvas creating a texture which can be used to suggest textures in stone walls or buildings or for producing highlights.*

The permanence and durability of oil paints is remarkable, as can be seen in any gallery of Old Master paintings. Oil paint will stay in perpetuity with the same brush-strokes or marks of the palette knife as when it was first applied. You can actually feel, by looking at a Rembrandt, how he applied the impasto highlights on his portraits, the paint still bearing the marks of his brush.

In towns and cities oil paints are less portable and easy to handle on site than watercolours or acrylics. It is possible to buy combination easel and paintbox sets (see pages 36–7) which reduce handling problems, but the slow drying makes the transport of wet and sticky canvases a problem and the handling of architectural details can be difficult when a painting is wet. Nevertheless the committed painter in oils will enjoy nothing better than to mould and shape oil paint on a responsive canvas in front of an inspirational scene. With the use of more turpentine, oil paint dries more quickly and agents are available, such as Wingel, which when mixed with the paint will speed up the drying process considerably.

By putting down a strong line-drawing in paint using turpentine, and including many architectural features such as windows, onto a canvas or board with a coloured underpainting, it is possible to produce a relatively dry base on which to add fluid colour and tones to complete most of the painting at one time. The line-drawing can be left to show through in the final painting. Although oil paints will blend together more easily than acrylics which dry immediately, the 'working' of oil paints, while producing tonal variations and gradations, will often produce a dirty combination of colours. Hence it is sometimes far more effective to apply colours separately in individual spots and let the eye of the viewer blend the colours together — as can be seen in many Impressionist and Pointillist pictures.

SUPPORTS

The support on which you paint in oils can have a significant impact on the texture and character of the paintwork in the finished picture. I have demonstrated in these pages three different effects — one using a heavy thick paint with strong impasto in the evening view of Camaret-sur-Mer. In this painting the paint has been applied very thickly with a flat bristle brush, with no underpainting showing through into the final painting. Some painters will use much thicker paint than this so that the brush-marks form an essential aspect of the picture, the flow and viscosity of the paint itself creating the mood and character of the painting. I personally find it hard to paint in this way and what is more, it is very expensive on paint!

In the lower picture on page 66, you can see that the paint is applied much more thinly and the texture of the canvas is clearly visible in close-up. When painting on a textured surface the paint tends to stick to the peaks of the support, leaving the troughs empty, so that as you draw your brush across the canvas you will leave a pattern of paint where the weave of the canvas catches the paint on your brush. This textured result can be most helpful in creating different effects and patterns on the canvas.

Textures can be created also by the way in which the underpainting is applied. For instance, on a smooth board, if the primer is applied with strong brush-strokes, it will show as a series of small ridges when the primer is dry. This will create a pattern or texture when drawing the brush across the surface — producing effects which can be very helpful in the final painting.

Alternatively you can create a totally artificial texture by using an underpainting in which materials such as sand, paper and cement have been added, making a very rough surface. In the picture shown below, I created the surface using paper, rice and ceramic tile adhesive onto which I then painted the impression of the small entrance to Locronan church.

I enjoyed the way in which the paint was absorbed into the surface in certain places and not in others — it was a fun picture to create. I tend to be very traditional in my painting in medium selection, subject selection and style. I hope in time to break the habit of years and experiment more with textured surfaces of all kinds. The subject of your painting can be influenced by the texture of the support you are using. A very heavy canvas may not suit a detailed architectural study — a smooth board will not have enough texture or 'tooth' to provide the effects which you may be seeking in the final painting. With time and experimentation, the perfect combination to suit your style or your subject, or hopefully both, will emerge.

My personal preference when using oils is to prepare the support and produce a coloured under-painting in acrylic which will dry quickly, then using oils to paint the picture. In this way time is saved and less problems created of painting into wet paint. For outside use again I prefer to make an acrylic painting and sometimes paint over the acrylic in oils in the studio, the fluidity and plasticity of oils being such that certain paintings will respond much better than if they were painted exclusively in acrylics.

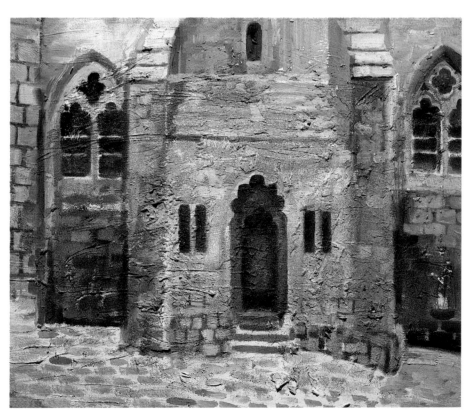

◁ **Loncronan.**
Oil on canvas. 20×24in (51×61cm).
This impression of the small side porch to the elegant church has been painted on a very rough texture created by applying various substances to the canvas, the principal being ceramic tile adhesive! Interesting effects can be created using unusual textures and it is often helpful to experiment.

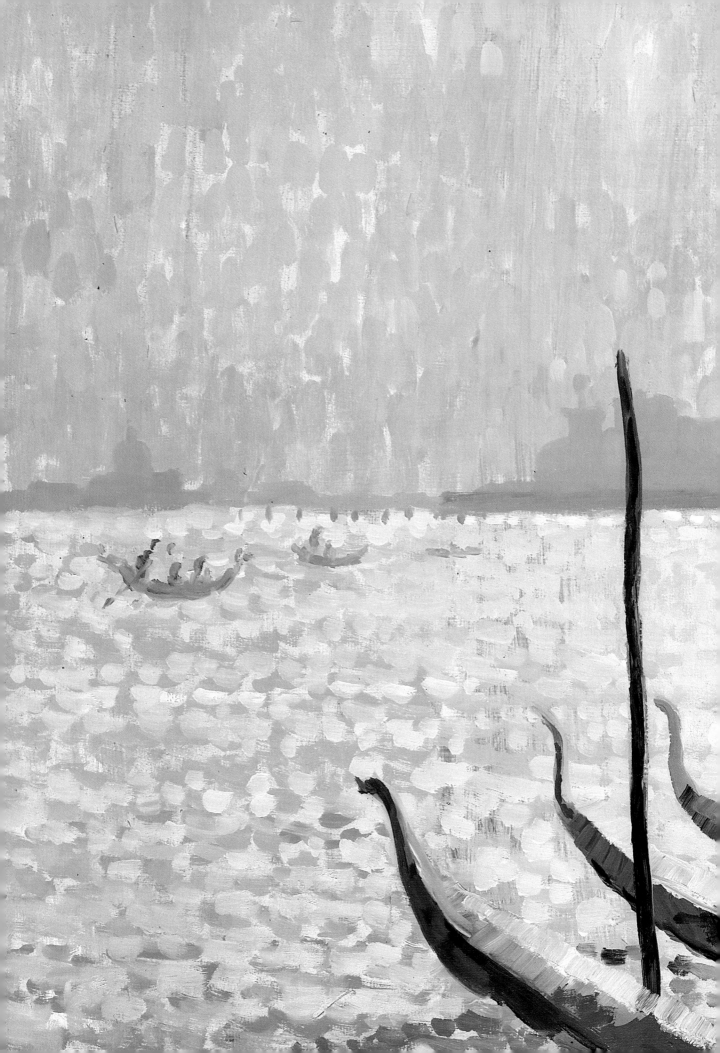

CHAPTER 6
COLOUR AND TONE

Cities can be full of colour, vibrant reds, shining golds, exciting purples and yellows. They can also be sombre, cool places with subtle blues, greys and umbers. You can choose to interpret what you see in colour to create a particular mood, atmosphere or character, and intensify your interpretation of the subject.

Venice, Evening. Acrylic. 16×20in (41×51cm).

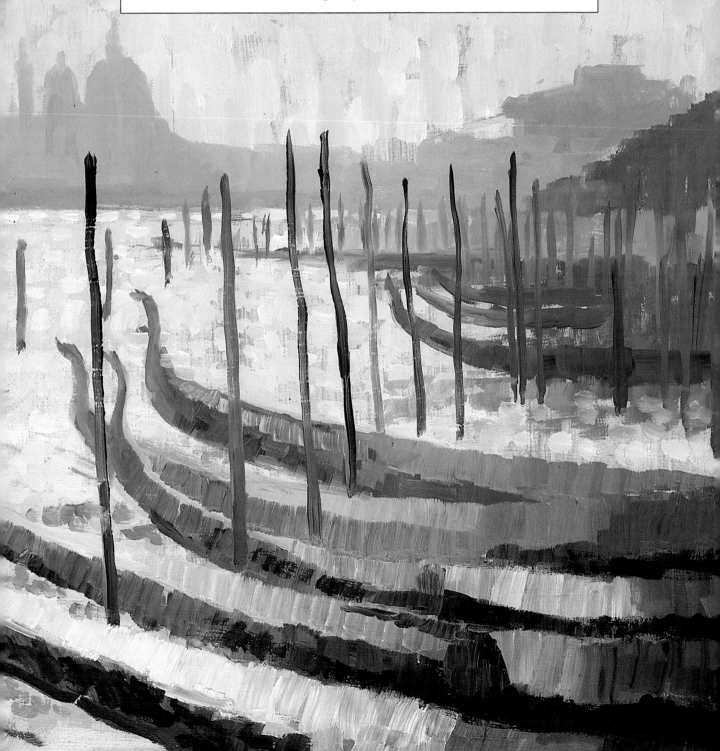

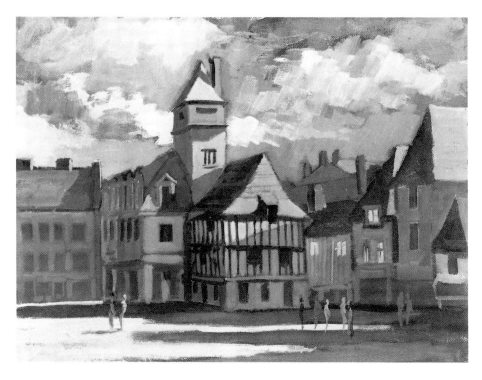

▷ **Quimperlé.**
Acrylic. 10×12in
(25.5×30.5cm).
*This monochrome painting
utilises one colour — Raw
Umber — and is a useful
exercise in examining the
tonal structure in a
cityscape. The low key of
this particular example gives
it a moonlit appearance.*

TONES

Often the experienced painter will utilise tones far more effectively than the beginner by using a full tonal range from the darkest of darks to the lightest of lights, whereas the beginner will be too timid in approach and produce a washed-out painting with no strength of form or depth of space.

Tone is simply how dark or light a patch of paint is in relation to the rest of the picture. A black and white photograph is pure tones with no colour. A photograph which is under-exposed will be too dark — over-exposed will be too light. The correct exposure gives a tonal range which appears to the viewer to be correct and which produces a balance of tones across the photograph. In cityscapes tonal values are critical if you want to capture three-dimensional space. To place one building behind another, or to create the illusion of square, circular or curved buildings, domes, steeples and columns, all require control of tone for success.

A well known household subject, such as a teapot, flower vase or jug, will demonstrate tonal values in totality, and painting objects in a still life setting can be very valuable to explore tonal relationships. In the still life opposite you can see that the three-dimensional shape or roundness is described by tones — grey shading on the body and handle. If there was only one source of light — a bulb or candle — then the tones which describe the vase would be more simple than in the watercolour illustration. With more sources of light, as in this case with several windows in the room, light appears on both sides of the vase. (An added complication is the shadow created by the flowers.) So what might appear to be a simple tonal exercise becomes quite complex.

Similar tonal relationships exist in cityscapes, often less complex than a shiny vase in a still life. Cityscapes usually have one light source which predominates — the sun — but reflected light from other buildings or the pavement add secondary sources.

Even on a cloudy day there is often a directional source of light, from the east, say, or from above, providing tones to describe a building's three-dimensional form.

In strong sunlight more complex relationships exist, with tones in cast shadows as well as tones which describe the form of a building.

The front of a building can have a range of forms; cylinders, domes, minarets and spires each of which, if drawn by an architect in plan or elevation, has a two-dimensional shape. To give the building volume and to describe it fully each dome, pillar or spire has to have a tonal description. In pencil we have explored hatching, cross-hatching and shading, all of which create tones to describe form.

MONOCHROME UNDERPAINTING

A traditional form of painting much in use until the advent of Impressionism was to paint a tonal composition with a single colour before adding the full range of colours later. In this way the tonal relationships and description of forms could be completed before complicating issues by adding

△**Tenby.**
Watercolour. 8×12in
(20×30.5cm) approx.
The yellow doors in the foreground are darker in tone than the roofs of the lower buildings which reflect the sun. Colours which are normally considered light in tone when placed in shadow will be darker in tone than those colours normally considered dark which are in sunlight.

△ **Still Life with flower vase.**
Watercolour. 9×13in
(23×33cm).
The complex tonal and shadow effects on a flower vase in a still life composition provide excellent experience and understanding of tones. The tonal relationships in paintings of buildings and cities are often less complex than those of a still life item such as a flower vase.

colour. This approach is primarily suited to oil, acrylic or gouache rather than watercolour. Both landscapes and portraits in oils were tackled this way and it is possible to see examples in museums and galleries. The Impressionists, painting in the open, changed the approach, with brush-strokes being applied directly to the canvas with colour and tone in their finished state from the beginning.

In watercolour it is possible to develop tones, gradually increasing the tonal range. Although this will often result in an over-worked painting it is useful practice in establishing tonal relationships.

TONAL VALUES

The confusion of colour and tone arises from the fact that yellow, for instance, is normally thought of as a light colour, but when it is in the shadow of a building it will be darker in tone than a red (which is normally

◁ **Quimperlé.**
Watercolour. 9×11in
(23×28cm).
*This watercolour
demonstrates a high key
tonal painting in which the
tonal range is deliberately
set high to suggest a bright
summer's day and a heat
haze.*

▽ **Vancouver Centre.**
Pen and wash. 14×20in
(35.5×51cm).
*The low key tones of this
watercolour provide the
wintry rain-laden
atmosphere of December in
Vancouver. The darkest
tones are of black ink, with
cool greys and greens
predominating in the
painting.*

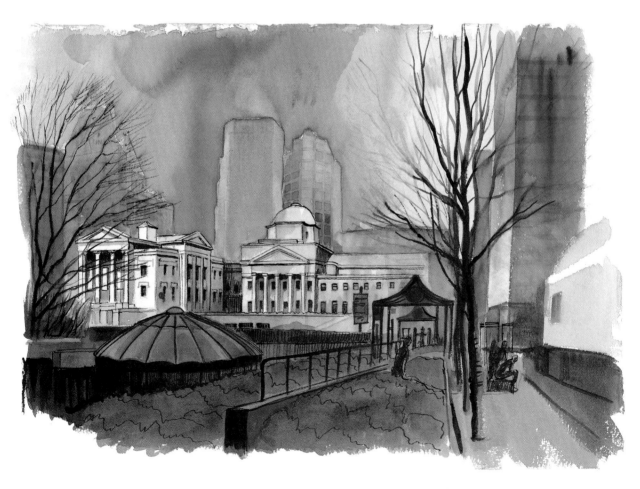

thought to be a dark colour) in sunlight. Thus, a yellow door in shadow will be darker in tone than a red roof in sunlight. It is important that you 'see' in tonal values in the city. Ignore the detail — the texture, the intricacies of architectural decoration of chimneys, porticos — what is the underlying form of the building expressed by its tonal values? Half-closing your eyes will help to eliminate detail.

Try to sketch in tones rather than lines — shade the shape of a building in three dimensions with no outlines at all.

Simplify by using only three or four tones — lightest (often the paper or priming), light, dark and darkest, and relate each tone in one part of the picture to that of another. Is that building over there lighter or darker in tone than this one over here? Does the tone at the back of building A appear darker or lighter than the front of building B?

The tones of buildings in the distance are less than those in the foreground, ie. the darks are less dark, and the lights less light in the distance — the tonal range is less.

All too often we find a dark shape in the distance protruding because it is darker than a dark tone in the foreground. The tonal range of buildings at a similar distance from the artist should be broadly the same.

In practice the darkest dark on a building will often be the window or an open door. The lightest light may well be the white window-frame. To set the tonal perspective in a watercolour I sometimes paint a window in the distance and one in the foreground and relate the rest of the tones in the painting to the two windows.

HIGH KEY AND LOW KEY

A painting can have tones which we describe as high key or low key according to the tonal range. A high key painting will have tones on a high scale from the lightest (pure white) to a middle tone, a mid grey. A low key painting has its tonal range on a low scale. A high key picture is often used to describe a very bright scene such as a beach in midsummer or a view looking into the sun when a summer haze lightens all the tones. The painting above left of Quimperlé in France is an example of this. Looking towards the sun the whole tonal range is lightened, reflecting the effects of a hot summer's day in south Brittany. A low key watercolour is shown below which shows downtown Toronto on a wet winter's day — a low overcast sky producing a dull grey effect.

A valuable method of improving the handling of tones is to paint on a toned support or background. With a dark ground you are more likely to produce a low key painting and vice versa.

It is possible to paint watercolour on a toned paper but this reduces the lightest tones to that of the paper — unless you use a white body colour.

High and low keys affect the mood of the painting, as seen with the examples shown here. High key paintings often have a light, delicate effect with a softness arising from the absence of dark tones. Low key paintings project a powerful or sombre mood with the dark tones often producing a hardness in the final painting.

△ **Georgian Balconies.**
Pen, watercolour and gouache. 12×9in (30.5×23cm).

The use of a toned ground can produce interesting effects and prove valuable in setting a middle-range tonal background.

COLOUR

An initial approach to colour is to add it to a completed tonal painting. We have already seen how pen and wash progresses from a complete tonal drawing in pen to a fully coloured painting by adding colour. Similarly, as in the traditional approach, a monotone painting can be 'coloured' to complete the picture. Clearly when adding colour to a monotone painting the tone of the colour which is added has to be similar to the underpainting. The most straightforward method of changing the tone of a colour is to mix black or white with it — although a better result may be achieved mixing complementary colours, as discussed later in this chapter. Alternatively, individual spots of colour and tone when placed together can form an impression of a tone, as used by the Impressionists and Pointillists and more recent schools of painting.

From the initial approach to colour and tone you will need to move on to a wider appreciation of colour in paintings. In cityscapes the full range of colour theory can be utilised to great effect. Cities may sometimes have a grey monochrome appearance but in practice, cityscapes respond dramatically to colour.

WARM AND COOL

Colours can be warm or cool. The impression that blue normally gives is cool but you can have warm blues. The impression of red is warm but you can have cool reds. The feeling and mood in a picture can be much

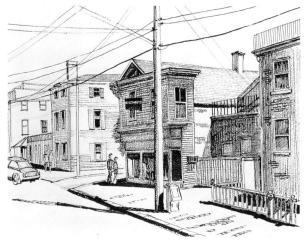

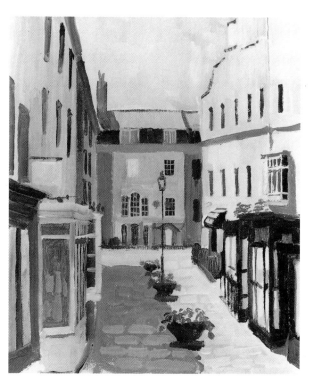

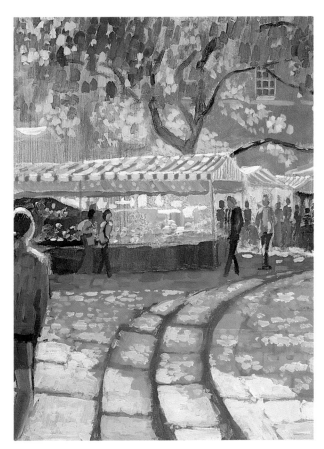

◁ A traditional approach to painting was to add colour to a monochrome underpainting, thus resolving all problems of tone. The colour to be added is of the same tone as the underpainting.
In these examples a pen and wash drawing of Newburyport, Massachusetts, has had colour added. The key tonal relationships had already been established by the pen-and-ink drawing.
In the lower two examples a monochrome view of a small street in Bath in acrylic is then coloured by the addition of colours with similar tones to the underpainting.

◁ **Colourful Shadows, Piccadilly, London.**
Acrylic. 20×16in (51×41cm).
A small charity gift market takes place in front of a church in busy Piccadilly in London, providing a colourful subject.
The shadows have been painted in purple — providing a vibrant contrast to the yellow sunlight passing through the trees. Touches of Cerulean Blue have been added to suggest reflected light and to create cohesion through the painting. The colour of shadows can dramatically enliven and give depth to many cityscape paintings.

altered by the use of warm and cool colours. Similarly the effect on the distance of an object from the foreground to the background is heightened by having cool colours to the rear and warm to the front.

An overall coolness in a painting helps to indicate the time of year, time of day or general mood. A sunlit winter scene will differ from a sunlit summer scene not only by the angle of the sunlight and intensity of tones but also by the coolness or warmness of the overall picture.

Often, by painting the colours as you see them in the city you will find that the season, atmosphere or mood of the moment is recorded, but to heighten or reduce warmth or cold feelings you will need to adjust the colours used.

All colours have their own degree of warmth or coolness which you will increasingly understand with experience. Usually adding blue will cool and red will warm but clearly there are other ways to generate cool or warm colours — using different combinations for example. The juxtaposition of warm and cool will add drama to a picture and a progression from warm to cool across the painting can improve its attractiveness. Look carefully at colours when next painting on site — the warm harbour quayside against the cool shadows from the dock warehouses, or the warm beach with cool shadows from umbrellas.

COMPLEMENTARY COLOURS

Drama with colours is often more associated with the juxtapositioning of complementary colours. The primary colours when mixed produce a secondary colour which is complementary to the third primary. This effect was used to great effect by the Pointillists and Impressionists, who applied complementary colours as separate brush-strokes side by side, leaving the eye of the beholder to link them into a particularly vibrant colour.

You should look intensely at shadows and try to see the variations which are there. Often you will find reflected light from a building nearby or from a building in line of sight both affecting the evenness of shadows, tones and colours. In shadows also, where the sun is no longer the primary source, on a sunny day you will find the blue of the sky affecting the colours of the shadows. Also try experimenting: where a shadow looks an even grey, add blue with some small brush-strokes of orange and see the effect where colours are side by side — for example make the colour of the shadow the complementary of the sunlight. You may find you achieve a startling result.

With practice you should be able to decide on the effects you are seeking and achieve them by using warm, cool or complementary colours.

UNDERPAINTING COLOURS

One way is to start with an underpainting which is warm or cool — or use a toned paper. The colour will permeate through the painting. If you look carefully at oil or acrylic paintings in exhibitions you will detect in many cases the contribution that the underpainting is making. Pastels especially depend on the colour of the support for many aspects of colour and mood.

A snow scene painted on a warm underpainting results in a glow to the picture and warmth of feeling despite the other indications of cold weather.

Alternatively, if there is much orange in the scene and you choose a blue underpainting, some vibrancy will result from the complementary colours you have used.

▽ **Cheltenham.**
Acrylic. 18×24in
(46×61cm).
In this winter scene the combination of Cobalt Blue and Azo Crimson in the sky produces a complementary colour to the sunlit yellow

stone of the houses, providing vibrancy in the colour contrast. Notice how the Raw Umber underpainting also gives a warmth to the whole picture.

Watercolour can also be painted on a coloured paper — or a preliminary wash can be added to provide an initial coloured support. There is always a danger, however, of disturbing the preliminary wash with subsequent washes.

REFLECTED LIGHT

Reflected light can play a significant part in city scenes. In a narrow street with the sun shining strongly on one side, the level of reflected light on the other side can be high. The impression of a hot sunny street will be improved dramatically by the reflected light on the shady side of the street; often reflected light will be gradated from top to bottom according to the exposure of the walls to reflected light at different levels up the wall. The colour of reflected light is influenced by the colour of the wall on which the reflected light is playing, together with the colour of the light being reflected.

Shadows will change in colour and tone as the shadows recede into the distance, with a blue trend in the colour becoming discernible. Yellows tend to jump out of the picture, blues recede — each colour will produce a different effect by its prominence.

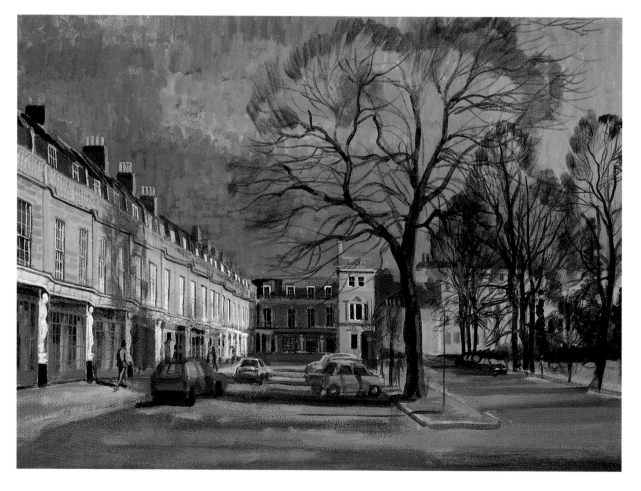

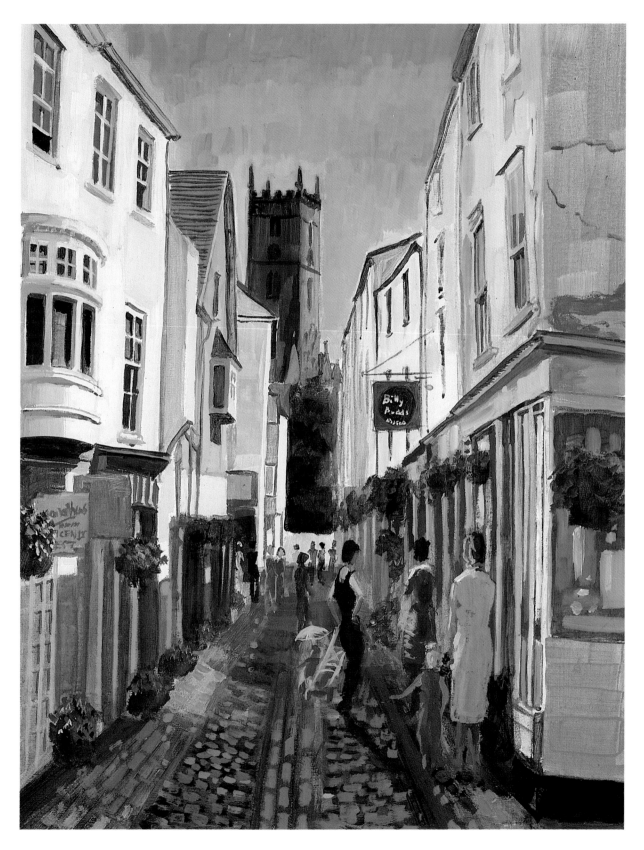

△ **Dartmouth, Devon.** Acrylic. 20×16in (51×41cm).
When sunshine strikes a narrow street such as this in the
old fishing port of Dartmouth, reflected light will provide
almost as strong lighting to the shaded side as to the sunlit
side of the street.

FOCUS WITH COLOUR

Rescue workers often wear bright colours so that they can be seen. A grey sea will disguise a man in the water in grey or blue, but dress him in orange or yellow and the eye instantly picks him out. The whole topic of camouflage, demonstrated in the wild a million times by the cryptic coloration of birds and animals, is concerned with the relationship of the colour and pattern of the creature with its background.

In painting it is exactly the same: a cityscape of grey buildings with brown pavements and grey streets will swallow grey-suited men, but one bright red coat will dramatically affect the whole painting. It does not only create an immediate focus but improves the total picture. You will see examples all the time — in New York with skyscrapers and dark streets, the sun shines onto a yellow flag and the whole panorama is dramatically changed. A splash of colour draws the eye immediately to it.

You can also see, when looking at a cityscape, bright colours which need to be removed from the painting as they totally distract the attention from the intended focus and unbalance the composition. Old Masters were well aware of the use of a splash of colour to focus

the attention and you will see examples in Canaletto, Constable, Vermeer or Turner of the deliberate use of colour as a focal point. The most flexible and mobile sources of spots of colour are people or vehicles. The incorporation of both into paintings enables you to play tunes on colour spots across the picture to the benefit of the total work.

Colour can add excitement to cities: look at a funfair or carnival, a market-place or fishing-harbour. Many marinas in cities provide dramatic colour. Colour makes the scene and creates an attractive subject for a picture. In many cities, gardens and flower-beds create a colourful spectacle, as do shop blinds, advertising signs and posters.

When looking at a possible picture examine the colour potential — some paintings will be entirely dependent on colour for their impact. Can you create the colour needed by adding touches, or by changing the colour balance? Cohesion across a painting can be achieved by the use of a similar colour palette throughout, or by adding spots of colour of similar tone and intensity across the painting, thus unifying the work in the eye of the viewer. A coloured support or ground will often provide the same cohesion where it shows through into the final painting.

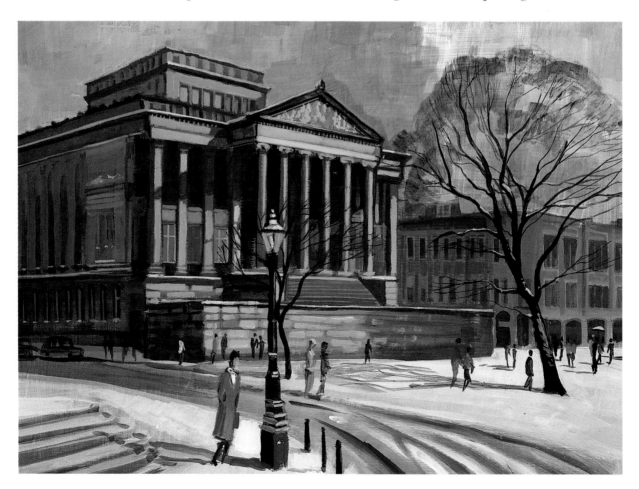

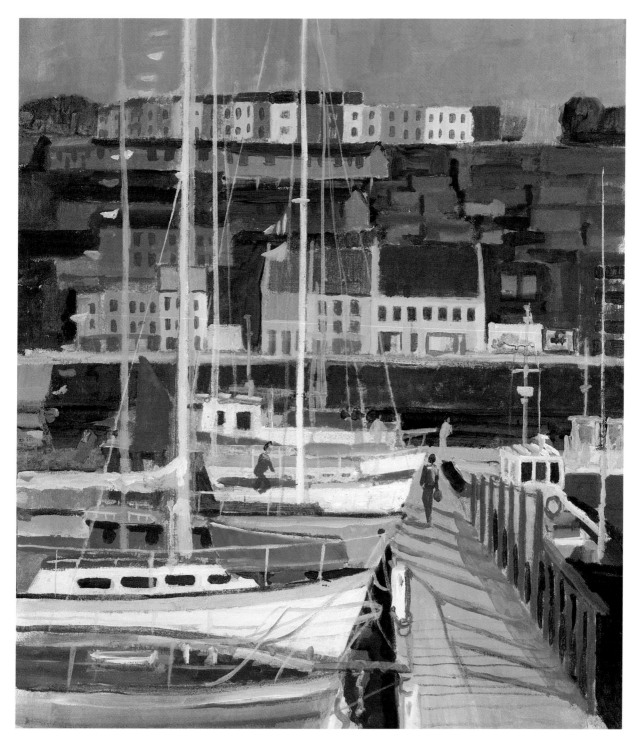

◁ **Preston, Lancashire.**
Acrylic. 18×24in
(46×61cm).
A splash of red on the coat in the foreground instantly changes this almost monochrome painting into a lively picture. The red colour acts as a focus for the eye

and also tends to emphasise the other small splashes of red in the picture. This technique of providing a very powerful spot of colour was much used by early painters including Canaletto, Constable and Turner.

△ **Marina Morning.**
Acrylic. 16×20in
(41×51cm).
The full realisation of colour spectacle is often found in marinas or harbours where the bright colours of the boats picks out colours in the rest of the painting. The

attraction to me in this scene was the colours of the houses on the hillside opposite, providing a background to the stronger colours of the boats. The aerial perspective in this painting has been suppressed to emphasise the colour harmonies.

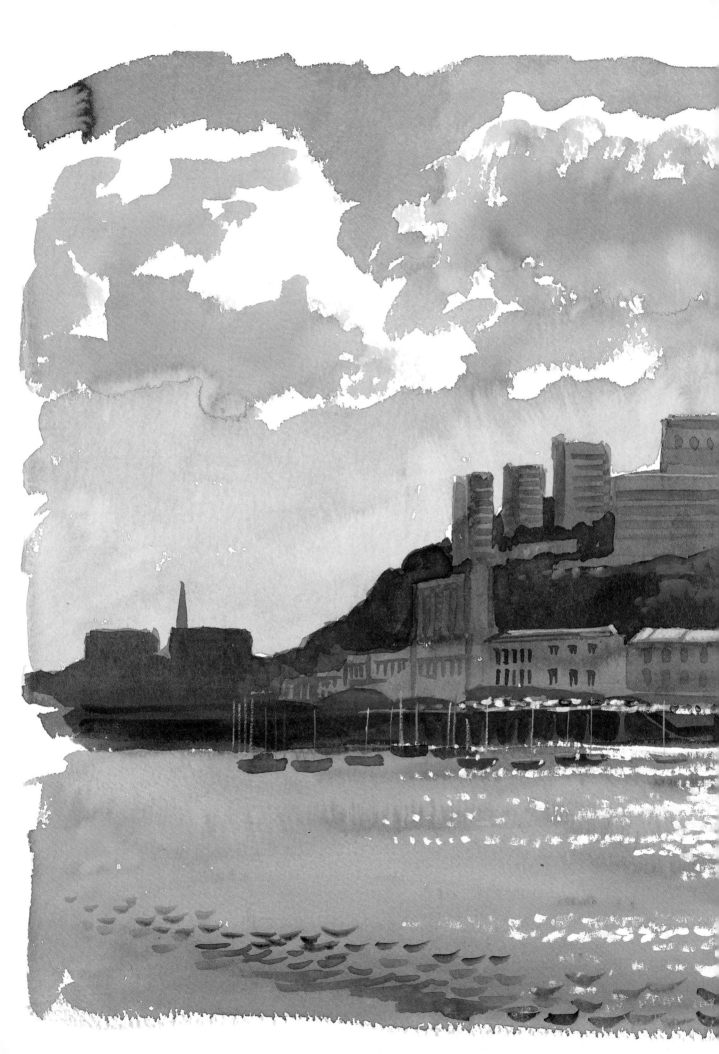

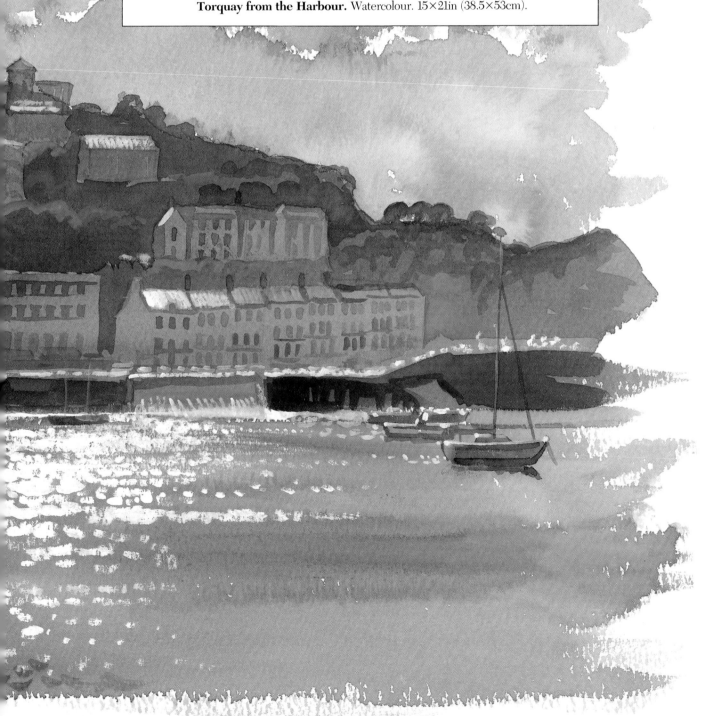

CHAPTER 7
LIGHT

A cityscape can be well drawn, of good composition with tonal balance and strong colour, and yet still be boring and unexciting. The missing ingredient is light.

Light is the essence of inspiration for most artists. What can be more beautiful than sitting by the water's edge on a hot sunny day, watching the reflections creating sparkles of light across the water with the city silhouetted on the horizon against a bright summer sky?

Torquay from the Harbour. Watercolour. 15×21in (38.5×53cm).

A cityscape with patterns of light and the shade — one minute providing a dark backdrop, the next a light one, skyscrapers, cathedrals and castles as the clouds pass overhead — can also be very dramatic. Selection of the scene for your painting should be heavily influenced by light and shade.

Look for the light which creates a splash of colour here, a deep shadow there, reflected light on buildings and a variety of sky effects — try to see the view in front of you as an abstract assembly of light and shade, colour and tone.

Midsummer is not always the best time to find the most dramatic effects of light and shade. Early or late in the year will provide long shadows and will tend to emphasise differences between sunlit walls and cool shadows. A low sun will throw its light onto tree-trunks and create columns of light and dark beneath a group of winter trees. Trees cast fascinating patterns across roads and onto buildings when a late evening sun throws long shadows. You will notice that the shadows look more intense in winter: there is less reflected light from the sky and surroundings to penetrate the shadows.

VARIATIONS OF LIGHT

Variations of light against dark and dark against light along a boundary such as the horizon will add interest. In the picture on this page of the Tower of London and the City from Tower Bridge, the sky is dark behind the Tower and light behind the City, thus providing an interesting variation across the picture. The sunlit Tower is emphasised by the dark cloud above it and the dark shuttering of the river-bank below. The reflections in the water create patterns of light and shade as well. The picture has alternating patterns of light and shade, colour and tone, all providing interest and variation.

In the oil painting of Chipping Campden, notice how the sunlit cottages on the left provide a contrast to the dark shadows of the building on the right, with a silhouetted edge between the two creating a strong contrast which immediately adds a sharpness to the picture. The sky treated with individual brush-strokes of different colours and tones has provided a dark background to the sunlit cottages, using complementary colours to add some vibrancy.

The lighter sky to the right of the picture provides a background to the dark building, creating the variation of tonal relationships between buildings and sky from one side of the picture to the other. The large expanse of foreground has been given interest and variation through the shadows cast by trees outside the picture to the right. These shadows also enable a textured pattern of brush-strokes to provide interest in what would otherwise be an empty foreground. The shadow across the middle of the picture joins the two sides of the composition and provides contrasts of light and shade in the road leading from the foreground into the heart of the painting.

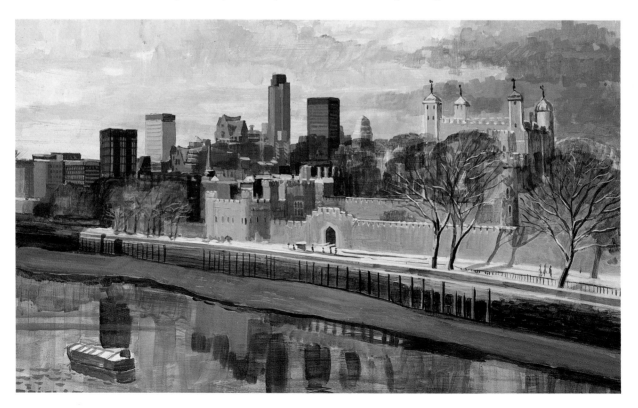

CHANGING LIGHT PATTERNS

In practice when painting outdoors you have to contend with constantly changing light. Even when the sky is cloudless, the sun will be steadily moving, changing shadows and the intensity of the light. In temperate climates such as Northern Europe the chances of a cloudless day are limited, so that the painter has to develop methods to overcome the problems of light variations. One way is to paint for a limited period only, say three hours in the middle of the day — and then return the next day at the same time. If you are extremely lucky the sun will shine on two days — if not your picture could take weeks to complete, risking other changes in your target subject. I have once achieved three consecutive days painting a harbour for two hours each day in sunshine, beginning at 8am, but in England that is exceptional.

Alternatively you can sketch, adding details of light, colours and tones in note form, for completion in the studio. My own views on this approach are that it is fine for the experienced artist who has achieved an understanding of colour and tone and can transfer his ideas from the sketch to the final studio painting — but for the less experienced painter the sketch will leave half the subject inadequately described.

Sometimes it is possible rapidly to describe a critical part of the subject and capture the light and shade, colour and tone parameters which are then used as the controlling element to complete the rest of the painting which has been drawn but not painted. Another approach was illustrated with Neil Murison's acrylic sketches — where quick freehand mini-paintings were used to grasp the colour and light elements of the painting, and could be used to complete the final picture at home.

I prefer to paint the final size but in watercolour or acrylic, leaving details where necessary to be painted afterwards. When timing myself on a painting outside it is the details such as windows which take the majority of the time so if I have the key aspects of composition, light, shade and colour captured, I can finish off the painting later with the details being provided by a camera or from the initial drawing.

The camera is particularly useful, not only because there is often an abundance of architectural detail, but also because light changes so rapidly in narrow streets or on complicated buildings that the only way to capture certain scenes is with the camera.

Ultimately you have to develop an outdoor *modus operandi* which suits you: if you have the ability to paint quickly — or have a good memory for light and colour — or enjoy working from sketches and photographs, then you will organise your outdoor techniques to suit yourself.

For all of us the experience and benefit of painting outside is essential — in no other way can you respond to the total environment and ambience of the situation, and select and interpret those elements before you to create your own unique interpretation of the scene.

◁ **Tower of London and the City.**
Acrylic on board. 18×24in (46×61cm).
The variation of light against dark and dark against light along the skyline adds interest and focus to this painting. Skies can often be used to assist light, colour and composition in a cityscape picture. Note how the reflection in the water helps to break up the foreground and lead the eye into the centre of the painting.

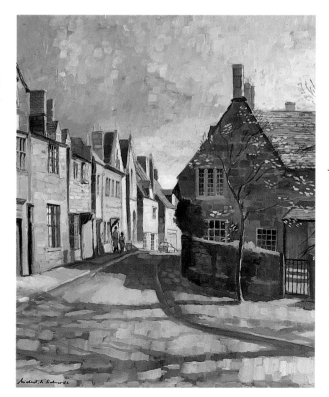

◁ **Chipping Campden, Gloucestershire.**
Oil on board. 36×36in (91.5×91.5cm).
The strong sunlight on the Cotswold stone houses on the left is offset by the large house in shadow on the right, with the foreground featuring shadows from trees which create interesting patterns across the street. The length of shadows and lighting on the buildings indicate an early winter scene. Note the virtual absence of shadows under the gutters and at the top of the windows on the left.

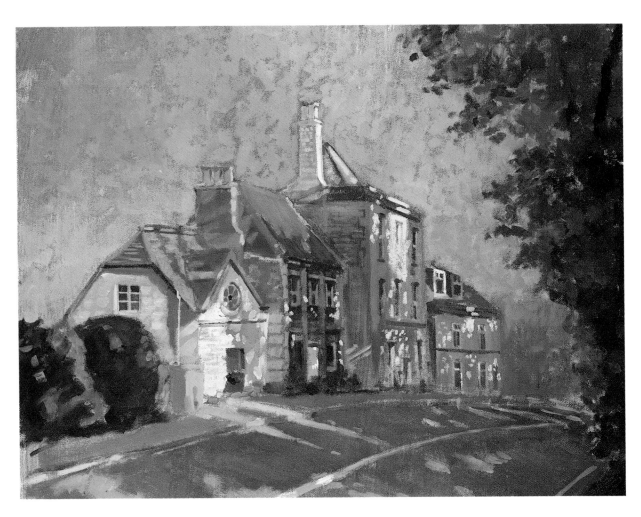

PAINTING INTO THE LIGHT

A favourite approach of mine is to look into the light with the sun shining into my face and paint the dramatic effects of light and colour which result. At the beginning of this chapter the scene across the water at Torquay on the south coast of England uses this viewpoint, providing dramatic lighting to the clouds. In the above painting, the same lighting provides a wintry scene with the sun shining through the branches of the bare trees. Using acrylics and with individual brush-strokes of different colours and tones, the light in the sky can be made to sparkle and provide a shimmering effect much loved by the Impressionists; the tones of the bridge, buildings, trees and figures have to be controlled and the colour used to give aerial perspective as well as vibrancy to the picture.

The introduction of trees into a cityscape can break up the monotony of geometric edges and straight lines, cubes or circles — trees introduce random variations in lines of branches and leaves, and as seen already introduce interesting shadow patterns. With the light shining through the trees, as in this example, the contribution of the tracery of branches is emphasised.

△ **Cotswold Cottages.**
Acrylic on canvas. 16×20in (41×51cm).
The dappled effect of sunlight on the front of buildings can create a fascinating picture of light and shade. The dark foreground helps to focus attention on the cottages, with the sunlight across the road leading the eye to the centre. This acrylic was painted on a ground of Raw Umber which shows through into the final picture in many places. The paint in several areas including the sky is very thin, allowing the underpainting to influence the colour and texture of the painting.

Backlighting in this way can produce a halo effect around the figures — which can be dramatic in its effect. Indeed many painters make the backlighting effect on the figure the principal subject of the painting. The detail of the painting opposite shows how the halo effect can provide a lively focus to the painting — where the two figures meet by the lamp-post with a spotlight effect similar to that used in theatre lighting.

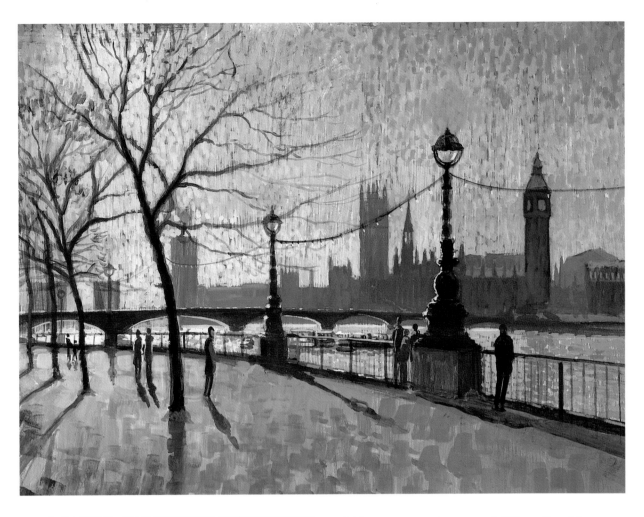

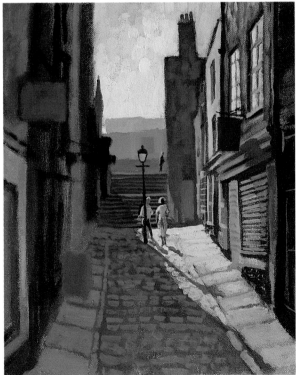

◁ **Afternoon Meeting.**
Acrylic. 12×10in
(30.5×25cm).

△ **Winter Sunshine.**
Acrylic on board. 16×20in
(41×51cm).
Painting into the sun creates dramatic effects of light and shade with buildings, bridges and railings silhouetted. Using individual brush-strokes of colour in the sky creates a luminous shimmering effect. The bare trees add variety of line and interest to the composition. The painting 'Afternoon Meeting' illustrates the effect of backlighting figures, producing the halo of light around each figure and creating a strong focal point in the painting.

LIGHT ON WINDOWS

When painting buildings you will find that windows can play a key role in signposting the angle and direction of the light, hence indicating the time of day — or the season. The strength of the light and hence time of year can be set by the intensity of contrast between sunlit walls and the shadows on the window.

The realism and depth of a building will be instantly changed by a different treatment of windows. Doors and other apertures obviously have a similar effect and have to be in co-ordination with the treatment of the windows, but in my experience it is always the windows which are the key. In fact the handling of the windows in a painting often says much more about your painting than simply the interpretation of light and shade. The degree of detail, colouring and tones set the style of the whole picture. Too often you will see paintings of buildings finely detailed but with windows which are a series of blobs and blotches — or a quite loose handling of a cityscape with tightly detailed windows.

You have to make up your mind what kind of painting you are pursuing and treat the windows accordingly. If your approach is realistic and detailed, use a brush that will cope with the fine bars of the window-frame. You should understand the lighting effects on a window-frame — practice on a complicated sash window from an eighteenth-century style house.

In the diagram opposite the principal shadows are cast by the top and side of the window aperture, and the bottom of the top window-frame: (a), (b) and (c)

respectively. Notice the angle of the shadow at point (a). The depth of shadow (a) will indicate the depth of the aperture — how far the window-frame is set into the wall — as well as the height of the sun — and hence time of day or season. Secondary shadows will occur on curtains and under each horizontal bar of the frame. With the majority of window-frames being painted white, the colour of the shadow on the frame is often blue, or a cool grey. Even when there is no sunshine the top of the window-frame will have a pronounced shadow (but with a soft edge). The painting of *The Old Shop* on a bright but not sunny day illustrates the soft shadows which occur in window-frames.

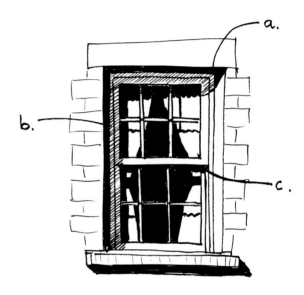

Windows play an important role in depicting light falling onto buildings. The depth of the shadow indicates the angle of the sun and hence time of day or season of the year. The treatment of windows has to be consistent with other aspects of the painting.

◁ **The Old Shop.**
Watercolour. 10×12in (25×30cm).

In the watercolour of The Old Shop the softness of the shadows indicates that the sun was not shining strongly yet the recess at the top of the window is still clearly shaded. In the bay window, note a reflection of the blind in the upper panes.

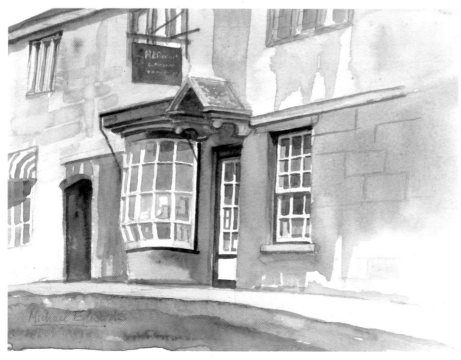

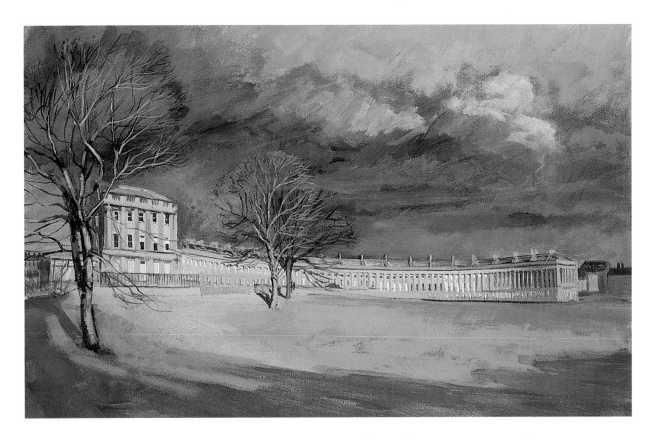

LIGHT IN SKIES

The sky can provide the focus for the light in a painting. Usually it plays an important role in setting tonal values, introducing colour or texture or providing balance and focus to a composition. I often leave the sky until last in a cityscape to ensure that it complements the rest of the composition. A picture which is quiet and still can be enlivened by a busy sky. Colour can be introduced, sometimes using complementary colours against particular parts of the painting to enliven the painting or as indicated previously in this chapter, the tone of the sky can produce a contrast of light against shade which varies across the horizon.

Light in the sky often sets the seal on the time of day or season of year. It can identify the location, a dark blue sky perhaps suggesting a hot southern climate in summer, a cool light sky suggesting winter — or northern latitudes.

Even clouds can be indicative of location. A continental weather system will produce a different cloud structure from that of a maritime climate. The location of the sun can be suggested by providing a lighter sky in the area of the sun. Sometimes, particularly in the late evening, the sun can be included in the painting. In this case it is a critical element of the composition and needs to be handled with care — but with successful use the evening sun can provide an exciting focus and atmospheric key.

△ **The Royal Crescent, Bath.**
Acrylic on canvas. 18×24in (46×61cm).
A dramatic dark winter's sky accentuates the low sunlight on the yellow stone of this magnificent Georgian crescent. The light on the trees emphasises the wintry lighting of the picture.

A dark sky, as in the painting of Bath's Royal Crescent above, can add a dramatic element, with the sun on the yellow stone making the building stand out vividly against the dark threatening clouds.

With watercolour skies the technical aspect of painting wet in wet dominates the treatment of clouds with soft and hard edges. Gently changing colours and tones demand considerable skill in handling the paint. The danger of leaving the sky until the end is that it can become a separated element and look like an afterthought. In a watercolour with the sky being added last, there is a considerable problem with the horizon. Trying to wash a sky into a complicated cityscape horizon can leave unsightly gaps between the sky and horizon.

Alternatively the sky and basic colours of a watercolour can be introduced as an underpainting to the whole composition. Sometimes a cityscape can be effective with the sky left as white paper, producing a painting in which the buildings are silhouetted against the plain white background.

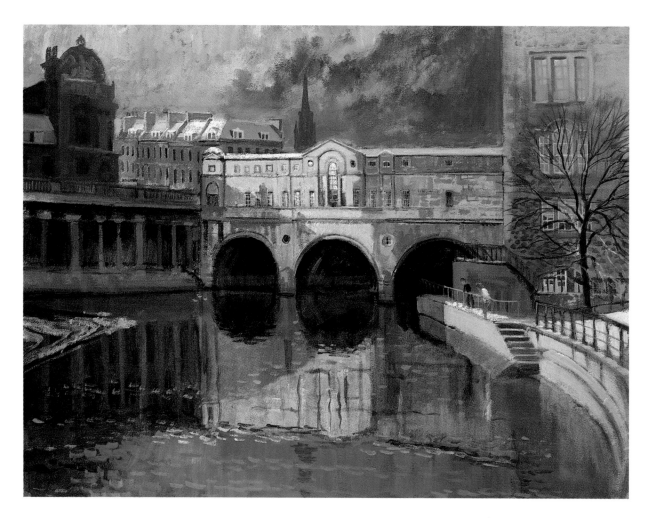

LIGHT IN WATER

Water in a city adds wonderful light, reflection and sparkle and can make the dullest picture come alive. Search out the harbour or waterfront and you will often find new views of the city and the activity of docks and marinas will in itself provide inspiration. Watch how light from the water reflects against waterside buildings, with wavelets of light passing across the stone or brickwork. The colours of boats, flags, bunting and sails can introduce splashes of colour (as illustrated in chapter 6).

Painting across a wide expanse of river can have its problems. Although such a viewpoint will often provide the best panorama of the city, the expanse of the water provides composition problems. But in the evening or early morning the atmospheric effects can be dramatic. Reflections of buildings in calm water can provide an attraction, the rippling effects contrasting with the solid motionless buildings. The light on a building when reflected in water will be darker than on the building. The darks when reflected are lighter, ie. the tonal range is less when reflected than in the original. The distortions in the reflection will enable a

△ **Pulteney Bridge, Bath.**
Acrylic on canvas. 18×24in
(46×61cm).
Water can add sparkle to
any painting and in the city
it introduces light and
movement. Docks, harbours
and rivers are all favourite
locations for the painter.

free handling of the reflected image to appear highly realistic. Remember that the reflection in your painting will be the same distance below the water's edge as the object is above it. With the addition of patches of ruffled water interspersed with calm stretches, the introduction of water into a cityscape can provide the opportunity for a wide variety of variations in light, colour, tone and texture.

FLOODLIGHTS AT NIGHT

By night, light can be from moonlight or floodlights. In Victorian paintings romantic effects of moonlight were a popular subject for society painters. With the romantic paintings of Samuel Palmer setting a precedent, many pictures of water and buildings lit by the silvery light of the moon were painted. Using a low key tonal range and monochrome approach,

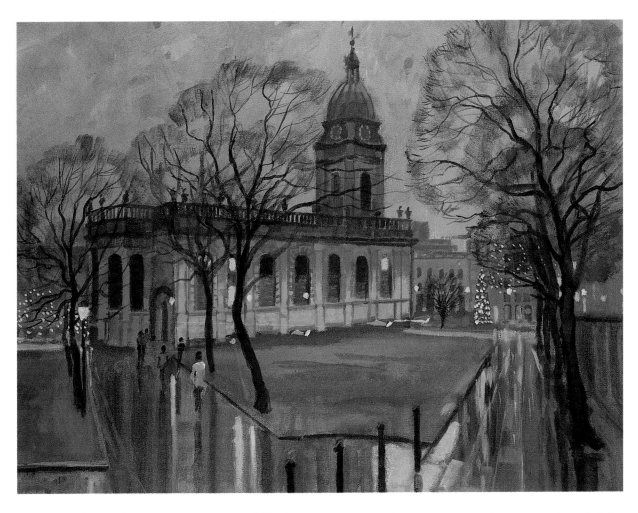

paintings of moonlit scenes are not as difficult as they appear, but are not a frequent subject for most painters today.

Artificial light however creates a whole gamut of effects and has been painted eagerly for centuries. The Impressionists' paintings of Paris by night come to mind. Clearly there is a problem in painting from real life unless, like me, you have a studio looking over a city square. I have not attempted painting by night in the car which I suppose is feasible but difficult. Consequently, unless you have access to a window with a night-time view, it is either necessary to sketch, take notes or use the camera (or all three). Floodlit scenes are fascinating to paint, with unusual tonal contrasts and fascinating effects of light in patches on buildings or reflecting from snow under a streetlight. If you know a particular scene well and have painted it in daylight, it will be relatively easy to convert notes of the floodlit night-time scene to a realistic painting. The camera is clearly of great value in floodlit paintings. You will need a tripod to enable long exposure times to be achieved without too much shake. The resulting photographs will provide much stimulating material from which to develop night-time scenes.

△ **Birmingham Cathedral.**
Acrylic on canvas. 18×24in (46×61cm).
Floodlights provide a challenge of lighting quite different from daylight. In this painting a wet day has enabled reflections of streetlights and Christmas decorations to be included to add interest and pattern to the foreground. The lighting of the cathedral picks out the mellow stone walls against dark surroundings and an evening sky.

In the painting of Birmingham Cathedral I have used an evening scene at Christmas when lights are placed in surrounding trees which, together with the streetlights and floodlights, provide interesting reflections on a wet winter's day. The floodlights on the cathedral create patterns of light and shade which are the reverse of daytime lighting and as there was still light in the sky, I was able to depict the outline of the cathedral and surrounding buildings against a grey winter sky. You will find other examples of floodlit paintings in this book, as I am very fond of the dramatic effects which often result from good floodlighting of city-centre buildings.

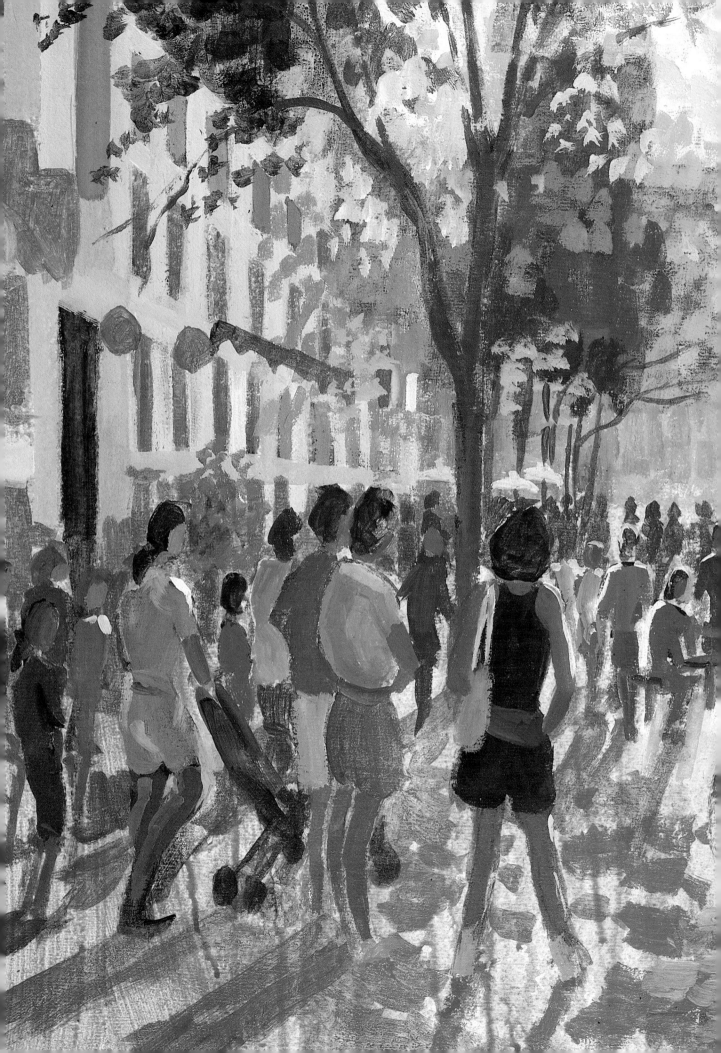

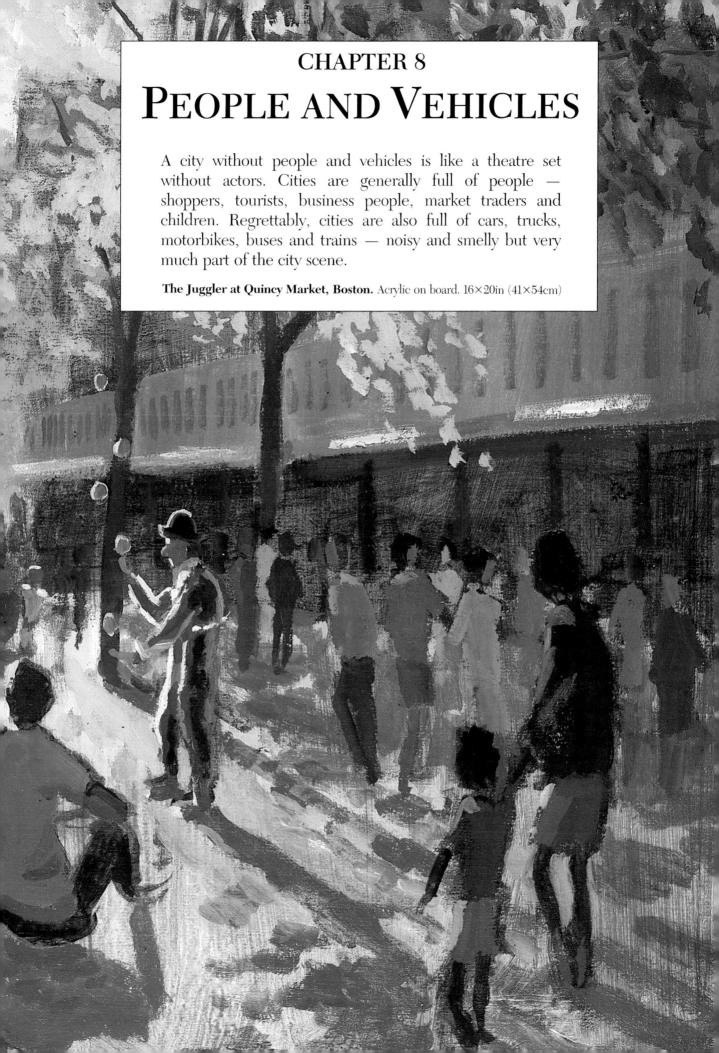

CHAPTER 8
PEOPLE AND VEHICLES

A city without people and vehicles is like a theatre set without actors. Cities are generally full of people — shoppers, tourists, business people, market traders and children. Regrettably, cities are also full of cars, trucks, motorbikes, buses and trains — noisy and smelly but very much part of the city scene.

The Juggler at Quincy Market, Boston. Acrylic on board. 16×20in (41×54cm)

△ *These sketches of people in a city square were made one lunchtime and captured tourists, residents, a busker and the passers-by of a city centre. Such sketching* *practice is invaluable to gain confidence in drawing people. With a small sketchbook you can be unobtrusive and unnoticed while you sketch.*

PEOPLE

In many paintings the artist has to focus on the people to represent fully the character of the town and city. The focus of this book is buildings and environment. Other books are available dealing fully with painting the human figure. Nevertheless, without an ability to include people and vehicles the artist in the city will be missing a key tool in his kitbag.

Drawing people is not easy. It takes usually much practice, and the keen student should attend life class to understand the fundamentals of anatomy and how to tackle the drawing of the human figure. In cityscapes the figures are usually small, clothed and in a limited number of postures — walking, standing, shopping, sitting down — and they are subject to the light in the painting and have to be painted as part of the environment. There are some principles which need to be applied constantly when dealing with figures in cities.

The size of the figure in the distance is smaller than that of figures in the foreground and the relationship of the recession from foreground to background is the same as the surrounding buildings in the painting. Figures are an excellent tool for emphasising depth and recession in a painting but they have to be

continually related to the buildings in the picture. Can the person depicted in the middle distance pass through the archway in the building to his left? — if not, he is over ten feet tall!

If the artist is standing at an easel his eye level is at head height; therefore the horizon level is at the height of his or her eyes. Every other head in the picture will be at the horizon level (assuming a flat street). On a hill the figures will obviously be higher or lower — and should be in perspective with the buildings.

MOVEMENT

People in cities are usually moving — walking, talking, pushing prams, carrying shopping, leading dogs or children. They are often in groups of two or more. Consequently you have not only to draw figures but to make them move. The head is one-seventh of the body, and is usually one-third of the width of the shoulders. The length of the leg is approximately half the height and the suspended arms extend about halfway down the upper leg. One way to tackle figures is to adopt a matchstick approach to get proportions correct and then add body, clothes and so on. The foot or feet which are supporting the figure are usually under the head unless the figure is leaning against a wall or gate, and there are curves to every figure; whether seen from front or side, the leg from hip to foot is never a simple straight line.

LIGHT

You will often find that the addition of light and shade immediately adds realism to a figure in your painting.

Light usually falls on the top of the head, the shoulders and top of the back, the buttocks (more on a woman than a man), the calves (when walking) and the lower arm. The depiction of these areas of light on a figure can often portray the movement in totality.

For the city or landscape painter figure drawing has to be practised again and again. The sketchbook which can be small enough to fit in your pocket or handbag should be instantly accessible. You can sit quietly in a city square alongside tourists or weary shoppers and quietly draw figures around you. Walking — seated — talking — busking — road-sweeping — eating ice-cream — carrying heavy loads — sunbathing.

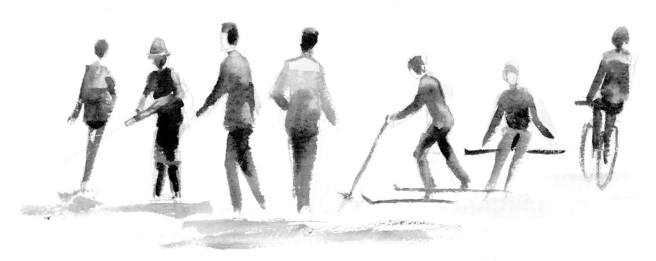

△ When painting people look for the effect of light on the figure — depending on the time of day, sunlight will produce highlights on head, shoulders, hips, calves and forearms. Quite often when painting in oils or acrylics it is useful to paint the figure in monochrome first before adding colour.

INTRODUCING FIGURES INTO CITYSCAPES

Figures should be an integral part of the cityscape from its original conception, through the initial drawings and into the final work. When first sketching, make notes of typical figures as they pass. Check to see where their heads and feet relate to buildings in the picture. Catch one or two different forms of clothing — and perhaps a child's action when holding its mother's hand or a porter carrying large boxes. You can always add further figures in the studio later. Some artists prefer to keep reference material of figures in different poses and actions in sketch-books for inclusion in paintings at a later date — but in my experience there is no substitute for capturing genuine figures in their environment. I personally use a mixture of sketching figures on the spot and using reference sketches later. The Old Masters, or certainly their followers, would buy books of figure drawings in different poses and literally copy them into their own paintings — thus the same figures sometimes occur in different artists' work.

In practice I usually paint the figure in a monotone when using oils or acrylics — grey for example — establishing the size, shape, movement and lighting before finally adding colour and detail. In watercolour I draw the figure in at an early stage, applying colour and tone when I have established the tonal structure of the picture. Faces are often left blank by painters when the figure is small-scale but even the most limited blob of flesh colour on a picture can dramatically improve the realism of a painting. In the foreground you may

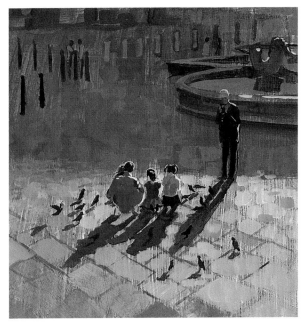

△ **Feeding the Pigeons, Trafalgar Square, London.**
Acrylic on board. 12×12in (30.5×30.5cm).
The subject of this painting in the city is the figures. A 'halo' effect of light around the figures emphasises the subject and the direction of the sunlight — which is supported by the angle of the shadows. This acrylic was loosely painted on a Raw Umber ground. Note how the bright red garment also focusses the eye onto the three children.

need to add features to the faces of figures. This adds complexity and unless well handled can mar an otherwise successful picture. Most cityscapes can be painted with figures in the middle-to-far distance. Where it is necessary to add features to the face, again practice makes perfect and you will find it far better simply to add light and shade for eye recesses, nose and mouth, rather than get into detailed facial drawings.

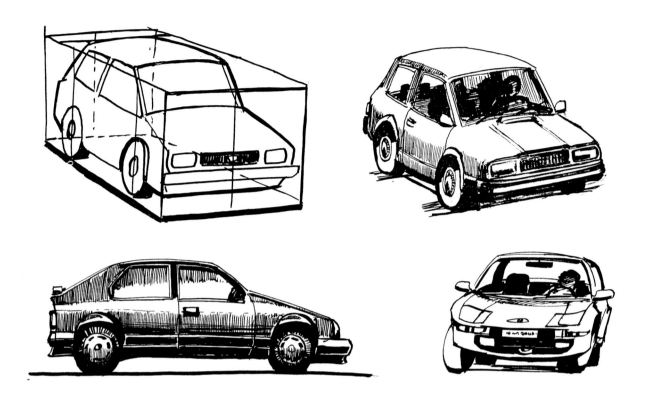

VEHICLES

Cars and trucks are a major obstacle to the enjoyment of painting in the city. Apart from the pollution aspects they often ruin the view, as they destroy the groundline of a row of buildings or shops, making it difficult to draw the scene in front of you and really detracting from the acceptability of the painting as few purchasers wish to buy a beautiful portrayal of a row of cars behind which is lurking a cityscape. There are avoidance tactics to minimise their effect, such as positioning yourself with a row of vehicles viewed from the front of the row — thus reducing ten cars to one with only a suggestion of others behind — or working in pedestrian areas or areas with restricted parking, or choosing times of reduced car density such as Sundays in business areas, or finding an elevated view to diminish the intrusion of the car into the painting.

Nevertheless the car will still appear and for realism it has to be painted. You must decide how important the accurate depiction of the car is to your painting. Does the fact that the car can be recognised as a 1985 Ford add or detract from your painting? or can the car be a generic 'eighties' or 'nineties' car? Fortunately for the artist, car styles are fast approaching uniformity and hence the opportunity arises for us to paint two or three generic styles which will pass for almost all makes of car! In the middle or far distance cars can be simplified into fundamental elements. Roof-line — bonnet (or hood) line — wheels — windows — and shadow on the ground underneath.

△From the approach to perspective shown earlier in the book the basic form of the car can be developed. Note how the wheels form ellipses according to the angle of viewing. The light *on the vehicle, as with the figure, has to relate to the overall lighting in the picture. Make sure that vehicle, people and buildings are to the same scale.*

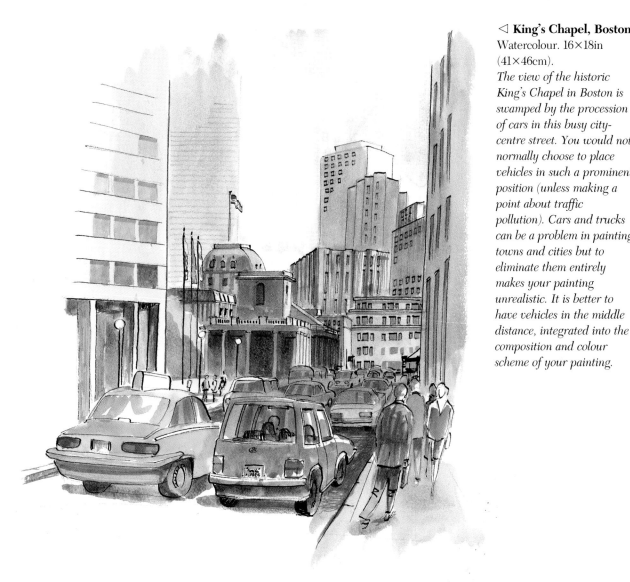

◁ **King's Chapel, Boston.**
Watercolour. 16×18in
(41×46cm).

The view of the historic King's Chapel in Boston is swamped by the procession of cars in this busy city-centre street. You would not normally choose to place vehicles in such a prominent position (unless making a point about traffic pollution). Cars and trucks can be a problem in painting towns and cities but to eliminate them entirely makes your painting unrealistic. It is better to have vehicles in the middle distance, integrated into the composition and colour scheme of your painting.

One of the easiest mistakes to make is on size and direction of travel. The car has to relate to the size of the street, the houses/shops/offices and the people in the painting. Can the person who is apparently at the same distance from the foreground in the painting get into the car? Is the car going uphill or downhill while the street is flat, or left or right when the street is not doing either?

Occasionally there are paintings you will see where the vehicle is a central feature of the scene: perhaps a New York taxi, a London bus or a derelict car in a run-down sector of the city. In these cases clearly the car has to be treated as a detailed 'still life'.

As with people much can be said about a car by the light striking the vehicle. Light hits the roof, the bonnet (hood) and the boot (the trunk). It will often reflect from the body just below the windows and perhaps from the wheel arches. The headlights will always stand out. Windows reflect or will be transparent showing the colour of the background through the car; they also show the structure of the car and other windows in the vehicle.

The placing of the vehicle in a painting has some features similar to placing figures. Both should be an integral part of the composition and should contribute positively to the painting, and not be obviously an afterthought. They can add a touch of colour in an otherwise monochromatic scene. They can help lead the eye to the focus of the painting, they can fill a dead spot with life. People can be, as in the Quincy Market picture, the principal focus of the painting, or contribute significantly to the character.

But while the viewer will be attracted by well placed figures in a landscape, the same is not necessarily the case for vehicles. Cars should be added sparingly to contribute to the painting but they are usually best kept as a supporting feature unless the painting has the car as the principal subject.

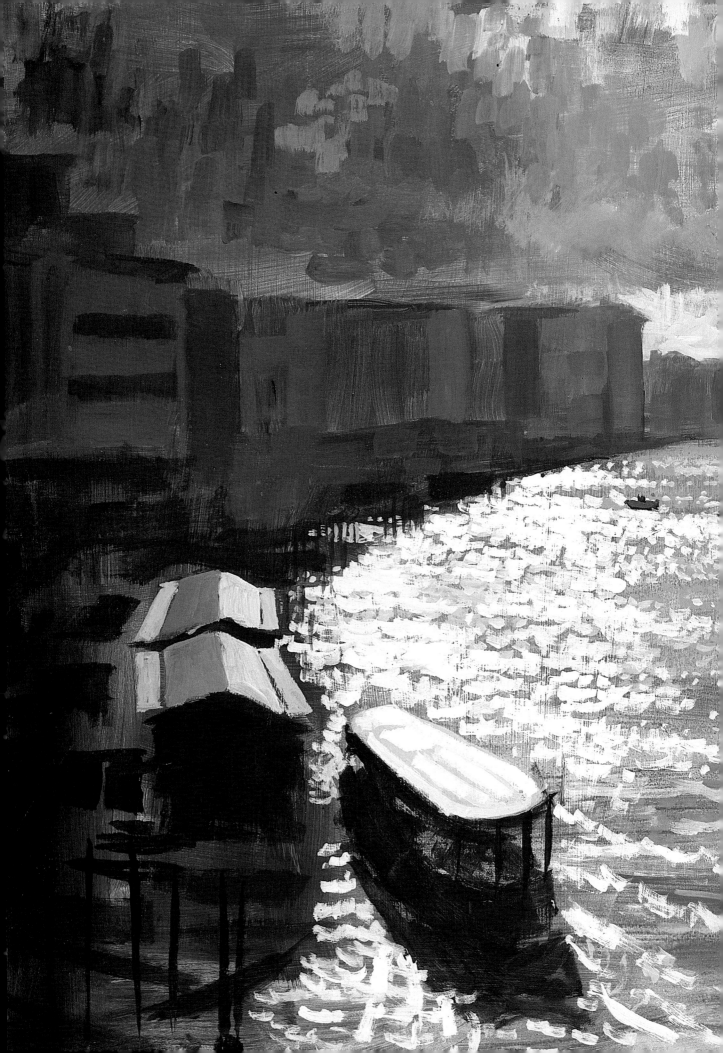

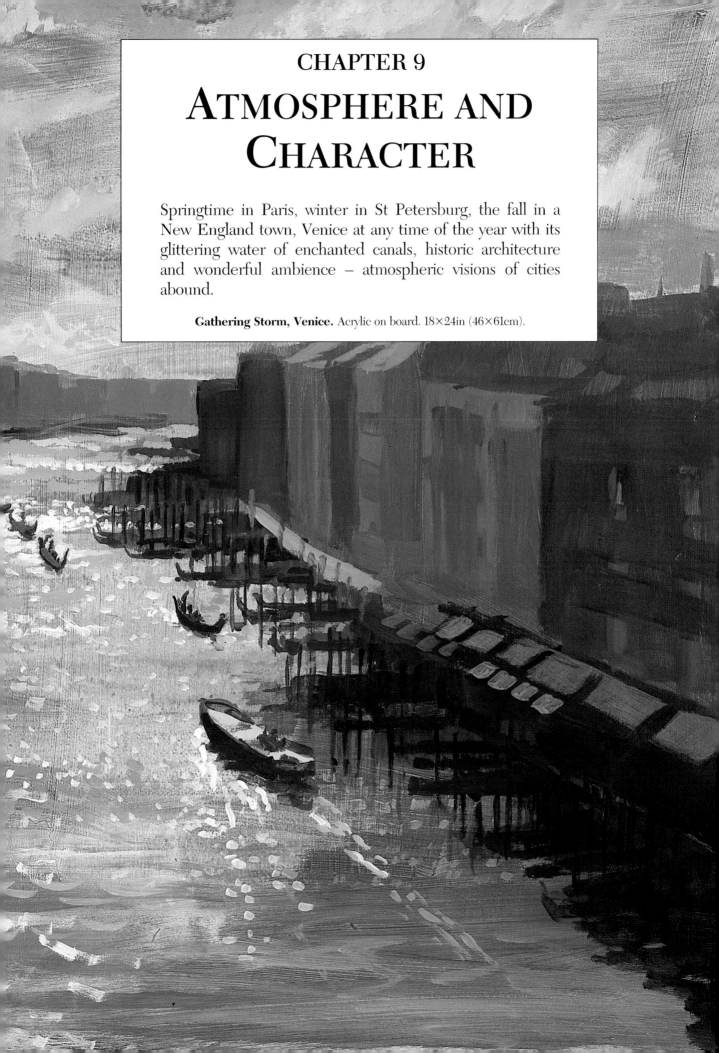

CHAPTER 9
ATMOSPHERE AND CHARACTER

Springtime in Paris, winter in St Petersburg, the fall in a New England town, Venice at any time of the year with its glittering water of enchanted canals, historic architecture and wonderful ambience – atmospheric visions of cities abound.

Gathering Storm, Venice. Acrylic on board. 18×24in (46×61cm).

▷ **Covent Garden, London.**
Acrylic. 18×24in (46×61cm).
The warm, bright lights contrasting with the cool snow were the focus of this painting. Reflections in the winter sky of the lights below are suggested by prominent square brush-strokes using cobalt, purple and white.

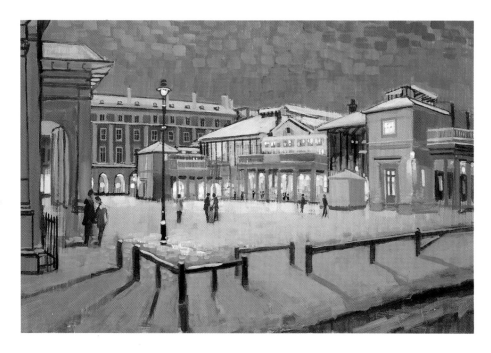

△ **Brixham Harbour.**
Acrylic. 30×20in (76×51cm).
The atmospheric effects of a late summer's evening are portrayed in this acrylic.

Painted on a ground of Cobalt Blue underpainting, the low sun and dimly visible backdrop of houses provide a theatrical effect.

SNOW SCENES

A key influence on the atmosphere in any city or town is the season of the year. In winter the impact of snow on a city is dramatic. The normal tone and colour balance is upside down, the sky often grey, the ground and roof-tops white, unusual contrasts are everywhere and patterns of light and shade can produce subjects for painters in abundance.

When it snows, try to obtain material for future reference. For part-time painters who travel to work, it is good practice to keep a camera in the office or workplace so that you can capture special effects in the town or city during breaks or when you finish. Sketch where you can: from home through a window, in the car with the heater running, or, as some hardy painters do, outside in all the elements with frozen fingers and watercolour washes which never dry!

Sunshine on snow can add sparkle and drama, as can night-time lights glistening on snow and creating patches of light and shade of great contrast. Look at the Impressionists' paintings of snow scenes. They had a fascination with colour in shadows in the snow, using blues, purples and greys to great effect.

In my painting of Covent Garden by night I was attracted by the fairy-tale atmosphere created by the warm sparkling lights coming from the Market Hall and surrounding buildings offset by the cool white snow, making an appearance of a palace of light and colour. The evening sky seemed to reflect back the glitter of the lights from the scene below transforming completely the Old Market Hall – once London's vegetable market and now full of restaurants, shops and boutiques.

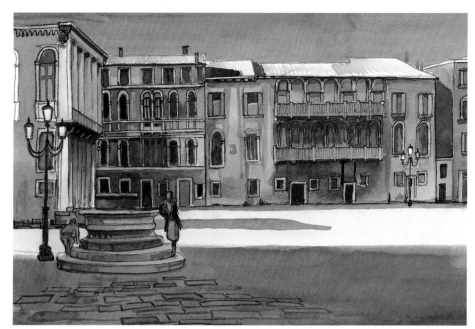

◁ **Venice.**
Watercolour. 12×16in
(30.5×41cm).
*In October in Venice the sun
is still quite hot but the
shadows are lengthening. In
this watercolour with pen
drawing added, strong
contrasts between light and
shade create the hot
atmosphere, aided by the
dark blue sky and light red
roof-tiles.*

The painting is an acrylic on canvas, using a Raw Umber ground thinly applied onto a white priming. The ground shows through in many parts of the painting. The buildings were drawn in boldly, using a Raw Umber/Payne's Gray mixture, many parts of the drawing remaining in the final painting. The composition could have been problematical with the vast expanse of the piazza, but the low barriers (to prevent vehicles entering) enabled the two sides of the picture to be linked. The strong horizontals in the composition being offset are the lamp-post and the tall portico of the church on the left.

In this type of picture, dependent on tonal contrasts between bright electric lights and the night-time darker tones, the use of a ground of middle tone is almost essential. This enables a proper range of tone from high to low to be established in the final painting.

Although I have often painted winter scenes from my car, including large 36×24in (90×60cm) paintings which needed contortionist antics to complete, in this case the parking was strictly controlled and in the wrong place so I resorted to a camera for the quick recording of the scene.

Figures in a painting have to reflect the season, with long overcoats and rather depressed postures in winter, while in rain the umbrella can be much in evidence. In summer bright colours, summer dresses, short trousers and figures in lively actions can all support a summer scene.

MOOD

In oils and acrylics, underpainting plays an important role in setting the mood of the painting. A blue underpainting, as in the painting of Brixham Harbour, produces a cool evening scene, the low angle of the sun strengthening the feeling of evening – the yellow colour of the light on the harbour dockside suggesting late summer rather than winter.

By using the light from directly behind the figures a theatrical effect is created, the fishermen being the leading players on stage under a spotlight, the backdrop being the harbour-side cottages of Brixham. The low-key tonal range provides an evening atmosphere. Thus many elements in the painting add up to the overall atmosphere.

Atmospheric effects have to be consistent throughout the picture, as in this case. Adding snow to a summer picture often looks just that – the summer colours, angle of the sun, high-key tones are all a giveaway that it is a summer picture with snow added.

SEASONAL IMPRESSIONS

In the Venice watercolour on this page, another atmospheric effect is demonstrated – the contrast between light and shadow in cities, which in summer can be very strong. The shadow is almost black, the sunshine on the piazza and roof-top very light. Even though the shadows are long the picture does not have a feel of winter – the strong contrasts in light and shade indicating perhaps late afternoon in summer or autumn, with a hot feel to the colours. The dark blue sky also indicates a hot climate in summer. In winter, skies are a lighter tone and a weaker blue in colour. Sunlight on clouds also helps to denote the season. Top lighting is indicative of summer, whereas in winter with a low sun the lighting is more usually from the side.

▷ **Gas Street Basin.**
Watercolour. 16×20in
(41×51cm).
Situated in the heart of Birmingham, Gas Street Basin is a reminder of the past industrial history of this city when it was the centre of an extensive canal system across the Midlands of England. The area is now subject to restoration but this painting has captured the derelict nature of the buildings, reflecting the rapidly changing scene throughout the heart of England's second city. The light and colours suggest a dull winter's day.

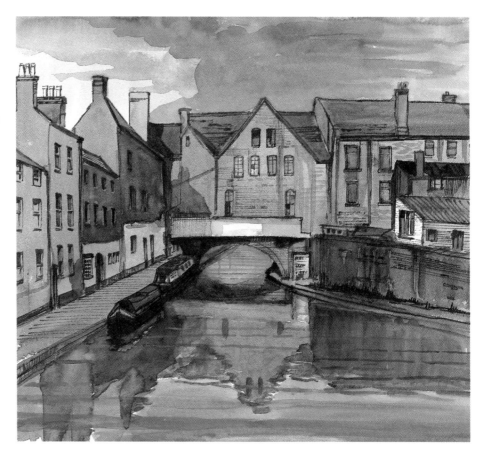

▷ **Misty Rooftops.**
Watercolour. 12×16in
(30.5×41cm).
A view of roof-tops and chimneys can provide an unusual and attractive painting with all the atmosphere of a misty dawn breaking across the city. The use of extensive washes and wet in wet painting has produced this rendering of an unusual view.

CHARACTER

The character of a city is often a complex mixture of elements from different parts: the dockside, the city centre, the ethnic quarters. Most cities are known by their central tourist sites but it can be more interesting in the back-streets. Similarly the history of a city is often revealed away from the hub — particularly the industrial heritage. The disused coal mine, old canal system or windmill will often point to a past very different from the present. One fascination of painting in towns and cities is to search out the hidden character or historical treasures and record them — creating, quite often, worthy paintings in their own right. The watercolour of Gas Street Basin opposite shows a part of Birmingham's past when it was a hub of the British waterways and canals. These old and dilapidated buildings surround a canal basin full of colourful narrowboats in an area which is being rapidly restored and developed. I was pleased to have recorded the scene before the place was entirely renovated.

You may find tucked away near you a view of roof-tops and chimneys which makes an interesting composition and provides a painting of character — sometimes reminiscent of the city. Particularly on a misty morning, as the sun is rising, such a painting will have all the mysteries of the city enveloped in the roof-top view.

The view below of Liverpool's famous waterfront viewed across the Mersey river in the early morning attempts to capture the mood of the dawn sky and the city awakening to another day. The small ferry boat adds to the scene — everyone who has had any connection with Liverpool has memories of the ferries across the Mersey. Character exists in the eye of the beholder — the residents of Liverpool will have a different viewpoint from the visitor — the worker a different viewpoint from the student — the painter probably a different viewpoint again. You would expect the painter to be highly influenced by the visual and the atmospheric effects in the Liverpool painting. But painters differ, thank goodness — each will have his own unique view and interpretation of the character and atmosphere in town or city.

▽ **Morning View Across the Mersey.**
Acrylic on board. 18×24in (46×51cm).
A famous view of Liverpool from across the Mersey, showing the dawn breaking behind the well-known Pier Head buildings. Painted in acrylic this picture not only portrays the atmosphere of dawn but also attempts to illustrate the character of the historic Mersey river which has played a dramatic role in Liverpool's past.

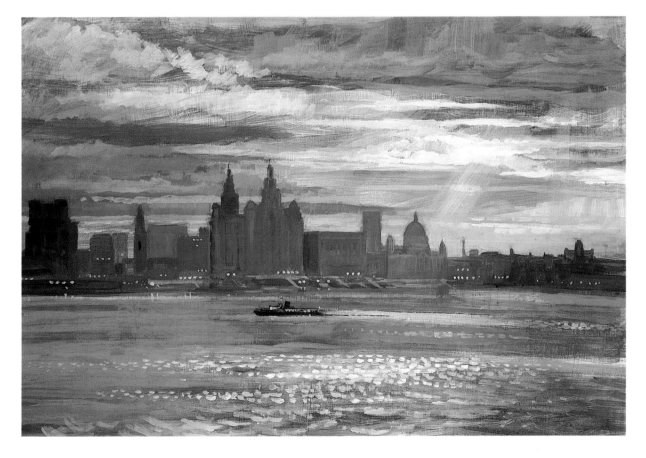

CHAPTER 10
REFERENCE MATERIAL

The sketchbook is the most important piece of equipment in any artist's kitbag. Practising drawing should be the daily diet of any serious painter, who should ideally keep old sketches and photographs in a library to provide inspiration for paintings in the future.

◁ *Architectural details such as in this sketch of Pembroke College, Cambridge, can help to build an understanding of features relating to different periods or provide material for finished pictures.*

▽ *Sketches for reference can include notes on colours and textures to be used in the studio later to complete a painting. For buildings with complex details a photograph can record quickly the complicated elements for later reference.*

▷ *Great value can be gained from keeping a sketch-book. On the page opposite is an indication of the types of reference material which can be jotted down while on site. Ranging from small details to landscape sketches, the use of the small portable watercolour box enables colour to be easily added.*

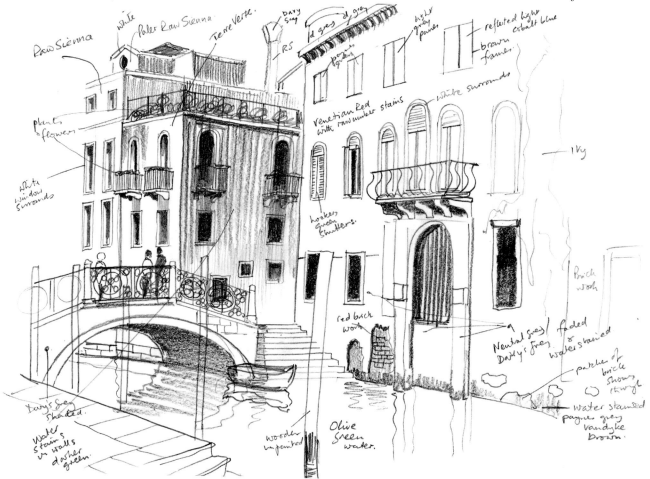

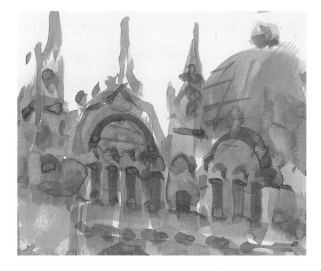

Neil Murison produces sketches in watercolour as well as acrylics. These provide an insight into composition and colour of potential pictures. Painted onto mounting-boards, these sketches form a valuable preliminary assessment before he commits himself to a full-scale painting.

Sketching in the city is a fundamental part of painting towns and cities. The camera is also a valuable supporting tool to be used with care. The traffic and the general hubbub in city streets make some views impossible to paint on the spot, or even on Sunday or sitting in your car.

Sketching in the city can be a joy in itself even if the sketches are not required for later paintings. A sketch-book can also provide a memorable record of a city in all its variety and detail, as will be seen in the next chapter's account of visits to Cambridge, Boston and Vancouver.

The sketch you make will differ according to the end use of the sketch. If it is a note of an interesting piece of architecture, a postcard of a visit or simply for the enjoyment of sketching, then use whatever medium or paper suits and try to be free and loose with the handling. For taking notes leading to a painting you will need to be more precise and accurate, in order to provide the information you may need for the later painting. Add notes to the sketch to indicate colour. It helps if you know well a particular range of colours as you can pin-point precisely the colour required. Tones can be part of the sketch; you need to indicate comparative tonal relationships. Keep your sketch-books to browse through in the future and quite often you will see something to inspire a painting.

MOBILITY

With the small watercolour boxes which can be tucked into a pocket the opportunity exists to make coloured sketches almost as easily as drawings. You can also obtain small watercolour boxes with their own reservoir for the water and a built-in dipper, which makes for even greater portability. Small watercolour or pen and wash drawings can be delightful and you may find that if you frame them they become highly desirable pictures in their own right. Get used to keeping a small sketch-book in your car or office so that when conditions are right you can quickly be in action, sketching a particular scene which is ideal for a painting. The small watercolour sketches of Venice by Neil Murison make beautiful pictures when mounted and framed.

USING THE CAMERA

The camera is a seductive piece of equipment which looks too easy for providing information for painting. Sometimes it can be the only method of obtaining information for, say, a commission which requires a specific view of a part of a city or individual building which otherwise would require you to be in the middle of a road! Cameras are now extremely user-friendly,

with auto-focus, auto-exposure, and so on. The only requirement is for you to compose the picture in the viewfinder and shoot. However, you will find that problems ensue. Many modern compact cameras have a wide-angle lens fitted as standard. While this is excellent for getting more of the happy wedding party into the picture, in the city it is a menace. It throws buildings that are in the medium distance far away, increasing the length of streets by an amount which if copied into a painting will be quite unrealistic. Wide-angle lenses can also distort verticals in close-ups of buildings, resulting in a totally inaccurate portrayal of the city in question.

However it is sometimes impossible to get sufficiently far away from the subject to get all of the target into the viewfinder without wide-angle. In these cases multiple shots overlapping each other on a standard 50mm focal length, which are then glued together, will provide a truer image of the subject. If you have exposure control you will be able to avoid the abrupt changes of exposure which an automatic camera will produce in such a multiple shot (a manual camera will not suffer from this problem).

The sequence of photographs on the right illustrate the multiple shot. Telephoto lenses on the other hand will collapse distances and again distort the subject.

The camera can be used creatively to inspire new approaches, and sometimes 'mistakes' in over- or under-exposure produce wonderful misty or dark photos. These can suggest all types of different approaches to painting. Occasionally it is worth taking the 'impossible picture' — directly into the light or in a dark corner of the room, or with impossible compositions — all foreground, no horizon — hopefully to create that happy accident which will inspire a creative painting.

Reference material from sketches or photographs can include people, vehicles and other street objects — or cranes, boats, aeroplanes, animals, birds — anything which you may wish to include. It is best to have a filing system to be able to retrieve the photos or sketches when you need them.

The three photographs right demonstrate the problems of focal length in obtaining accurate reference material. The top photograph is a wide-angle 35mm, the second, 50mm and the third, 80mm. The wide-angle throws the objects away from the camera giving false impressions of distances.

Most small automatic cameras have standard lenses of 35mm (which no doubt are intended for general family snapshots). If it is impossible to include all the subject without using wide-angle then a multiple shot as shown right is preferable.

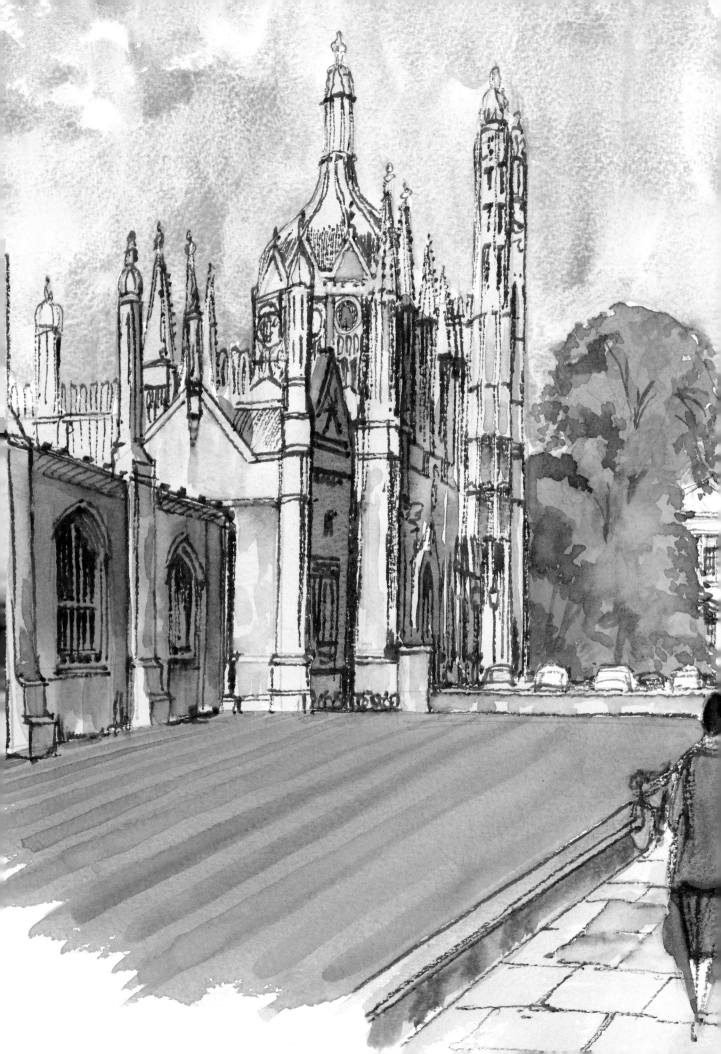

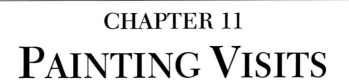

CHAPTER 11
PAINTING VISITS

There are many facets to the character of a great city. On a short visit the painter can only hope to catch an initial impression. In this chapter I have included my own impressions of three beautiful cities visited recently – Cambridge, Vancouver and Boston – with examples of subjects chosen and the sketches or painting techniques employed.

King's College Entrance. Pen and wash, 16×20in (41×51cm).

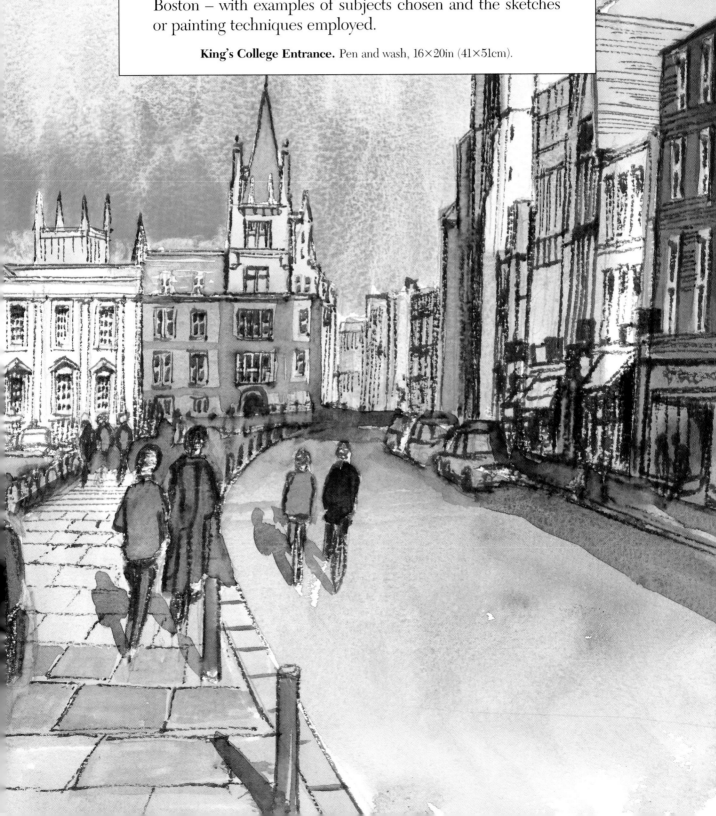

A VISIT TO CAMBRIDGE

Cambridge is an elegant university town famous throughout the world for its academic prowess — and its spacious historic architecture set in green lawns and alongside river-banks.

At the same time Cambridge is a bustling regional centre with throngs of students, shoppers and tourists filling the small back-streets and the ancient cloisters. Yet it is easy to find a quiet corner to sketch or paint uninterrupted. The previous page shows the entrance to King's College on the left, with Gonville and Caius College at the rear and an example of the many immaculate Cambridge lawns in front of the colleges. This painting is a watercolour to which has been added a drawing in brown ink using a calligraphic felt-tip pen, and was completed in the studio from sketches and photographs.

My visit to Cambridge in the late spring was perhaps typical of a painting and sketching trip in England,

with sunshine and showers requiring some rapid mobility and the use of opportunities to paint or sketch under cover whenever possible.

In one of the sunny spells I completed the watercolour of the famous King's College chapel shown below — this must be one of the most elegant buildings in the world, situated in vast lawns running down to the edge of the river.

I preferred this view to the more usual scene across the river as I particularly liked the blue misty appearance behind the trees and the gate of the path leading across the Backs. I painted this directly (with no preliminary drawing) in order to retain the freshness and spontaneity of the scene, using Ultramarine and Cobalt with touches of Crimson for the buildings. The shadows across the path link the picture together and create a sense of aerial perspective, drawing your eye into the picture.

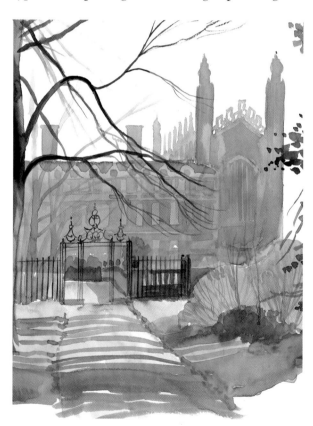

△ **King's College Chapel from the Backs.**
Watercolour. 10×12in (25×30.5cm).
Painted directly without prior drawing this sketch *emphasises the misty coolness of a late spring morning, with the warmth of the path contrasting with the coolness of the buildings.*

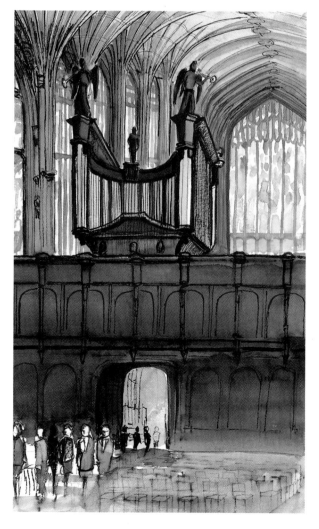

Fortunately I had almost completed the painting when the rains came and I had to beat a hasty retreat into the chapel itself — where, after getting permission, I started sketching the impressive organ on top of the wooden screen dividing the nave from the chancel. I would have preferred to paint the famous altar but could not find a suitable place to sit — and there were many tourists passing through that area.

I usually find locations where I can paint relatively unaffected by spectators but on this occasion had to contend with large numbers who at one time completely encircled me. The sketch was therefore rapidly concluded. I used a black felt-tip on Cotman 140lb with light washes of watercolour depicting stone and windows.

Cambridge is entirely flat and an ideal terrain for bicycles, which the students ride in their thousands. In the late afternoon the bicycles and pedestrians were silhouetted on the road (within a restricted vehicle area). As I have already indicated, I am fascinated by the effects of the light when looking into the sun and thus was excited by the halo effect around the people in the road. I took a photograph to catch the people and sketched the view noting the tones of the surrounding buildings.

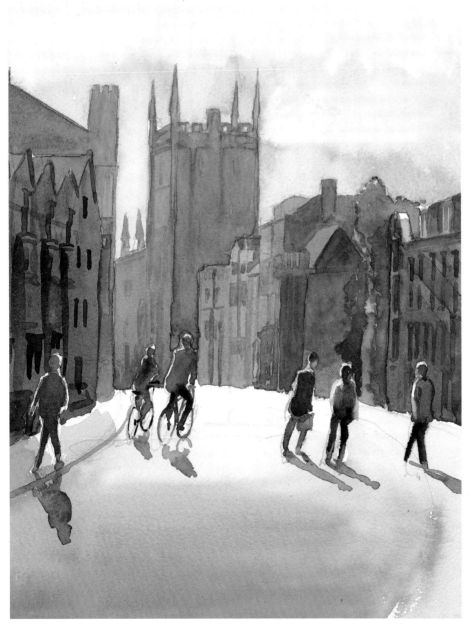

◁ **Trumpington Street, Cambridge.**
Watercolour, 8×10in (20×25cm).
With dramatic backlighting the ever-present cyclists and students are silhouetted against the light. With this type of lighting the tonal control is essential, with the darkest tones reserved for the figures.

◁ (Opposite) **Interior, King's College Chapel.**
Pen and wash, 10×12in (25×30.5cm).
On a rainy day the inside of buildings makes a useful refuge with often inspiring subjects. The fan vaulting of this famous chapel is especially fine and the central organ feature makes an interesting subject.

At this point I was quite pleased with my visit and had seen many opportunities for further sketching and painting. The next day the rains came again and I retreated into the bowels of one of the older colleges in Cambridge, Corpus Christi — where fortunately my daughter had a room at the time. From her window I was able to tackle the opposite corner of the quadrangle, which I gather is the entrance to the library — the attraction of the view was not only the architecture of the college but also the view of Cambridge over the college in the background. I painted a strong wash of colours onto 140lb Bockingford paper, keeping where possible to an outline sketch but leaving white paper showing to maintain some freshness in the work. I then applied brown and black ink over the painting in a bold fashion (correcting errors of drawing where necessary), to create a strong spontaneous feel to the composition. I was pleased with the outcome — an unusual view and, considering the rain was falling at the time, a productive use of a wet morning, although perhaps not so productive for my daughter whose studies had been disrupted by her artist father commandeering her room!

You should always seek out the unusual as well as the well known views. I was lucky to spot the Corpus Christi opportunity of the corner of the quadrangle and there were several other such views, looking through archways, under bridges or in college courtyards, which would have given similar sketches.

I wanted to capture a wider context of the city of Cambridge so I proceeded to walk around the city — it had stopped raining but was overcast. There is a city market in the centre with one of the many Cambridge churches forming a backdrop. I was able to sit quietly in a doorway to produce a drawing of the market shown opposite.

Peterhouse College entrance caught my attention, and again I was able to sit in a corner unmolested by tourists or students and produce a quick sketch of this elegant and unusual gateway.

The centre of Cambridge has a maze of small streets and shops. Often at the end of the street a college tower or spire reminds one of the town-and-gown nature of the city. I found one such street where the white and coloured fronts of the cottages curved down the narrow street with the tower — not of a church but of the Cambridge University Press forming an elegant backdrop to the view.

Finally I went to the riverside, where in summer hundreds of punts are moored and students making some money in their vacations punt tourists along the backs of the colleges and through the meandering waterways between green, well kept lawns. In the spring before the punting season started a solitary punt

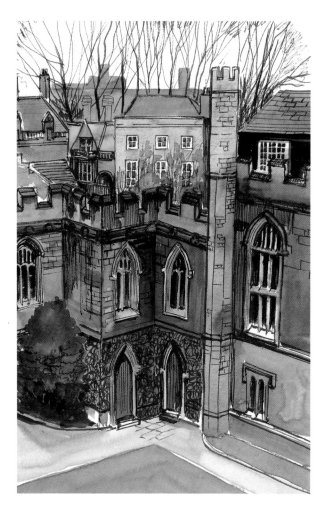

△ **Corpus Christi College.**
Pen and wash, 18×16in (46×41cm).
Painted from a room high in the college overlooking the quadrangle, this unusual view contrasts the houses outside the college with the more elegant stone surroundings of the quadrangle.
The line work was added to the base watercolour using a calligraphic pen.

rested — the water reflecting the bright sky beyond. This was the ideal subject for an acrylic sketch which was rapidly completed, using a Neutral Grey underpainting on a small board primed with acrylic primer. From my all too brief visit I had started to obtain a feeling for this most beautiful spot, almost cut off from reality with its regal spires and towers and fresh-faced students pedalling from lecture or laboratory to halls and houses. I had started to learn its history, was overwhelmed by its architecture and above all wanted to bring my paints and sketch-book back to spend more time in this most beautiful setting and enjoy again the peace and serenity of courtyards and riverside.

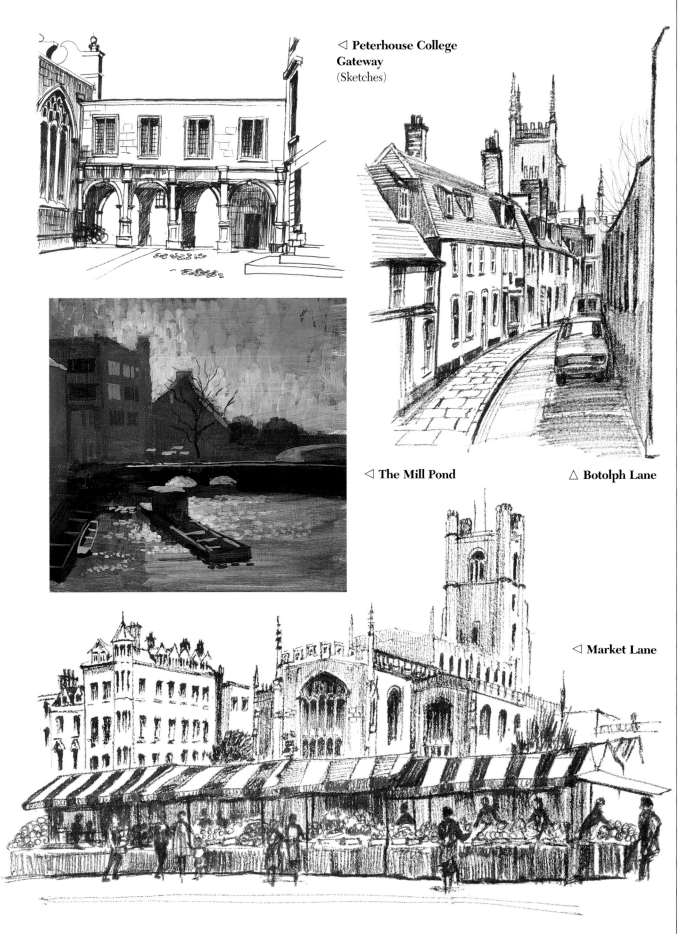

◁ **Peterhouse College Gateway**
(Sketches)

◁ **The Mill Pond**

△ **Botolph Lane**

◁ **Market Lane**

A VISIT TO VANCOUVER

Vancouver is one of the most beautiful cities in Canada. A spectacular coastline with many rocky inlets and pine trees is backed by towering mountains, snow-covered in winter. The harbour extends into the city with the centre of Vancouver rising from the waterfront. Since Expo Canada in 1986 the skyline of the city has been enriched by the sail-like profile of the hotel and exhibition centre which formed the Canadian pavilion at the exhibition.

With dramatic skies and calm waters the city provides panoramic, dramatic vistas by day and night.

In the watercolour painting I have tried to capture the changing colour and light of the famous waterfront view as seen from Stanley Park.

Vancouver has water on several sides. I stayed in an apartment twenty-two floors up overlooking English Bay, a wide clean stretch of water which included twenty or more large ships at anchor waiting to move into the Vancouver docks. The bay has a lengthy beach and promenade and the fortunate apartment dwellers can within minutes be promenading along the shore of the Bay. All the waterside beaches have large tree-

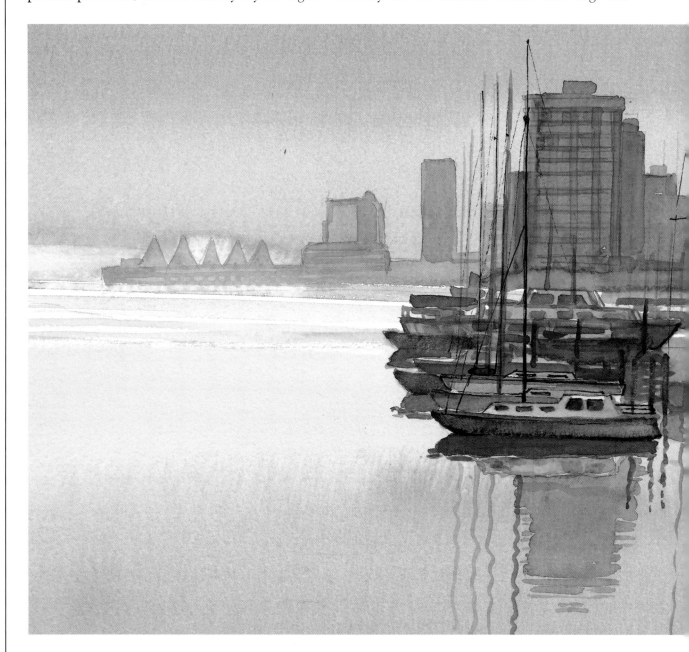

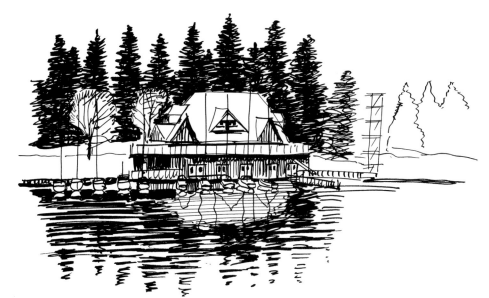

◁ **Vancouver Rowing Club.**
Sketch.
Set against the fir trees of Stanley Park, this clubhouse makes an interesting subject for a quick sketch.

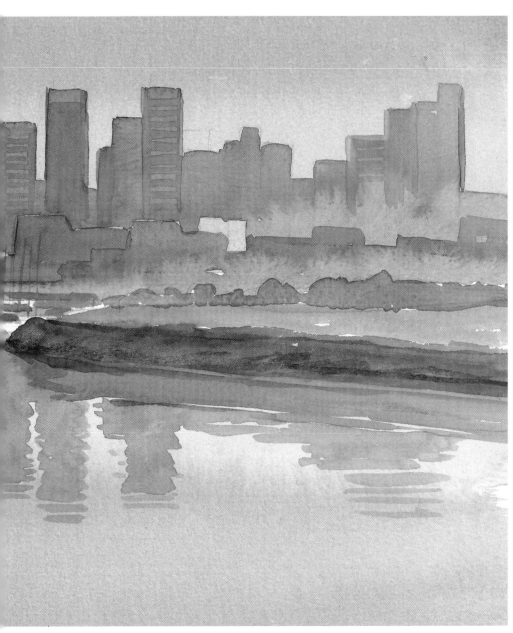

◁ **Vancouver waterfront.**
Watercolour, 16×20in (41×51cm).
Few cities have such a dramatic view which is so accessible for the painter as Vancouver. The harbour and waterfront run alongside the city centre and on a calm winter's day the reflections of the modern skyline in the harbour make an attractive waterfront painting.

The sky and water were washed in using the same wash, with buildings, boats and foreground added later. The tonal relationships were critical to achieving aerial perspective.

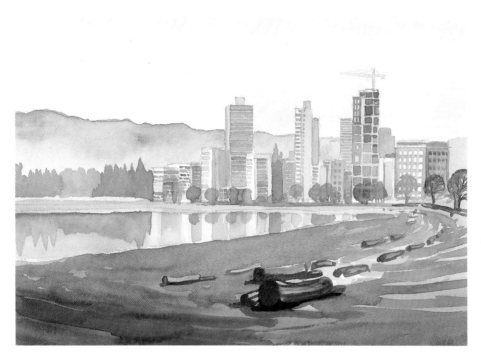

◁ **English Bay, Vancouver.**
Watercolour. 12×16in (30.5×41cm).
A misty winter day is represented in this watercolour from the beach of English Bay near the centre of Vancouver. The use of a soft pencil drawing and restricted tonal range produces an overall softness and misty feeling to represent the atmosphere of the day.

trunks and logs washed up onto the shore — from the vast logging operations further up the coast. In my watercolour these can be seen in the foreground.

I chose a soft watercolour to capture the misty winter scene on the shore. The crowded skyscrapers line the promenade, with more being built and squeezed into the area, each vying with the other to provide waterfront views from the apartment windows. Returning to my twenty-second floor I spent two hours painting the view, which to an artist from a provincial English city is, to say the least, unusual.

When I visited Vancouver the winter was unusually mild with no snow on the mountains and a permanent bank of low cloud which usually kept the mountains hidden. I painted the aerial watercolour at a time when the mountains had reappeared but the clouds still rested ominously below, ready to roll back over the city at any time. Painting tower blocks poses problems of perspective and handling. Should you detail each window — suggest the windows and structure — or leave each block in a sculptural shape? — it is really a decision which relates to the total picture and your objective in first tackling the subject. My reason for painting the view from the twenty-second floor was the novelty — but also to try to convey the space and character of these tall towers sprouting out of the city-street level, making a pattern of man-made intrusion into the mountain and mist of British Columbia.

It is a subject and view I could paint many times with totally different results in oils, acrylics and watercolour. Vancouver has much to sketch: it has its old traditional streets — Gas Street and surroundings — rescued from the bulldozer and skyscraper

developments and restored to provide visitors with some inkling of the history of this great city. A tourist attraction is the steam clock billowing clouds of steam across the street, a constant source of amusement and interest to camera-toting visitors. Gas Street also has a fascinating collection of boutiques, galleries, gift shops and restaurants — with, ever present in the background, the towering reminders of modern downtown Vancouver. The strange art deco building of the Hotel Europe on the edge of Gas Street provides a dramatic corner building and an innovative design solution from the days before building everything of steel and glass brought a uniformity to city-centre architecture. The shopping-streets of the city were crowded, busy places and the sketch was recorded on a bench seat. These sketches were quickly produced using calligraphic felt-tip pens and a pad of cartridge paper.

Vancouver has a lively arts and craft movement, with some well known Canadian artists based in the vicinity. Much of Canadian contemporary painting is focussed on wildlife or the dramatic landscapes of Western Canada.

Close to downtown Vancouver is a centre for arts and crafts: Granville Island. Situated under a major road bridge the island is a hive of activity with studios, workshops, galleries, shops, a market hall and restaurants. When choosing places to sketch the towering presence of the steel structure of the bridge was a dramatic challenge. I found a spot where a composition was created showing Mulvaney's Restaurant and other buildings dwarfed by the sheer scale of the bridge. The composition consists of a complex of triangles. The buildings forming a solid base on which

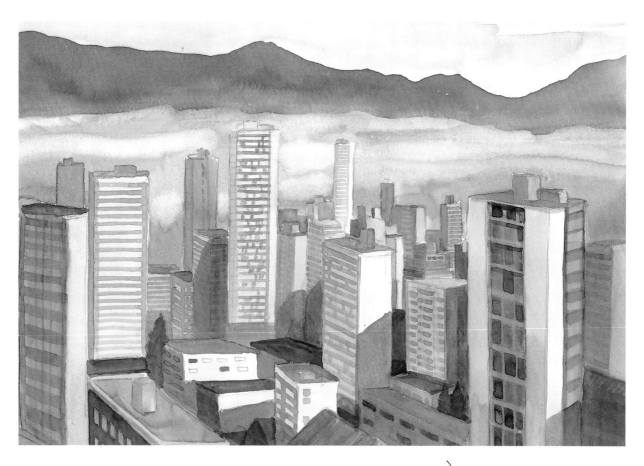

△ **Aerial View, Vancouver.**
Watercolour. 12×16in (30.5×41cm).
Painted from the twenty-second floor, this unusual view poses certain problems of handling the tower blocks — how much detail should be included, what amount of vertical perspective should be used.

It is always interesting to try different angles for developing your experience in sketching the city.

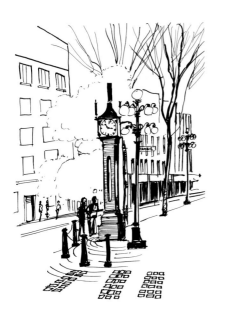

Sketches of Vancouver.
The sketches of Vancouver on this page include the steam clock in Gas Street, the Europe Hotel, and a fashionable shopping street. All are aimed at recording unique aspects of Vancouver's character.

the curves and triangles of the bridge could rest. The vertical edge of the bridge leads the eye into the structure of girders which themselves form a frame for Mulvaney's Restaurant. With a composition as unusual as this one never knows whether the end result will succeed but I was quite happy at the outcome. I used a strong pen-line to emphasise the lines of the steel girders. A subdued colour wash was added, not only because of the winter season but also to emphasise the essentially linear nature of the sketch. In the dark hut-like building shown to the right of the picture was a hand-loom where a lady produced beautiful woollen cloth of soft blues and greens.

I could have stayed much longer on Granville Island, with many other subjects for sketching and lots of arts and crafts to explore. Travelling back to the city by the little ferry from Granville Island provided the spectacle of the lights of the city in the evening reflecting on the water with the bridge silhouetted against the sky — another subject for a future painting!

On New Year's Day we travelled to Vancouver Island via a long ferry-crossing, with magnificent scenery and a close encounter with a pod of killer whales lazily making their way between the Gulf islands. Victoria on Vancouver Island is the capital of British Columbia and the site of the provincial

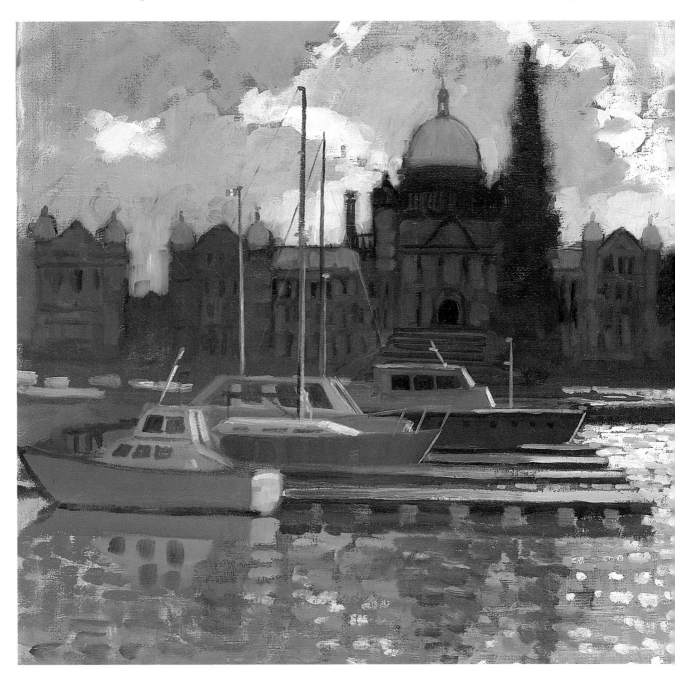

government. It was cold in Victoria Harbour but the impressive legislative building with its green domes, overlooking the ships in the harbour, was a sketch I could not miss. I sat with numb fingers sheltering from the wind and painted into the light, with the building silhouetted and light sparkling on the water.

The sketch was started in watercolour but, with long drying times and increasingly cold fingers, it was finished with a ball-point pen to capture the details. However, it was enough to create an oil painting back in my studio in England. The oil painting kept quite closely to the sketch, the composition being the same, the principal development being the sky which from my memory of the scene was more dramatic in cloud formation than I was able to convey in the sketch.

A vigorous cloud structure adds life to the picture. It helps the atmosphere of winter and also provides a clear indication that the sun is behind the building, thus being consistent with the rest of the painting. A low tonal range with blue as a predominant colour added to the wintry feel. Two spots of bright red added a touch of colour, the Canadian flag at a masthead and a lifebuoy on the deck of the nearest boat.

After a short stay on this delightful island with great hospitality, some wonderful scenery and a very English atmosphere, it was time to return to London.

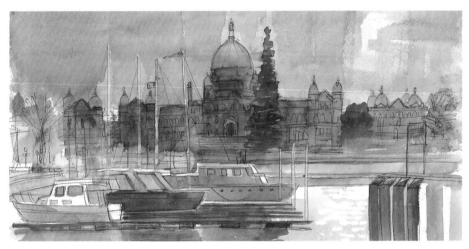

◁ (Opposite) **The Legislative Building, Victoria, Vancouver Island.**
Oil on canvas. 20×24in (51×61cm).
On a very cold New Year's Day, the sketch above was hastily drawn using watercolour and a ball-point pen. Masking fluid was needed to create the highlights on the water. In the studio the oil painting opposite was created from the sketch with the winter sky more dramatically emphasised. Note the touches of red in the boats to add focus and interest.

◁ **Granville Island, Vancouver.**
Pen and wash. 16×12in (41×30.5cm).

A VISIT TO BOSTON

A city with historical connections and yet modern and successful, Boston is a most attractive place to visit with lots to interest the painter.

Located around its famous waterfront, Boston towers over the bay with a cluster of modern skyscrapers in the midst of which is the nineteenth-century customs tower.

I painted the city from the water's edge on a very hot July day with the temperature over 30°C. The skyline of downtown Boston was outlined by the intense blue sky with the quayside reflecting an almost white glare. Behind me ships and boats scurried back and forth around the harbour.

The tourist hub of the city is Quincy Market, with Faneuil Hall and its golden dome standing at the end of the square. The market buildings are a hive of activity with all types of traders selling pizzas, ice-creams, gifts and foodstuffs with the surrounding buildings full of elegant shops and restaurants. A mecca for tourists, Quincy Market is fortunately well

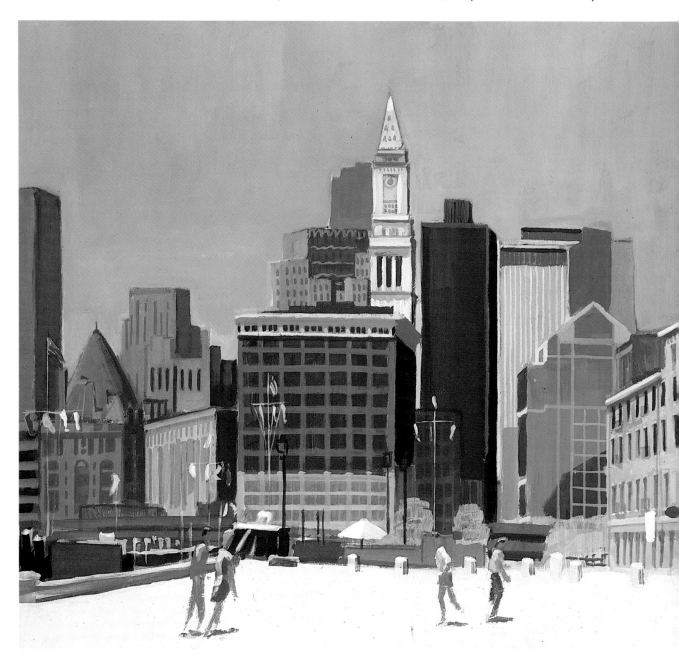

▷ **Quincy Market, Boston.**

Watercolour. 16×12in (41×30.5cm).

The tourist centre of Boston, Quincy Market has a central market building surrounded by cobbled piazzas with trees and benches. The pattern of light and shade was attractive with Faneuil Hall at the end showing through the trees.

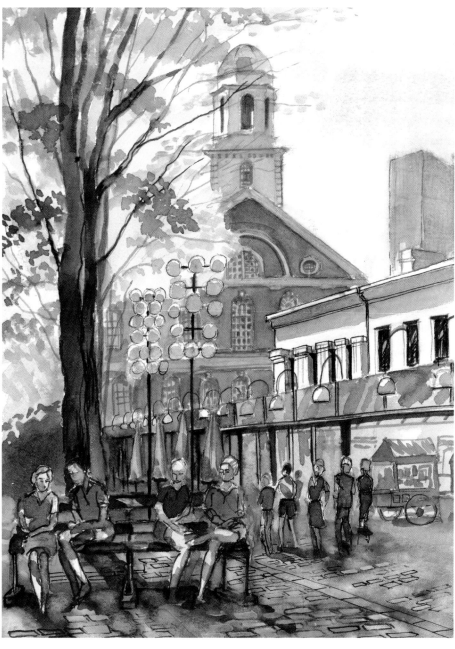

◁ **Boston from the Waterfront.**

Acrylic on board, 18×24in (46×61cm).

My objective in using acrylic for this view of Boston was to capture the strong colours and stark outlines of the city on a hot summer's day.

endowed with trees which provide welcome shade on a hot summer's day. Benches are provided throughout the square and are usually filled with visitors eating ice-creams or take-aways or simply resting and watching the world go by.

The benches provide an excellent sketching location and the watercolour above was completed looking towards Faneuil Hall — the shade of the trees providing a fascinating pattern of light and shade across people and cobblestones. The location was so pleasant and easy to sketch that I completed several pen-and-ink sketches and some more watercolours. There is much more to Boston than Quincy Market so I followed the 'Freedom Trail' for a part of its way

around the city. This route takes the visitor to all the most historic parts of Boston with its connections with the Boston Tea Party and the start of the war with the British.

Old South Meeting House (shown far right) was the gathering-place of the plotters before the Boston Tea Party. I chose a view with the light behind the church primarily because it was the most convenient view-point — it provided an interesting pattern of lights and darks in the foreground which contrasted with the cool tower blocks behind the church. Downtown Boston is a business hub with well dressed business executives hurrying hither and thither and mixing with camera-wielding tourists, sellers of frozen yoghurt and ice-cream and the odd artist like myself! Just outside the business centre is the State House: this impressive building has a dome covered with gold leaf which shone and glistened in the bright sunshine. Opposite is a large park which provided shade and rest for many who wished to escape from the heat of midday. Even in those temperatures the inevitable joggers sweated their way through a lunchtime fitness tour of the park.

△ **Quincy Market.**
Sketch.
The pen-and-ink sketch used a black felt-tip calligraphic pen on Montval 130lb watercolour paper. Sketched from a gallery overlooking the market, the raised viewpoint makes for an interesting sketch.

◁ **State Capitol Building**
Sketch.

▷ **Old South Meeting House.**
Watercolour. 20×16in (51×41cm).
The Boston Tea Party was planned in this building. This watercolour contrasts the straight mechanical lines of the tower blocks with the elegant spire of the church and the trees in the square.

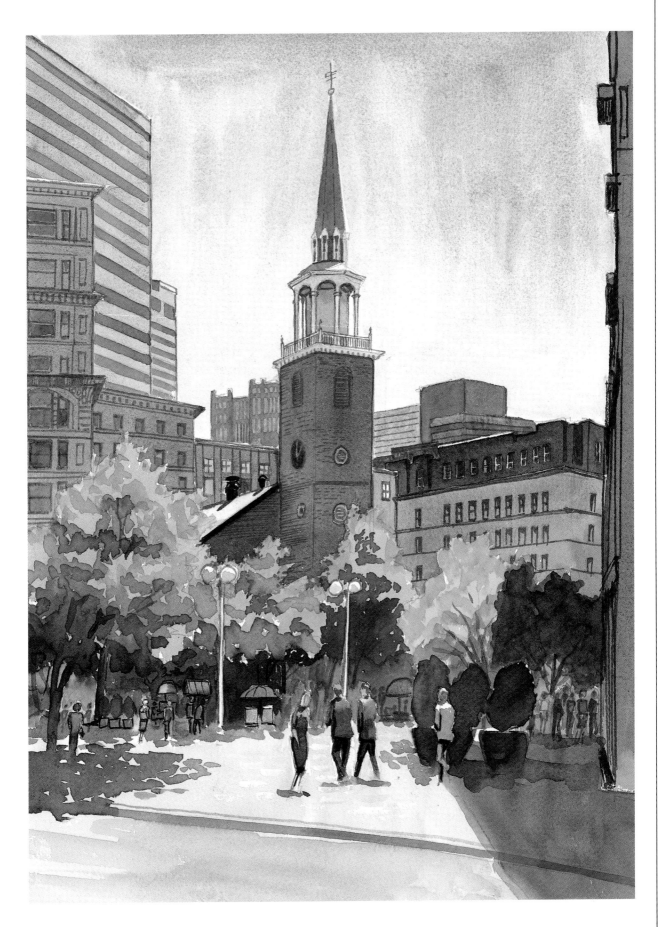

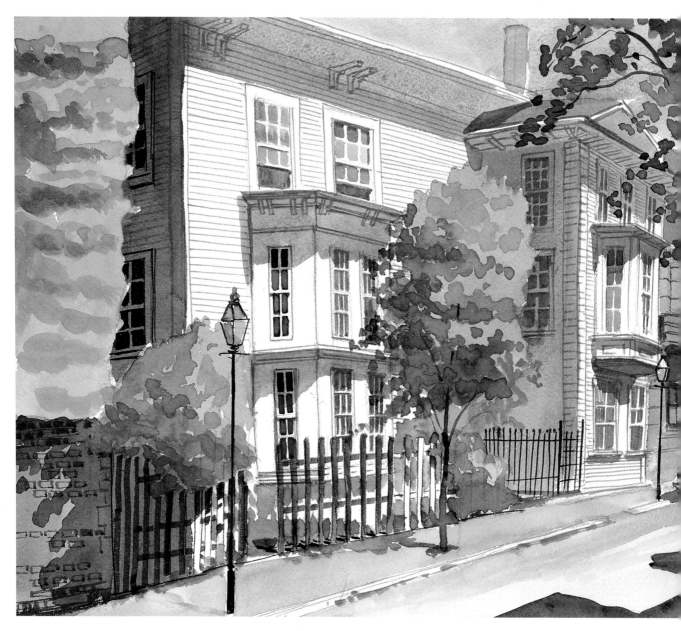

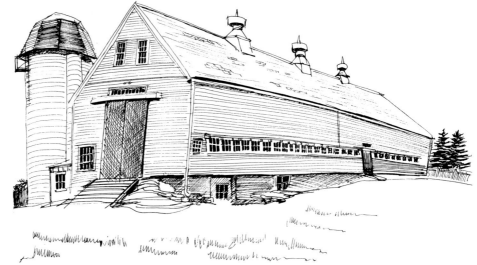

△ **Houses on Pinckney Street, Boston.**
Watercolour. 16×20in (41×51cm).
Boston has many historical streets with elegant traditional houses in clapboard and brick. Shadows in this painting indicate that the sun is high overhead with strong contrasts between light and shade. The pen-drawing on top of the watercolour is valuable to emphasise the clapboard construction.

'PAUL REVE

Boston has many interesting architectural details such as the windows at the top of the page. Clad in a cuprous metal the windows had a green coloration, with elegant decorative motifs. Paul Revere is the folk hero of Boston's history. His statue is a focal point on the 'Freedom Trail' incorporating many historical buildings.

A traditional New England barn at Applewood Farm, Hampton Falls, illustrates the size and elegance of the early farm architecture still to be seen in rural New England.

A few hundred yards further and one enters the ancient Beacon Hill quarter, now the home of the wealthy Bostonians. Narrow tree-lined streets contain elegant clapboard and brick houses. Lovingly restored, each house is a memorial to the early inhabitants of this thriving seaport. The houses on Pinckney Street (left) I sketched sitting in the shade of the trees and tried to capture the cool elegance of the white clapboards in the bright sunshine. Painting on a Cotman Montval 140lb paper I completed a brief pencil outline, followed by the watercolour and completed by a pen drawing on top. There are many interesting details around Boston, including the windows of many of the old houses, which have a cladding of a copper-based material which gives a beautiful green patina to the surface. The sketch above was drawn in North Square, where Paul Revere's house has been restored and converted into a museum.

A statue of Paul Revere on horseback, commemorating his famous ride, is situated in a tree-lined walkway behind North Street Church (which was also a famous building of the revolution). A quick sketch using the calligraphic felt-tip provided a reminder of the history of the revolution and Boston's famous ancestor.

New England is a delightful part of America and its scenery is not unlike some parts of England, making it an attractive spot for British tourists. I visited Portsmouth and Newburyport during my stay, and made sketches of their splendid traditional clapboard and brick buildings. There are some beautiful barns, one of which I have included: Applewood Farm, Hampton Falls. These very large wooden structures, built by the early farmers of New England, sheltered the cattle, hay and foodstuffs from the cold New England winters. Altogether Boston and the surrounding country make a great visit for the painter, and I believe the colours in the fall are quite stunning, so I am planning my next trip already!

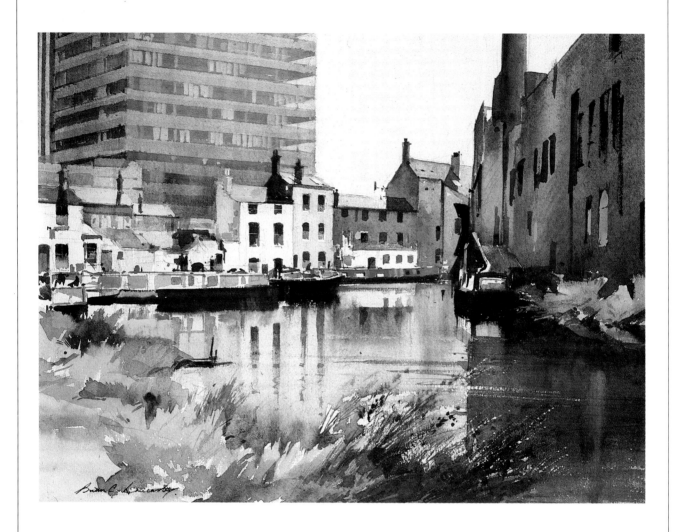

△ **Gas Street Canal by Brian Lancaster.**
Watercolour. 12×16in (30.5×41cm).
Brian Lancaster paints crisp watercolours which exhibit precise draughtsmanship but do not become tight. His washes are very clean with a single wash of the correct colour and tone providing a translucent clarity. In this canal-side scene Brian has focussed on the houses and barges but his inclusion of the office block in the background indicates a city-centre location for the picture. Note how the loose treatment of the foreground helps to enliven the painting.

△ **The Watershed by Neil Murison, RWA**
Acrylic. 20×24in (51×61cm).
Neil Murison paints acrylics in a very spontaneous way with considerable use of glazes to give depth and light to his shadows. The brushwork is kept very free and the painting has a freshness and atmosphere which inteprets the location exceptionally well.

△ **Lincoln by Patrick Collins.**

Pen and wash and oil pastel. 16×20in (41×51cm).
The original pencil lines have been left in addition to the pen, which keeps the picture loose and interesting.

Patrick captures well the busy shopping-street with the towering presence of the cathedral behind. Note how the extensive use of white paper makes the picture a lively and dynamic work.

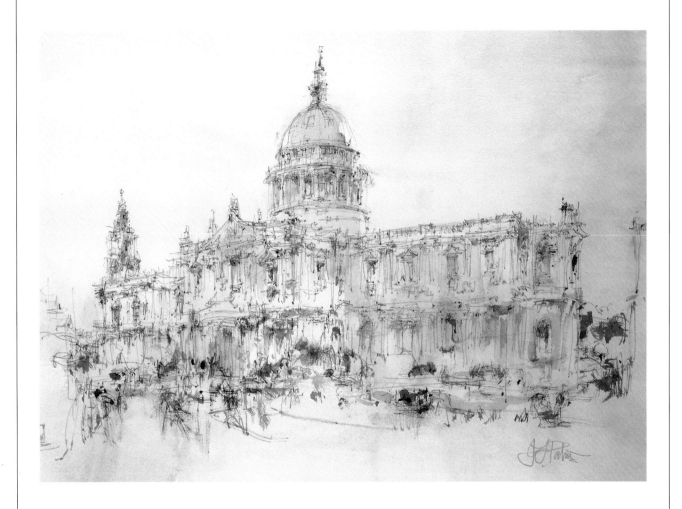

△ **St Paul's Cathedral, London, by John F. Palmer, RWA.**
Pencil and wash. 16×20in (41×51cm).
A unique pencil and wash technique epitomises John's work. The delicate touches of the pencil suggest the decorative features of Wren's architectural masterpiece. The enormity of the cathedral is captured and by his use of very delicate washes John somehow achieves a feeling of light and atmosphere.